EXPRESSIONISM

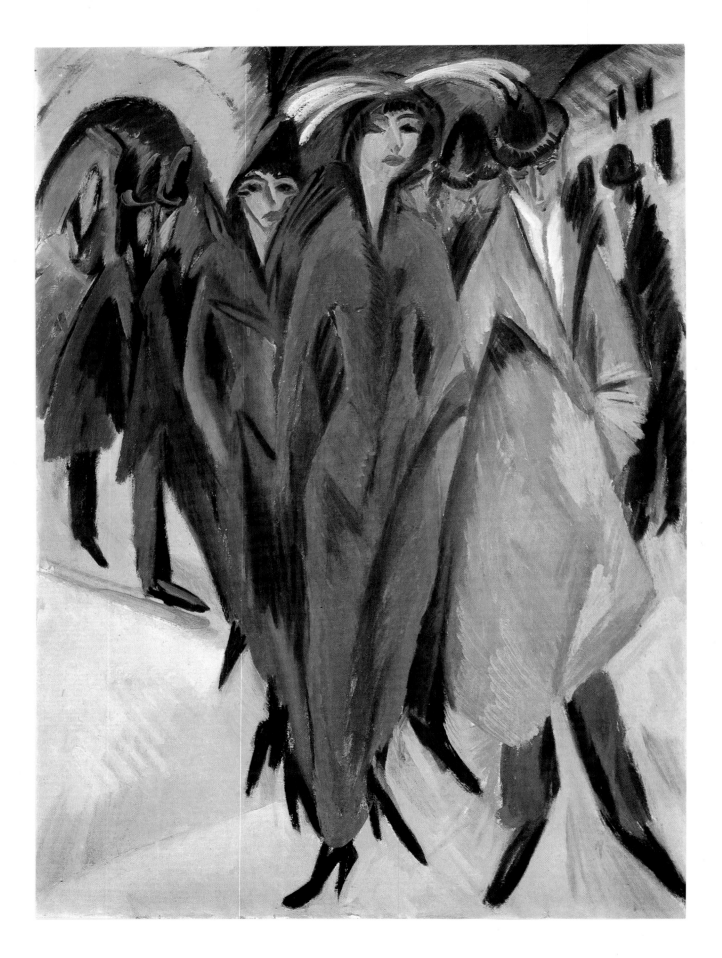

Paul Vogt

EXPRESSIONISM

German Painting 1905–1920

Text translated by Antony Vivis

Colorplate Commentaries translated by Robert Erich Wolf

HARRY N. ABRAMS, INC., PUBLISHERS, NEW YORK

Editor: Nora Beeson

Library of Congress Cataloging in Publication Data
Vogt, Paul
　Expressionism: german painting 1905–1920.
　Bibliography: p.
　Includes index.
　1. Expressionism (Art)　2. Painting, Modern—20th
century.　3. Prints—20th century.　I. Title.
ND196.E9V6313　　　　759.3　　　　79–18049
ISBN 0–8109–0852–2

Library of Congress Catalog Card Number: 79–18049
© for George Grosz and Max Pechstein: VG Bild-Kunst, Bonn
© for Heinrich Campendonk, Wassily Kandinsky, Paul Klee, Oskar Kokoschka,
Otto Mueller, and Karl Schmidt-Rottluff: Cosmopress, Geneva
© for Emil Nolde: Stiftung Seebüll Ada und Emil Nolde, Seebüll
© for Ernst Ludwig Kirchner: Dr. Wolfgang and Ingeborg Henze, Campione, Italy

© 1978 DuMont Buchverlag, Cologne
Published in 1980 by Harry N. Abrams, Incorporated, New York

Printed and bound in Japan

Frontispiece: Ernst Ludwig Kirchner. *Women on the Street*. c. 1914.
Oil on canvas, 49 5/8 × 35 3/8″. Von der Heydt-Museum, Wuppertal

CONTENTS

COLORPLATES

INTRODUCTION

Anyone concerned with twentieth-century German painting can hardly fail to encounter the key word Expressionism. It typifies, as it were, the essential nature of German art and characterizes its position within the context of international artistic developments. Recently, much has been written about Expressionism both as an artistic and as a literary phenomenon, without, however, providing a full explanation of its exact nature or stylistic characteristics. Discussion as to when the term Expressionism was first used has resolved the real problems no more successfully than the mere cataloguing of its varied and often contradictory aspects, although variation and contradiction are certainly two of its essential features.

In 1976, Paul Pörtner, speaking as a literary historian, expressed the provocative opinion that it had never been entirely clear whether Expressionism had existed at all, "at least, in the form in which it was passed down in many later versions." Pörtner also pointed out that only a few artists described themselves as Expressionists, and that many whom we include in its intellectual field did not wish to identify themselves with it as a concept. This, he argued, proved fairly conclusively that Expressionism was accepted more as an artistic achievement of individuals than as a common style.

Certainly Expressionism was not merely an interlude, after which "normal" artistic conditions could be restored. This idea is contradicted by its historical role as the symbol of an experiment in expression closely bound up with the German tradition, and as the precondition of a certain view of reality, which characterized the shattering of man's place in the world. This tragic tension between the ego and the world, which we encounter in the critical situation around 1900, challenged art not to reproduce the visible but—in Paul Klee's words—to make the visible truly visible. Such a vision could no longer accept traditional concepts of nature as a frame of reference for reality; indeed, it begged the question as to whether communication from within was, in fact, the real object of art, for which a new, more abstract form and interpretation would have to be found. In any event, the confrontation with the world that such a vision implied would need intense human participation, an increased ego perception. Thus the demands of the younger generation at that period were consistently directed at emotional rather than pictorial targets. Their aim was to penetrate to the spiritual essence concealed behind critical awareness, to unleash the instinctive as the expression of a new naturalness. The German painters and writers, in particular, proved to be deeply involved in that boundless subjectivism which

had grown out of the general crisis at the turn of the century—the feeling of dislocation, the isolation of the individual, the destruction of man's traditional, confident relationship to the world around him. Hermann Bahr described the situation in typically Expressionist fashion:

"Never was any period so shaken by such horror, by such dread. Never had the world been so deathly silent. Never had man felt so small. Never had he been so afraid. His misery cries out to heaven: man cries for his soul, the whole period becomes one long cry for help. Art cries out too, cries in the depths of darkness, cries out for help, cries out for the spirit: that is Expressionism."

Although the drama of the situation appears in a poetically heightened form here, the fissure that had opened up in about 1900 ran deep. It affected the existence both of the individual and of society at large. The need to articulate on the one hand the gathering conflicts within the industrial bourgeois age, and on the other a sense of profound insecurity and anxiety, in the hope of initiating a healing process, had shaken belief in the mediating claims of traditional art. Traditional art was considered incapable of coming to grips with the illusory world of the visible, which was now seen as an urgent necessity. Thus means other than the traditional ones had to be found. These were present only by implication in 1900, but they did allow a possible new direction to be perceived. To achieve an awareness of all the problems, however, took time. It is one of the characteristics of Expressionism that it continued to express itself for a long time in indefinite terms, usually synonymous with the titles of the authoritative publications of those years: *Sturm—Aufbruch—Aktion—Ruf* (*Storm—Revolt—Action—Summons*) and the like. All this was aimed at a process of change, not at its end products. Yet today, ironically, the very frankness and openness of this attitude strikes us as just one more characteristic of the Expressionist style.

Quite revealingly, the often quoted "naturalness" used as a synonym for the "inner reality of the human being" was itself the end product of a process of reflection. "Naturalness" was not, however, synonymous with "primordial"—another popular term which intellectuals already regarded as archaic by then. Both as an escape from the stresses of society and as the denial of traditional values, nature was seen as an elemental force. To follow one's impulses uninhibitedly, to break the previous aesthetic norms, became an enticing goal. To convert nature into form, however, was a complicated process. Some believed that the form should be sought outside the conventions of art: through free forms,

strong colors, the vocabulary of lay art, or by turning to the works of primitive peoples, which held the promise of that powerful primitiveness long since alien to the Europe of that period. The growing tendency among artists to style themselves as "savages" was foreshadowed as early as 1903 by Paul Gauguin:

"Sometimes I have gone back a very long way, further than the horses of the Parthenon, to the Dada of my childhood, my good old wooden horse. I am not ridiculous, I cannot be ridiculous, because I am two things which can never be ridiculous: a child and a savage."

The difficulties that the young painters had to overcome did not result only from public resistance to their emphatically stated ideas. They arose, for the most part, from their own intentions and demands. Their theory that every feeling, as long as it was strong enough, must be directly expressed in art led to the fallacy that the strength of the emotion directly determined the quality of the work. This explains the large number of works in which the unfettered scream was unable to find a form. Their paintings wrestled obsessively with self-inflicted problems wherein impetuosity was elevated to an imperative, lack of control to a criterion, and the role of the "spiritually disheveled artist"—in Werner Haftmann's phrase—to the norm. The Expressionist was free to indulge himself in his provocative or esoteric actions. He challenged the public to join in his cry for release and, at the same time, rebuffed them with his *odi profanum vulgus*. This double role was perfectly suited to his image as a "savage," which was no contradiction at that point. More and more, the public came to accept him not as the guardian of the temple of hallowed traditions, but rather as a prophetic force opening gates to a future world, as an elemental power ruthlessly creating for himself that space to which the "normal man," subjected to the pressures of social order, never dared lay claim.

This did not, however, bring the artist any closer to society, even when society accepted his special position. In fact, by pointing the way to the possibilities of freedom and intellectual independence, the artist was actually widening the old gulf. Inevitably the independence he extolled could never be anything but freedom of the individual, not that of society. André Malraux had the same idea when he wrote: "Since the Romantic age, poets, painters and musicians have been creating a common world for themselves in which all things enter into a relationship with one another, but not with the world of others."

Particularly remote were those artists who defended their role within the traditional social order but saw themselves placed in a difficult position by its collapse. The conserving role of art was played out; its new function as a permanent revolutionary force quickly became its chief hallmark and ultimately led to demands for a new structuring of society. A logical consequence of this was a shift in the former standards of assessment. The Neo-Primitivism propagated by the Expressionists deliberately, and not, as is often assumed, out of sheer incompetence, was part of their struggle against the authoritarian value system of a style of art adapted to the requirements of certain social strata. The flowering of the woodcut at that time was an eloquent proof of this, since the woodcut has always been the most democratic means of expression for German artists.

Not everything that had an expressive flavor in the fifteen years between 1905 and 1920 in Germany or Austria was actually Expressionist. The range of variation between different forms of subjective expression was so great that their outlines are blurred —the impressive artistic ability displayed in marginal areas, for example, was often not enough to define the situation unambiguously. Artists' accents changed with the reactions they provoked. Expressionism only grew to its full artistic stature in the work of a few leading exponents. So its countenance remained Janus-faced. It existed between intellectuality and instinct, between the desire for discipline and the urge toward release, between the mass and the individual. At the drop of a hat, genuine drama could be turned into strident pathos, deep emotion into hectic posturing, closely defined deformation into chaotic shapelessness. These qualities, regarded by many critics as negative, could also be seen as advantages: lack of tradition as spontaneity, destructiveness as boldness, rootlessness as inner independence. It is still difficult to reconcile these contradictory positions.

All attempts to define Expressionism as a style must ultimately face the fact that it cannot be so termed simply because any definition of its specific nature is bound to be fragmentary. Every attempt at definitive interpretation has merely unearthed fresh problems. Viewpoints change according to the attitude of the interpreter; the old divisions between its supporters and opponents still exist.

Nor does this essay attempt to provide a history of Expressionist style. The author willingly admits his own doubts as to whether the multifarious possibilities can be covered exhaustively by this overtaxed, although now legitimized, term. The pictorial examples, chosen deliberately, embody the old dialectic in German art between form and expression. They contrast Emil Nolde's highly emotional expression with the symbolism of Franz Marc's romantic, universal feeling; the undifferentiated visions of the Pathetiker with the intellectual formulations of Wassily Kandinsky. Painters such as Lyonel Feininger, Paul Klee, and August Macke are also considered because they stood firm against contemporary expressive trends and found their own paths. It seemed appropriate to include the two Austrians—Oskar Kokoschka and Egon Schiele—although it was Kokoschka who had the more decisive influence on the Expressionist scene in Berlin.

Restricting ourselves to the period 1905 to 1920 is logical, considering how Expressionism developed. Measured against its achievements and their aftereffects, Expressionism constitutes only a brief chapter of the art of our century. 1905 was the year of the founding of the Brücke (Bridge), its first artistic germ cell, and is therefore a good starting date. Fourteen years later, in 1919, the Dadaists would proclaim the death of Expressionism. In 1920 the art historian Wilhelm Worringer would also speak of the "crisis and end of Expressionism," and most scholars then agreed with him.

Nevertheless, what Expressionism had achieved proved durable. Retrospectively we can see that all subsequent stylistic trends in Germany had first to come to terms with Expressionism—if only by standing against its ideas. Ironically, of all people, it was the rulers of the Third Reich who were to resuscitate it. Their hatred endowed it, for the second time in its history, with the dignity of a symbol of freedom from state control, of the independent creative spirit struggling against ideological compulsion.

Its worldwide reputation after 1945 came about by a com-

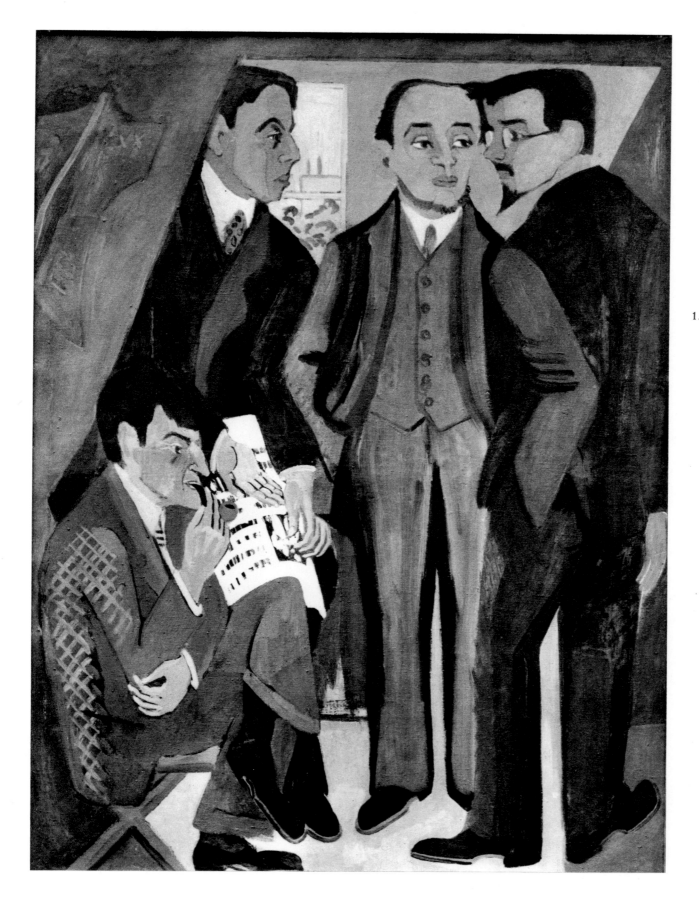

1. Ernst Ludwig Kirchner.
The Painters of the Brücke
(from left to right: Mueller,
Kirchner, Heckel,
Schmidt-Rottluff).
1925. Oil on canvas,
65 3/4 × 49 1/4".
Wallraf-Richartz-Museum
and Museum Ludwig,
Cologne

bination of circumstances that once more brought expressive feeling and action into the center of the artistic arena. But the reasons for its recognition in our own day are quite different. One factor is our somewhat melancholy nostalgia for a period that was still capable of producing the energy for revolutions in the belief that these could mold the future. In any event, the

fifteen years during which Expressionism flourished brought about more than the breakthrough of what Ernst Ludwig Kirchner called a "new generation of art creators and consumers!" They changed our perception of reality once and for all. Even so, a conclusive account of Expressionism's sources and the limits of its legacy has yet to be provided.

THE SITUATION AROUND 1900

The revolt of the young, revolutionary-minded artists at the beginning of our century did not occur by accident. It must have come as a surprise to their contemporaries, as there was virtually nothing to connect the first artistic utterances of this new generation with the themes, missions, and goals of traditional art. The powerful shock effect produced on the bourgeois public by the works of the "primitives" of that period was twofold. First, viewers felt helpless when faced with pictures that deliberately rejected tradition and made nonsense of accepted art-viewing criteria. People were also forced to recognize that the whole raison d'être of art had changed so radically that any conventional response to it seemed doomed in advance. This provoked both bitter rejection and enthusiastic acceptance—reactions that were just as emotional as those the young artists were expressing in their work. For the perceptive, however, there had been many warning signs of the approaching changes. The scandal caused when the public had forced the closing of the Munch Exhibition, held in Berlin in 1892, was still fresh in people's memories. However, the Berlin Secession under Max Liebermann, born of the protest against this action, said more for the freedom of the artist as such than for Munch's frightening and enigmatic paintings which German artists still found alien. At that time even Impressionism had not yet been digested in Germany; its followers were still seen as bold innovators and regarded with suspicion by the academies, which had to defend themselves against the desire for change on the part of their own most gifted students— antagonized by mainstream court painting.

Vincent van Gogh had died in 1890. He was one of the first to take the bold step of constructing behind the optical reality of the surface image a second, artistic reality, whose dimensions reached into the spheres of the spirit. The new status of color as a pure expressive value enabled an artist to convey directly what he felt, instead of resorting to gesture or mimicry. The first exhibition of Van Gogh's work shocked as many people as it impressed; but after 1900 the European art scene could no more dismiss him than it could the Belgian James Ensor. Ensor's tormenting imagery of masks and phantoms was yet another expression of the alienation of the artist from the world, and of the profound scepticism about visible reality, which the new century had to face. At issue here was not the crisis of a disturbed artistic personality, as contemporary critics would have had their readers believe, but the disturbed relationship of the human being to the world around him. Tradition no longer offered any remedy for the truly urgent problems. The traditional rules and doctrines were no longer capable of bridging the gulf which was gaping ever more widely. Admittedly, at that time tradition and society were still strong enough to cover up the tensions, paper over the cracks, and shore up a concept of reality that no longer corresponded to the truth. But it was impossible to dismiss nagging doubts, to deny the portents of the approaching upheaval. Only a nudge was needed to reveal the crisis. And this the young artists provided.

From the standpoint of official German art in 1900 there was little sign of the impending convulsions. Rapidly advancing industrialization and the prosperous middle-class associated with it gave the impression that art was participating in the economic boom as the symbol of prosperity, culture, and faithful representation. Compared to the consistency of development in France, the profusion of the German output was positively bewildering.

The plethora of different trends—including nature lyricism, historical painting, Art Nouveau, pleinairism, and the prevailing vogue for landscape-oriented art—did little to help clarify the situation. Profusion there was, but also scarcity of outstanding achievement. The academically trained artist had become an instrument of social classification. He functioned, in part willingly, in part reluctantly, as the representative of a class whose ideas did not always correspond with his own, but which he nevertheless felt obliged to respect. This was one of the reasons why academicism became the watchword for devalued artistic achievement, even if the accusation at that time came only from its numerous opponents, who lacked, however, any common program. There were individuals—freaks and renegades in the eyes of the mainstream artists—whose unconventional opinions and output stood out against their colorless background. These "deviants" were the products of the same academies as the representatives of the official mainstream, but they possessed a higher sensitivity to the underlying currents of the age, a finer instinct for contemporary commitment. They took things further, and they provided that creative unrest without which the German academies would have become completely moribund by the end of the nineteenth century. None of them achieved a radical breakthrough, but their ideas contained so much dynamite that we must attribute to them the function of revolutionaries in an otherwise monotonous artistic landscape. They served as catalysts for their generation. Their achievement lies in the imperturbability with which they defended their ideas and tried to realize them, regardless of all opposition.

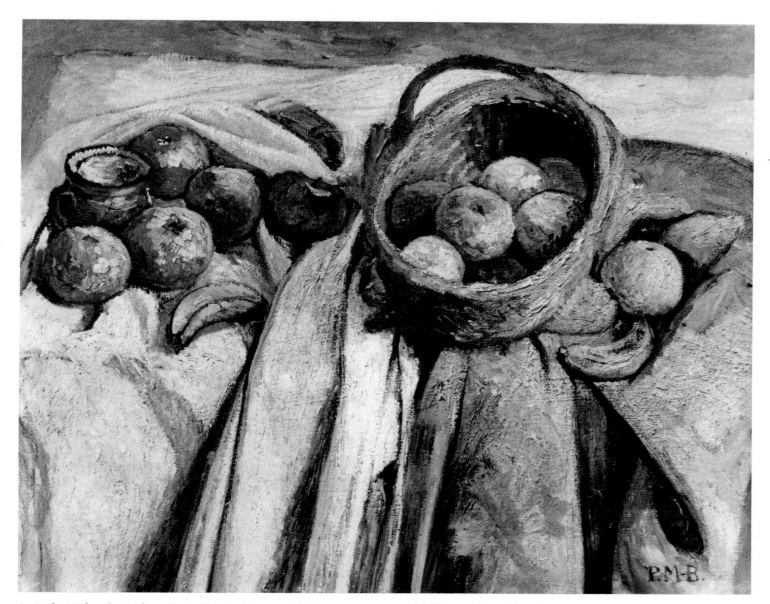

2. Paula Modersohn-Becker. *Still Life with Fruit*. 1905. Tempera on canvas, 26 3/8 × 33 1/8". Kunsthalle, Bremen

Some like-minded artists were to be found among the followers of nature lyricism, who, as the legitimate heirs of the German Romantics, developed their emotions apart from the great art centers, in the isolation of moor and heathland regions such as Dachau and Worpswede, "lost in the admiring contemplation of nature." Others were to be found among the German pleinairists whom the academies labeled members of the avant-garde, before hesitantly opening their doors to them; still others, among the representatives of Art Nouveau, who were already developing concepts in which the reality of nature could be replaced by highly evocative abstract shape. From all three schools, fine threads can be drawn across to the new century. Their influence was limited to Germany, but it was their very singularity, as well as the stubbornness of the artists themselves in rejecting the French stimulus and defending their own positions, which clarified the fundamental harmony of views between the various artistic groups.

The greatest influence was exerted by pleinairism. To call it "German Impressionism," as art literature has done repeatedly,

is misleading. Its aims were very different from those of French Impressionism. Certainly the artists of both countries shared the same enthusiasm for atmospheric light, and the transitoriness of earthly phenomena, whose immediacy they sought to convey by means of a specially developed personal style. Their views on the essence of nature and the mission of art, however, were poles apart. Where the French were realists, the Germans were idealists. Where French painters made a strict division between nature and art because they were aiming at a reality heightened by the hand and eye of the artist, the Germans were intent not on succumbing to the fascination of the eye, nor on describing phenomena, but rather on grasping the very essence of things. The difference of approach is most marked in their use of color. German artists were not interested in the purity and intensity of tone, nor in the legitimacy (independent of nature) or the compositional value of color. They saw paint more in terms of its emotional than its chromatic values (it was only in the later period that there were a few brilliant exceptions). The role of color as the agent of expression, mood, and emotion, and as the

11

embodiment of individual style were both achieved by dynamic brushstrokes, emphasizing the material, producing brightness not from color but from the contrast of broken tones. Unlike the shadeless light of French Impressionism, the shadows and hence the physicality of the shape were retained as the draftsman's scaffolding for the pictorial construction, which is often still visible behind the color.

Nevertheless, German artists certainly admired French Impressionism, precisely because it seemed so difficult to reconcile with their own ideas. It continued to inspire them by the brilliance and richness of its use of color, by the apparent lightness of the style, the weightlessness of matter, its choice of subjects, and its unaccustomed freedom. Like French Impressionism, German pleinairism was by no means a rural art; it was the expression of the big cities, but it still maintained an association with the ancient mythology of nature. One reason why this movement had problems establishing itself in a center such as Berlin was the rigid attitude of the Imperial Court and its representative, Anton von Werner; but despite their touchiness about innovation, even the court could not prevent the ultimate triumph of pleinairism. Thus it came about that German pleinairism—scarcely revolutionary in comparison to the international situation—was still regarded as "modern" long after 1900; and it was therefore seen by the young artists as reactionary at a time when it had not even been completely accepted by the public.

The nature lyricism we have already mentioned, which partly overlapped some of the ideas of Art Nouveau, probably influenced the German mentality more than pleinairism. Almost from the start it showed a latent desire for expression, for stylizing nature into a metaphor of an overwhelming emotional experience. The primordial permanence of the landscape was a powerful reflector of emotion: burning sunsets, silent silver birches against a lowering sky, lonely huts against the darkness of the moor could symbolize an entire range of emotions. It was not even necessary to have a new vision of things. The painting of small landscape schools such as Dachau or Worpswede remained conventional. They demonstrated that, in a particular intellectual situation, nature could be evoked atmospherically by its own physical appearance without a detour via allegory or mythology—as shown by the work of Arnold Böcklin or Franz von Stuck. All that was needed was a slightly exaggerated color, a little simplification of form, a small rearrangement of things in order to arouse a spiritual response to nature through the image. This was also significant for early German Expressionism: the expressive faculty of graphic techniques had been tested, the expressive value of color alluded to, object had been converted into emotion. True, this had more to do with Romanticism than with Expressionism, but it was still contemporary. Nature was now capable of turning from mystery to horror to symbols of underlying trend and painful melancholy. In the background we glimpse Edvard Munch, the symbol of a related outlook on life which seems to have been very characteristic of this period. Later we shall see how the young Expressionists reacted to such stimuli. We should not forget that in 1899 Emil Nolde settled in Dachau for a time.

To give a full account of Art Nouveau's influence on art after 1900 would be beyond the scope of this essay. It should simply be noted that this movement, which had a firm ideological foundation in Germany, had set itself objectives that, at least according to the traditionalists, displayed anarchist leanings. Once again the main target was the academy. In 1896 *Die Jugend* (*Youth*), which was to give its name to the German movement Jugendstil, was published in Munich. It was not an art journal in the traditional sense. Aggressively and cynically caricaturing the contemporary scene, anticlerical, often vicious in its responses, it became the watchword of an avant-garde that had the will, but not the strength, to achieve the decisive breakthrough. It lacked the personalities, the geniuses who could have drawn historical lessons from that which was merely idealistic wishful thinking.

Nevertheless, Art Nouveau became the pathfinder for the next generation. As a movement of revival not only in painting but in handicrafts and interior design as well, it also attracted leading exponents from other fields. It became less a matter of the renewal of form than of the shaping of a new design for living. External stimuli played their part too: Munch's expressive themes, Ferdinand Hodler's monumental and rhythmical gesticulative style, the exciting line drawing and erotic subjects of the Englishman Aubrey Beardsley, and the ideas of the Belgian architect Henry van de Velde, together with ideas from Eastern and East Asiatic cultures. Almost from the start, line and color took on a new meaning, especially where notions of absolute form, independent of nature, were concerned. Until recently, the exaggeration of linear functions and the abundance of decorative application have clouded the view of Art Nouveau's real achievement. The idea that the line has not only a form-defining function, but also the capacity to create in the abstract, is one of the most daring insights of that time. The same is true of color. As early as 1896 Fritz Endell formulated his views on the emotional effectiveness of nonrepresentational colors. He was concerned with "creating absolutely pure surface backgrounds in which there hovers a lost music of shapes and colors." The reference to symbolism is obvious, and nature lyricism was also given new stimuli from this source.

The implications were extraordinary. They pointed directly toward abstract painting, which, as Wassily Kandinsky realized, created the conditions for the renaissance of graphic art in Expressionism. As far as handicrafts and the idea of the functional nature of form were concerned, the movement ultimately influenced even the Bauhaus.

EXPRESSIONISM

Those Expressionists who have talked about their art have always stressed its unconditional nature, elevating their independence from models or influences to a watchword of their art. This was not a falsification of history, but it does call for a more precise interpretation. The facts suggest that the Expressionists were working in the same general direction as the younger generation; and that their work did not gain the independence it required by totally rejecting tradition or holding aloof from every other intellectual and artistic current, but rather by a process of elimination which made most of them instinctively reject everything that did not directly advance their own development. However, each artist's receptivity and independence depended on his personality and his situation. Instinct and knowledge played equal parts in the development of the Expressionists' language of form and concept of color. No influence that had been sieved through the filter of artistic consciousness could be considered harmful. How much influence outside stimuli had depended largely on local conditions —the influence of landscape, for example, was a striking one. North and South constituted independent focal points. The situation in Munich was influenced by the background of Russian and French art. Munch and Van Gogh had far less effect there than they did on the artists of Northern and Central Germany. It is impossible to view the art of the Blaue Reiter in the same way as that of the Brücke or of Nolde. The Westphalian scene tended to follow Northern German developments, whereas the Rhineland showed closer links with the South. The personalities of the artists were as different as the ways in which they used their expressive technique as a "common style." What bound them together was no more obvious than what divided them. Their points of departure also varied. In Dresden and Munich, close or loose associations of friends and kindred spirits served as nuclei, whereas no comparable groups sprang up in the North and West. In Northern Germany, in particular, the loner was a typical phenomenon.

NORTHERN GERMANY

Emil Nolde and Christian Rohlfs were very clear embodiments of Northern German individuality. The two taciturn friends came from similar backgrounds. Both were the sons of small farmers, not destined by birth to be artists, but called to art by inclination and determination, which made things more difficult for them than for others. Their untrained instinct pointed them toward an expressive art, although by a roundabout and arduous path. It was a long time before the two painters were able to articulate effectively.

At first Nolde traveled around—he worked in Switzerland as a handicraft teacher, and because the painter-prince Franz von Stuck in Munich would not accept him as a pupil, he sought advice from Adolf Hoelzel in Dachau. Not until he returned to his northern home were the conditions ripe for the development of his own characteristic style, which evolved from intimate contact with the landscape of plains, coast, and sea into a rich pictorial language embodying his expressive feeling for nature. The literary and the classical were alien to his art, which stood in direct relationship to life, to those powerful forces that lie behind surface appearances. The visionary element is part and parcel of this landscape. The heightening of visible reality reveals this visionary element, which establishes the relationship between the ego and the world without aesthetic regulations, without artistic doctrine, trusting entirely to instinct. Such a procedure, however, is fraught with dangers. It ignores the *penser fait sentir* of Henry Martineau, trusting instead to the impulses of the heart—"instinct is ten times greater than knowledge," as Nolde put it. This contact with the Dresden Brücke, which he joined for a year in 1906, made him familiar with the related ideas of much younger artists. But the age gap was too great, the demand in Dresden for collective work too contrary to his own temperament to result in any lasting association. Nevertheless, the advances toward color then being made by the Brücke under the influence of late French Impressionism were his decisive experience during that period. Slowly the artist's rootlessness disappeared.

From then on Nolde put all his faith in the medium of color. It became both medium and object, all the daemonic and primeval construct of his imagination was entrusted to its symbolic power, its intense allegorical value (fig. 3). With it, in happy hours of labor, he achieved works of lasting conviction. Nolde's art does not so much develop as return to familiar themes. The drama of his imagery is transfigured into a radiant epic simply by the process of maturity. In his grandeur and in his limitations, in his strengths and in his weaknesses, Nolde represents the German Expressionist par excellence. Light and shade are united in his oeuvre according to a predetermined pattern: painting as the dark destiny of the individual, and as the emanation of an ecstatic vision directed toward passionate expression (colorplates 5, 6, 7).

Rohlfs was different. The driving forces behind Nolde's art were alien to him. Rohlfs traveled the traditional road via the Weimar Academy, where he soon attached himself to "revolutionary" pleinairism. At the age of fifty, Karl Ernst Osthaus took him to the newly created Folkwang Museum in Hagen where he was confronted with the work of the bold innovators of the time—Van Gogh, Gauguin, the Fauves, and the Neo-Impressionists—soon enough for the artist to profit from the encounter, but too late for him to dedicate himself unreservedly to the new ideas. Compared with Nolde, Rohlfs was only halfheartedly an Expressionist. It is true that his work straddles the dividing line between suppressed Impressionism and the anti-Impressionist expressive function of color. Between them lay the influence of the dynamic brushstroke of artists such as Van Gogh, and the pure color of Neo-Impressionism. Both pointed the way toward color as metaphor. The reaction followed between 1905 and 1907, parallel to the first utterances of the Brücke and the French Fauves (colorplate 3). The powerful and materially substantial works that appeared after 1906, as well as the more reserved works expressing precise emotions that appeared after 1914—both Expressionist in character—show that Expressionism was not always weighed down by the "burden of crude formulae." Artists such as Rohlfs, who never abandoned their links with the traditional laws of painting, who evoked emotion sensitively, differentiated their vision in their painting, attempted to give the elemental a coherent form, were capable of formulating Expressionism in a sophisticated style of painting. What they desired was to liberate themselves from their self-imposed category of "savages," to transpose expressive color and suggestive form back to the object in order to define their new vision through it (fig. 4). In this way the concept of "Nature," much quoted at that time, could once again signify a direct understanding between man and the world around him. The elemental thereby lost its aggressive character but could

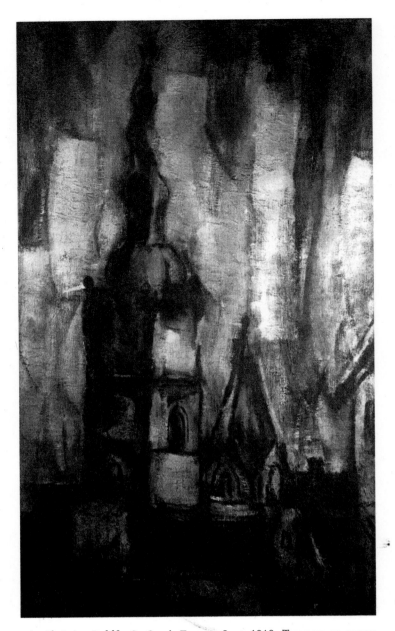

4. Christian Rohlfs. *St. Peter's Tower at Soest*. 1918. Tempera on canvas, 39 3/8 × 24″. Kunsthalle, Mannheim

be structured into the desired synthesis of nature and emotion, observation and delight. It is only logical, therefore, that Rohlfs would develop a distinctive late oeuvre as a synthesis of his long labors, in which this struggle for expression emerged in an overridingly existential feeling.

The art of Paula Modersohn-Becker, one of the few important women artists of this period, also belies the verdict pronounced on Nolde but applied to Northern Expressionism in general: "Natural-daemonic, amorphous, emotional and exaggerating color." Her language is rich in sensitive intermediate tones, shows moderation at a time of unrest and a compassion for people, which is expressed with more reserve than in the sociocritical accusations of Käthe Kollwitz. It was no easy task to put ideas like this across in the small artists' colony of Worpswede. Her painter friends misunderstood her and attacked her attempts to give nature less prominence in her painting than personal feeling, which, for her, came first. Once this feeling was expressed, "clear in color and shape," then nature could step in to make the created object look natural. Here one can draw a clear distinction between the nature lyricism of her colleagues and her own expressive outlook (colorplate 2): her husband and her painter associates always started from a stylized natural form and aimed

3. Emil Nolde. *Mary of Egypt: Death in the Desert* (right panel of triptych). 1912. Oil on canvas, 33 7/8 × 39 3/8″. Kunsthalle, Hamburg

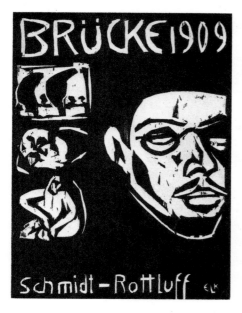

Im Jahre 1902 lernten sich die Maler Bleyl und Kirchner in Dresden kennen. Durch seinen Bruder, einen Freund von Kirchner, kam Heckel hinzu. Heckel brachte Schmidt-Rottluff mit, den er von Chemnitz her kannte. In Kirchners Atelier kam man zum Arbeiten zusammen. Man hatte hier die Möglichkeit, den Akt, die Grundlage aller bildenden Kunst, in freier Natürlichkeit zu studieren. Aus dem Zeichnen auf dieser Grundlage ergab sich das allen gemeinsame Gefühl, aus dem Leben die Anregung zum Schaffen zu nehmen und sich dem Erlebnis unterzuordnen. In einem Buch "Odi profanum" zeichneten und schrieben die einzelnen nebeneinander ihre Ideen nieder und verglichen dadurch ihre Eigenart. So wuchsen sie ganz von selbst zu einer Gruppe zusammen, die den Namen "Brücke" erhielt. Einer regte den andern an. Kirchner brachte den Holzschnitt aus Süddeutschland mit, den er, durch die alten Schnitte in Nürnberg angeregt, wieder aufgenommen hatte. Heckel schnitzte wieder Holzfiguren; Kirchner bereicherte diese Technik in den seinen durch die Bemalung und suchte in Stein und Zinnguss den Rhythmus der geschlossenen Form. Schmidt-Rottluff machte die ersten Lithos auf dem Stein. Die erste Ausstellung der Gruppe fand in eigenen Räumen in Dresden statt; sie fand keine Anerkennung. Dresden gab aber durch die landschaftlichen Reize und seine alte Kultur viele Anregung. Hier fand "Brücke" auch die ersten kunstgeschichtlichen Stützpunkte in Cranach, Beham und andern deutschen Meistern des Mittelalters. Bei Gelegenheit einer Ausstellung von Amiet in Dresden wurde dieser zum Mitglied von "Brücke" ernannt. Ihm folgte 1905 Nolde. Seine phantastische Eigenart gab eine neue Note in "Brücke", er bereicherte unsere Ausstellungen durch die interessante Technik seiner Radierung und lernte die unseres Holzschnittes kennen. Auf seine Einladung ging Schmidt-Rottluff zu ihm nach Alsen. Später gingen Schmidt-Rottluff und Heckel nach Dangast. Die harte Luft der Nordsee brachte besonders bei Schmidt-Rottluff einen monumentalen Impressionismus hervor. Währenddessen führte Kirchner in Dresden die geschlossene Komposition weiter: er fand im ethnographischen Museum in der Negerplastik und den Balkenschnitzereien der Südsee eine Parallele zu seinem eigenen Schaffen. Das Bestreben, von der akademischen Sterilität frei zu werden, führte Pechstein zu "Brücke". Kirchner und Pechstein gingen nach Gollverode, um gemeinsam zu arbeiten. Im Salon Richter in Dresden fand die Ausstellung der "Brücke" mit den neuen Mitgliedern statt. Die Ausstellung machte einen grossen Eindruck auf die jungen Künstler in Dresden. Heckel und Kirchner versuchten die neue Malerei mit dem Raum in Einklang zu bringen. Kirchner stattete seine Räume mit Wandmalereien und Batiks aus, an denen Heckel mitarbeitete. 1907 trat Nolde aus "Brücke" aus. Heckel und Kirchner gingen an die Moritzburger Seen, um den Akt im Freien zu studieren. Schmidt-Rottluff arbeitete in Dangast an der Vollendung seines Farbenrhythmus. Heckel ging nach Italien und brachte die Anregung der etruskischen Kunst. Pechstein ging in dekorativen Aufträgen nach Berlin. Er versuchte die neue Malerei in die Sezession zu bringen. Kirchner fand in Dresden den Handdruck

5. Ernst Ludwig Kirchner. Cover of 4th Annual Portfolio of the Brücke. 1909. Woodcut

6. From the *Chronicle of the Artists' Group Brücke*. 1913. Woodcuts by Ernst Ludwig Kirchner and Karl Schmidt-Rottluff. 12 5/8 × 10″

thus to reach emotion. For Paula Modersohn-Becker this was too anecdotal an approach, which smacked of genre painting. A stay in France helped: her study of Cézanne and Gauguin, of formal and pictorially decorative art, helped her to clarify her own position (fig. 2). To reveal hidden human values beyond the accidents of nature, to cultivate a style that was capable of expressing essential truth simply and nobly, to convey the emotions of the heart—these were her objectives. And so, almost automatically, her own individual development was attuned to the prevailing existential feeling in the Europe of the new century.

As we have seen, the contribution of the North to Expressionism could fill a separate monograph. What the North lacked was a linking community, and that carefree, youthful élan which, out of the sense of a common intellectual comradeship, sprang up in Dresden and Munich. This sense of community among the young revolutionaries was unknown in the North, where it was a question of distinctive individuality rather than of the expectant feeling of a common mission.

THE BRÜCKE

It is only from recent research that more precise details have come to light about the origins of the Brücke (Bridge) association of artists. Kirchner's attempted chronicle came to grief in 1913 amid controversies concerning the highly subjective text. On the other hand, the reminiscences of Fritz Bleyl, parts of which were published by Hans Wentzel, cleared up a number of doubts, although they were not always in agreement with the oral comments of his friends.

The original situation in Dresden differed from that in other associations and secessions founded at the time. Here there was no group of young artists banded together in a common protest against the regimentation of the Academy, but four self-taught students at the technical college. They were all passionately inter-

ested in art because they regarded it as the symbol of intellectual independence, the way to self-liberation. It took them a long time, however, to come to terms with the idea of practicing art not as a vague vocation, but as a profession. The two friends Fritz Bleyl and Ernst Ludwig Kirchner had been studying architecture since 1901 and completed their examinations in 1906. In 1904 they were joined by Erich Heckel and in 1905 by his friend Karl Schmidt from Rottluff. Graphic works and occasional experiments in color have come down to us from their school and early college days, but nothing of genius. In June 1905, however, Schmidt-Rottluff managed to sell a woodcut *Morning Sun* at the Sächsische Kunstverein. The students gratefully accepted the freedom that the teachers allowed their often unruly protégés. Six hours of free drawing a week brought them into contact with the young professor Fritz Schumacher, whose teaching theories had matured through his contact with English Art Nouveau, with the developments in Munich, and the works of the Belgian Henry van de Velde. The teaching of Carl Weichardt and Friedrich Meyner in ornamental and figure drawing was also free of academic regimentation.

Their graphic work was extremely lively from the very start. The decorative black-and-white texture of their wood- and linocuts revealed the various stimuli of their early years. There was no reason to call these artists Expressionist. At first, painting was not even their main activity. It was not until 1906–7 that it developed under the same stimuli that inspired the young Fauves in France to their bold fledgling works. These were communicated to the Dresden scene by the Arnold Gallery, which exhibited the innovators of the period from 1905 to 1907. In 1905 Van Gogh's tempestuous colors were exhibited. His dramatic personal style as well as the expressiveness of his colors had a lasting effect on the Germans, whose eyes were particularly keen in this respect. Acquaintance with French Neo-Impressionism followed in 1906 through the exhibition held at the Sächsische Kunstverein. This gave them the courage to take risks with color which they

came to know in a previously unheard-of purity and intensity in the paintings of Paul Signac and Georges Seurat. If we also mention the exhibition of works by Edvard Munch held in the same year, we can see how many new possibilities in art had now opened to the young painters.

If we look at the situation at the time, we can understand why they were later unwilling to acknowledge their early works and even destroyed some of them, although this certainly does not justify their actions. The obligation all the members of this generation felt to start afresh, to reject all traditions, as well as their struggle for primitiveness as the precondition for uprooting the artist from his traditional context and throwing him back on his own resources, demanded a strict denial of everything that could be regarded as a link with any kind of mode. And this is where the contemporary French scene was so radically different. Fauvism had flourished on the soil of traditional French painting and thus avoided those problems which in Germany were behind the revolution of young people. For the Fauves, this tempered the climate, because tradition referred them back to the tried and tested aesthetics of color. Nor had Cézanne's warning "art is a harmony parallel to nature" lost its meaning in France, even for the young bloods.

Initially, Cézanne's importance as a pathfinder went unrecognized in Germany, and at this time meant little to German artists. They regarded form not as the symbol of a higher law of the pictorial organism, but as the vehicle of expression, as a means of conveying the "universe within" in pictures. Every form of abstraction—at that time appropriately called deformation—was based on metaphysical necessity. The function of the picture consisted in conveying a powerful feeling for life, in interpreting the confrontation of man with the world, and in making visible those inner forces and associations beyond the visible world, which were seen only as a pseudoreality. Particular value was attached to color. It gave up its descriptive, illustrative, and decorative functions in favor of purity of utterance—both in materials and in psychology. The young artists quickly developed into colorists, and even if they later restricted their material, its emotional value was not suppressed, and it remained the vehicle of that "new feeling for life" which was being propagated on all sides.

The approaching revolution was already dimly visible in the few early works of the Brücke—in their urge for the primitive expressed in spontaneous primary colors and dynamic brushstrokes; in their excited struggle for a "new naturalness," which the young artists thought they would find in unspoiled nature; in the promptings of Eros; and in the friendship of youthful fellowships. Their tendency toward collectivism and their search for individuality (which were not contradictory), as well as their sense of mission (which they directed at the public while despising it, viz. the *odi profanum vulgus*, which was written in their common journal), were all true to their age. The amorphous emotionalism of those years, the tendency to destroy form in an expression of inner movement independent of a final structure also appears in the literature of the time. We have only to remember the attempts to liberate the passions current since the years of *Sturm und Drang* (whose proponents, like the artists of the Brücke, came from a bourgeois background); or the alarm signals of the federal youth movements about 1900; or the pictorial power of the Nordic sense of destiny as exemplified by Ibsen, Strindberg, or Munch.

Kirchner's phrase "monumental Impressionism" is a good description of those early years, if by monumental we mean the transcendence of Impressionist logic. For in the pictures of the young Dresden artists everything was intuitive, the gift of the moment. Only the self-taught are capable of such temerity.

While still undecided about its aims, the Brücke was officially founded. It was transformed from a circle of friends into a registered organization with a chairman, members, and a program, which, as G. Krüger has shown, "sounds like a compressed version of the introductions written by Max Burkhard and Hermann Bahr for the first volume of the *Ver Sacrum* of 1898."

Nevertheless, this was the inevitable first step toward the exhibitions in which they planned to present their own work to the public. The Brücke thus made its entry into the contemporary art scene, apparently between the winter of 1905 and the spring of 1906. Shortly after its foundation, the circle was widened to include a new member, Max Pechstein, whom Heckel had met. This scholarly painter, a successful graduate of the Dresden Academy, was superior to the other members in natural insouciance and technical knowledge. He was long regarded as their leading figure. Nolde also joined the Brücke that year. The fermentation process of the early days lasted through the succeeding years, although gradually a direction could be recognized. The period from 1907 to 1911 was the first artistically important stage of the new Expressionism. During these years the transition from collective creation to an individual style was completed. Despite continued agreement in principle, the various temperaments and views made themselves more and more clearly felt. Although Nolde again departed and Fritz Bleyl took up teaching, the works of Heckel, Kirchner, Pechstein, and Schmidt-Rottluff identified them as the initiators of the artistic revolution.

The various ateliers, including a former butcher's shop at No. 60 Berliner Strasse, which Kirchner took over from Heckel in 1906, and a cobbler's shop close by, were the scene of a lively artistic life. As well as the professionals, who were paid for by the artists jointly, girls from the neighborhood acted as models (colorplate 12). The spartan furnishings, with the home-dyed, strongly colored wall hangings which have come down to us through pictures of those years, were in keeping with their new image of themselves as artists. The Academy and the museums were no longer to be their seats of learning. Long hours were spent in the halls of the Dresden Gemäldegalerie. The color, style, and composition of the Old Masters offered reference points for their own efforts. According to Heckel, certain characteristic features of Jan Vermeer's perspectives had a lasting influence on his work, as did technical studies on the paintings of Albrecht Dürer. All of them admired Lucas Cranach's *Venus* and were delighted to come across a print of it later in Otto Mueller's atelier. Their studies of old German woodcuts and printing blocks in the Germanische Nationalmuseum in Nuremberg did not have a direct formal influence on their graphic art but confirmed an essential affinity, based not so much on the line of the traditional teaching as on an inner agreement. In the unpublished chronicle of 1913, Kirchner also reported on the early "reference points in art history" which they found in Barthel Beham, Cranach, and other German Masters of the sixteenth century.

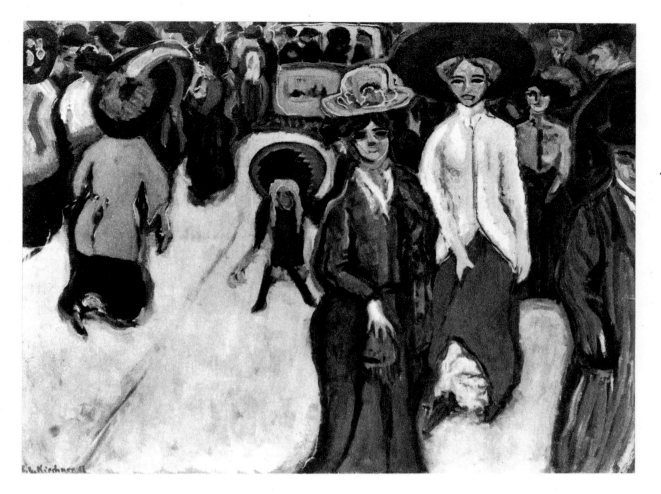

7. Ernst Ludwig Kirchner.
Street, Dresden. 1907.
Oil on canvas, 59 × 78 3/4".
The Museum of Modern Art,
New York

In their search for the primitive and nontraditional they came upon the ethnological department of the Dresden Museum. African sculptures and masks, carved beams from the Palau Islands, and cult figures from the Bismarck Archipelago provided sources of inspiration. The fact that Nolde and Pechstein did not take the museums to be the last word on native culture, but traveled to the South Seas themselves, symbolizes their response to the creativity of natural man not yet stilled by civilizing influences.

The artist's life was divided between town and country. Street pictures, circus and cabaret scenes (fig. 17), and atelier paintings alternated with paintings of the Saxon lakes and the Northern German coast, whose harshness they appreciated. They loved returning to the Moritzburg lakes in summer with their girlfriends "in order to study the nude in open naturalness." Dangast, the little fishing village on Jade Bay, was turned by Heckel and Schmidt-Rottluff into a center of early Expressionist art (colorplate 11). Kirchner went again and again to Fehmarn, although his love of nature was vastly different from a citydweller's sentimental nature worship, or the notions of nature lyricism.

Thus it is often difficult to decide whether figure or landscape was the favorite subject of the Dresden years. The same elemental driving forces were common to both. Their break with tradition was unequivocal, the concepts of ugliness and beauty they inherited were superseded by a new concept of reality. Eros and youthful passion were identified as "natural" creative drives, which, if appreciated for their own sake and natural vigor irrespective of their application to art, could help liberate man.

Developments after 1907 are easy to follow. By 1910 there had been more than thirty exhibitions of works from the Brücke circle, both paintings and graphics. Simultaneously two collections had been started. Except for Cuno Amiet, none of the foreign members took part in these exhibitions. The list of exhibition sites is a long one. Among the first was the Folkwang Museum, founded in Hagen in 1902 by K. E. Osthaus; although first intended for French contemporary art, it was soon taking note of the new German situation. Nolde wrote in his reminiscences that it appeared to them like "a celestial sign in Western Germany." On the list of sites we find Bonn, Göttingen, Königsberg, Freiburg, Hamburg, Flensburg, Magdeburg, Krefeld, Gotha, Erfurt, Dortmund, Rostock, Naumburg, Frankfurt-am-Main and Frankfurt-an-der-Oder, Aachen, Gerau, Dessau, Danzig, Lübeck, Mönchengladbach, Jena, Leipzig, and Hannover, as well as Prague, Solothurn, Copenhagen, and Christiania. Berlin does not figure on the list until 1912, and Munich was finally added in 1913.

However long this list may seem, it should not blind us to the fact that the works exhibited continued to be controversial, and restrictions were placed on the wider influence of Expressionist art for some time to come. Critics seldom offered words of appreciation whenever they paid any attention at all to the small Dresden artists' group. The usual reaction was ill-natured resistance, and some exhibitions were closed prematurely.

If we look at the works produced between 1907 and 1910, bearing in mind Kirchner's subsequent mistaken dating that was recently corrected by research experts, we can see the common foundations of the Brücke painting in all the works of this period, despite certain "aberrations" resulting from their delight in experiment and constant search for new ideas. The sensual value of color sustains the creations of this short period, although their purely elemental power, whose effect depends mainly on the vitality of the application, often results in stridency. Although the energy of the technique sometimes overshadows structure and composition, the characteristic features still stand out: the harsh

8. Max Pechstein. *Indian and Woman*. 1910. Oil on canvas, 32 1/2 ×
26 1/4″. Collection Morton D. May, St. Louis

The move meant more than simply a change of residence. It set the seal on the period of mature Expressionism which was to gain prominence with surprising speed through its contacts with avant-garde centers in Berlin and the experiences of the metropolis. In terms of structure, the development of the Expressionist vocabulary had been completed by that time. Now, problems of socio-critical content and the themes of urban existence came to the fore, against which landscape painting, as a personal commitment by the artist, stood out even more sharply than before.

The intellectual climate of avant-garde Berlin was dominated at that time by literary Expressionism, whose influence on the Brücke painters has only sporadically been dealt with previously. The "Moderns" met in various clubs and circles. It was in Berlin in 1910 that Herwarth Walden (fig. 26) founded the journal *Sturm*, which became the mouthpiece of the young movement and a focus of contemporary European art. In 1912 he opened his famous gallery, in which the leading figures of the time were exhibited. Here the painters of the Brücke as well as those of the Blaue Reiter were to be found—the Cubists, the Futurists, and the loners.

In 1910 the New Secession split off from the circle around Moritz Melzer, Max Pechstein, and Georg Tappert (fig. 11). The first number of Franz Pfemfert's *Aktion*, which brought

vigor of Schmidt-Rottluff, whose uncompromising nature both daunts and fascinates; the boldness of Heckel, which combines sophistication with sensitivity; and Kirchner's restless, decorative talent, in which psychological tensions are first revealed. Pechstein was the first to succeed with the public. In 1907–8 he had traveled to Paris and Italy on an Academy grant, had seen Fauvism at first hand, and won over Kees van Dongen as a member. His more conciliatory style of painting, giving preference to harmonious tones, and his delight in the decorative effects of form, struck his contemporaries as very different from the violence and harshness of the other painters. For years he had been regarded as the leading figure of Expressionism. This partly explains why he was the first to break away from the circle and move to Berlin in 1908. His flat on the Kurfürstendamm often became a home for the other artists on their trips to the capital, where an intellectual bustle was developing quite unlike the peaceful residential town climate of Dresden. The pull of this center was strong, and it was only a matter of time before the Brücke moved there.

In 1910, under the chairmanship of Pechstein, the New Secession was founded in Berlin and the Brücke joined it en masse. Otto Mueller also joined that year. In 1911 Kirchner moved to Berlin and with Pechstein founded the MUIM Institute (Modern Instruction in Painting). They were followed only weeks later by Schmidt-Rottluff and Heckel, who took over Mueller's atelier in Steglitz. The Brücke, expanded by the arrival not only of Mueller but also of Bohumil Kubišta from Prague, was reunited in one place.

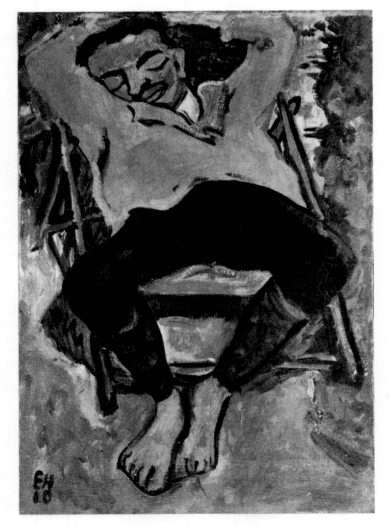

9. Erich Heckel. *Pechstein Asleep*. 1910. Oil on canvas, 43 1/4 ×
29 1/4″. Staatsgalerie Moderner Kunst, Munich

together antibourgeois literary circles and was avowedly political, appeared in 1911 and soon afterward opened its doors to the graphic arts as well. The unjustly forgotten group of Pathetiker, whose name typifies their ideas—consisting of Ludwig Meidner (colorplate 37, figs. 14, 20), Richard Janthur, and Jakob Steinhardt (colorplate 38, fig. 16)—saw the light of day in 1912. Painters such as Lyonel Feininger and Max Beckmann were also living in the capital at that time, although they had no direct link as yet with Expressionism.

By this time at the latest, Expressionism had become a watchword for the "Moderns." It was gradually gaining public notice as well, and was generally referred to when modern art was mentioned. In 1911 Lovis Corinth, whose powerful pleinair painting was obviously receptive to expressive tendencies at that time, described even the Cubists as "Frenchmen of the newest trend, known as Expressionists."

Under Berlin's influence, the works of the Brücke artists became far more sharply defined. In the paintings of those years the "inner picture" crystallized into the insight that what had to be made visible were experiences, not phenomena. The hectic, unnatural life of the big city, the corruption and sickness, the social crisis, the chiaroscuro of human existence in a metropolis inspired the artists to metaphors of such symbolic power that it was not difficult to see reflected in them the existential situation that existed shortly before the outbreak of World War I. These works simultaneously expressed fascination and horror, fear and alienation. Nolde described his nightly pub rounds "where impotent asphalt lions and hectic demimondaines with faces as ashen as powder or rotting corpses sat about in their elegantly audacious robes, carrying them as if they were queens" (fig. 15). Had not Vincent van Gogh's painting of the Arles café at night tried to say "that the café is a place where one can go crazy and commit a crime"?

The night scenes, the whores and their clients, the brothel scenes, all underline the antibourgeois attitude of the painters, but they must not be interpreted as a criticism of the urban way of life. Most of the encounters are portrayed without sentimentality. These artists are not moved by the pathos of Expressionist fiction, which accepts the girl as the victim and thus as the real moral heroine. In these paintings they are facts of life in a big city, wherein the ambiguity and two-faced nature of existence is revealed, the filth behind the proud facade in which these artists discovered the first cracks.

The great number of street scenes (Frontispiece, fig. 7), pictures of circus and cabaret shows (fig. 17), the representation of the period by subjects removed from bourgeois life, the artists' sympathy for the fringe phenomena of the urban inferno stand in sharp contrast to the survival of the notion of the natural life that had developed in Dresden.

The confrontation between reality and idyll, risk and security, the infernal and the Dionysian was now cruder than ever. In such subjects the individuality of the painters emerged particularly clearly. Heckel's landscape radiated a strong but serene atmosphere, the tranquillity of which was sometimes downright anachronistic. Schmidt-Rottluff's primitive nudes, together with his richly colorful landscape abstractions, occupy a special position (colorplate 13). He had made fewest concessions to the pressures of the city. Kirchner's self-destructive psychological studies

(fig. 19) sometimes—especially in the Baltic pictures—give way to a truly classical equilibrium, even when the human being figures prominently.

At this period of artistic maturity common activity and travel were no longer guarantees of success. The Brücke as an association was at an end. The marked individuality of the various artists did not imply any fundamental rivalry but it did mean that the various

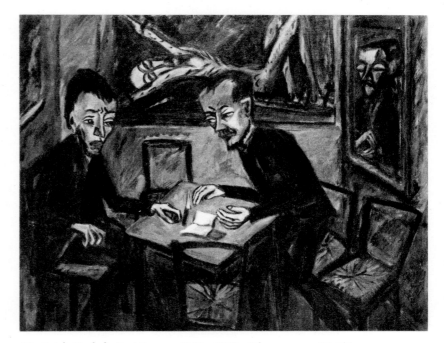

10. Erich Heckel. *Two Men at a Table*. 1912. Oil on canvas, 38 1/4 × 47 1/4". Kunsthalle, Hamburg

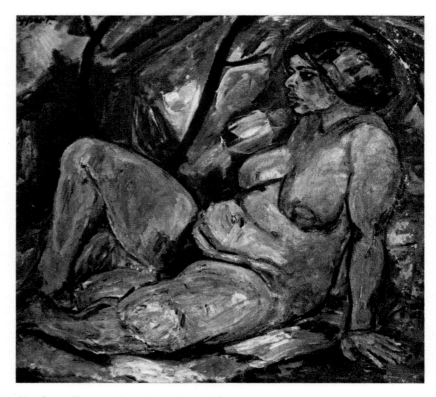

11. Georg Tappert. *Betty Seated*. 1912. Oil on canvas, 39 5/8 × 41 1/2". Private collection

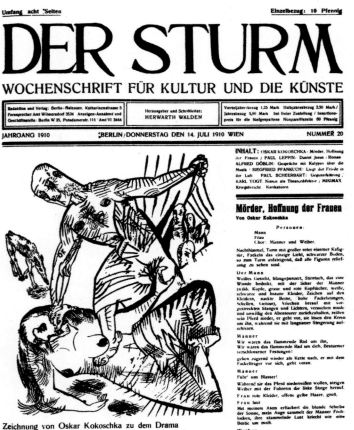

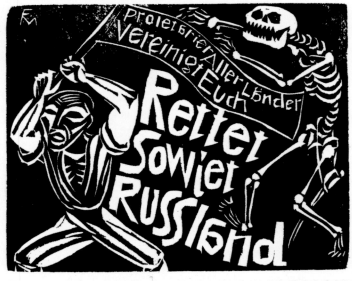

12. Title page of *Der Sturm*, with a drawing by Oskar Kokoschka to his drama *Mörder, Hoffnung der Frauen* (first published here). Berlin and Vienna, 1910. 16 1/8 × 11 7/8″

13. Conrad Felixmüller. Title page of *Die Aktion*. Berlin, 1920. Woodcut, 11 × 8 3/8″

theories were incompatible, and this led to the need for greater differentiation. It is therefore not surprising that in May 1913 the more passive members were startled by this lapidary note: "This is to inform you that the undersigned have decided to dissolve the artists' group 'Die Brücke' as an organization. The members were Cuno Amiet, Erich Heckel, E. L. Kirchner, Otto Mueller, Schmidt-Rottluff."

Pechstein's name had already disappeared; he had been expelled in 1912 when he took part in the summer exhibition of the old Berlin Secession in contravention of the artists' agreement to exhibit only with each other. Nevertheless, even after the dissolution of the Brücke in 1913, the other painters did take part in the summer exhibition, an astonishing event when one remembers the old rivalry between the young and the established artists. The animosities had mellowed, and the Brücke as an artistic achievement could no longer be ignored. The foundation of the Free Secession in autumn 1913 had no importance for future developments, although all former members of the Brücke joined it.

Leaving their organization did not mean a total break from the other painters who continued to be friends. Only Kirchner broke off all connections after he moved to Switzerland in 1917. A caesura of a different kind had more impact: the outbreak of World War I put an end to artistic flights of fancy and scattered the painters far and wide. Those who returned to Berlin in 1918 were faced with a changed situation. We shall consider them later.

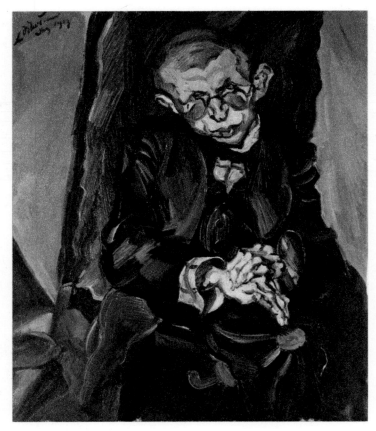

14. Ludwig Meidner. *Portrait of Max Herrmann-Neisse*. 1913. Oil on canvas, 35 1/4 × 29 3/4″. The Art Institute of Chicago (Gift of Mr. and Mrs. Harold Weinstein)

WESTERN GERMANY

In about 1910 a third and very active artistic center developed in Western Germany in addition to Berlin and Munich. It was distinguished not so much by the presence of artists of European standing, but by its role as a focus and crossroads above all for French influences. Several cities of the Rhine and Ruhr regions distinguished themselves by an active cultural policy concerned mainly with fostering the full range of contemporary art. As well as Hagen with its Folkwang Museum, Düsseldorf, Essen, Barmen-Elberfeld, Cologne, and Krefeld were the principal places whose initiatives are still regarded in our own day as trailblazing. The famous Sonderbund exhibitions in Düsseldorf and Cologne, Gosebruch's early support for Nolde and the German Expressionists in Essen, and the collecting activities of the Barmen art association are milestones in the history of the new European art.

The first Sonderbund exhibition in 1910 provided an extremely telling picture of the actual developments. The "German Impressionists," as they were still called, whose local flavor could scarcely be overlooked, were seen and judged against the background of French painting: Van Gogh, Cézanne, Matisse, and Braque were quoted as authoritative figures. The Munich scene around Kandinsky and Jawlensky was considered on equal terms with the "youngest Germans"—in other words, Kirchner, Schmidt-Rottluff, Hans Purrmann, and Karl Hofer. Signac, Edmond Cross, and Christian Rohlfs represented "spectral Impressionism," in which the "transition," or rather the inner affinity, to Kandinsky's "colorism" was rightly acknowledged.

Western Germany showed itself even more in command of contemporary actuality at the second Sonderbund exhibition held in Cologne in 1912. This was the first international survey of contemporary developments, a year ahead of the no less famous Erster Deutscher Herbstsalon (First German Autumn Salon) which Herwarth Walden held in Berlin. The aim of the exhibition was to introduce the younger generation, and to show their evolution and origins. The "Fathers of the Moderns," still little known to the general public at that time, were in some cases given rooms of their own. Included were Van Gogh, Gauguin, Cézanne, and Munch, but also El Greco. Around them were grouped the young painters and sculptors, some of whom were no longer represented in Berlin one year later: Wilhelm Lehmbruck, Ernst Barlach, George Minne, the painters of the Brücke, the North Germans Nolde and Rohlfs, the Swiss Ferdinand Hodler, the French Picasso, André Derain, and Maurice de Vlaminck, to name only the most important.

This remarkable activity revealed the open-minded and cosmopolitan character of a region that was gaining more and more importance through advancing industrialization and whose international contacts were not confined to trade and industry. Naturally, those artists who had settled there also benefited from the lively intellectual exchanges, but to classify them as "Espressionist" would contradict the facts. The traditional idea of a Rhenish Expressionism to include such painters as August Macke or Heinrich Campendonk misinterprets the essence of their art. It is the emphatically French element of Macke's art, in particular, that lends liveliness and brilliance to his color (colorplates 25, 26). The lighthearted sensuality of his compositions places this Westphalian artist, who was influenced by the Rhineland, closer to

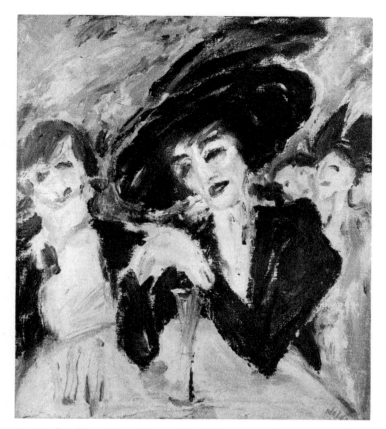

15. Emil Nolde. *A Glass of Wine*. 1911. Oil on canvas, 34 5/8 × 28 3/4". Stiftung Seebüll Ada und Emil Nolde

16. Jakob Steinhardt. *Apocalyptic Landscape*. 1912. Oil on canvas, 31 7/8 × 22 7/8". Private collection, Israel

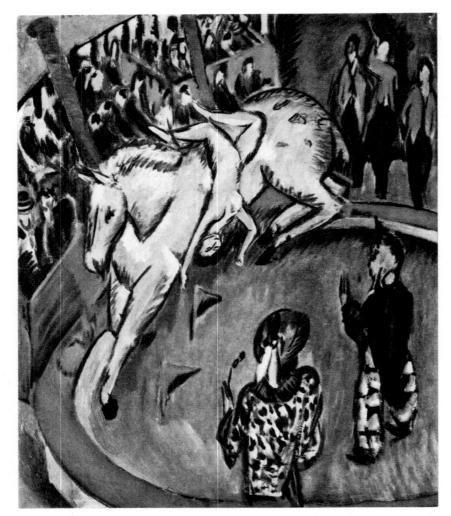

17. Ernst Ludwig Kirchner. *Girl Circus Rider*. 1912. Oil on canvas, 47 1/4 × 39 3/8″. Roman Norbert Ketterer, Campione, Italy

Munich and Paris than to the Brücke. This same independence governed his attitude to the painters of the Blaue Reiter who were personal friends of his. It was soon to be expressed in a decisive rejection of their artistic utterances and theoretical premises. One can sense this inner distance in his warning to his friend Franz Marc against "thinking too much of the intellectual." The restless pathos, the fragmentation of form by Expressionist emotion, the search for cosmic relationships, the influences of Russian mysticism and symbolism in Marc's work seemed to Macke to miss the real purpose of art, the visual poetry and true goal of painting. His motto, "to me, working means delighting in nature," combined with ideas of the Orphic, i.e., colorful Cubism of Robert Delaunay, indicate the goal he had set himself. This was in the metaphor of color, in the poetically purified image of the world organized according to patterns of color and independent of content. No other painter at that time retained such independence from the expressive spirit of the age. Indeed, his art was characterized by its refusal to be "expressive." The same applies to Campendonk's painting, although he lacked the artistic greatness of his models and remained more dependent, illustrative, and symbolist. Yet his human, sometimes dreamlike, art bequeathed to his age a harmony that could not be ignored (colorplate 27, fig. 21).

The situation in Westphalia was different. The phlegmatic, earthy, introspective nature of this landscape was better prepared for the challenge of Expressionism. There was a latent willingness to respond to the stimuli emanating from Northern Germany.

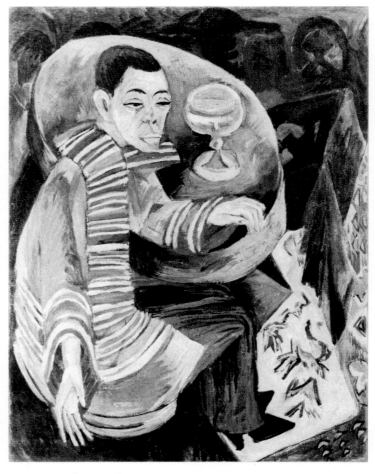

18. Karl Schmidt-Rottluff. *Rising Moon*. 1912. Oil on canvas, 34 7/8 × 37 3/4″. Collection Morton D. May, St. Louis

19. Ernst Ludwig Kirchner. *The Drinker (Self-Portrait)*. 1915. Oil on canvas, 46 7/8 × 35 5/8″. Germanisches Nationalmuseum, Nuremberg

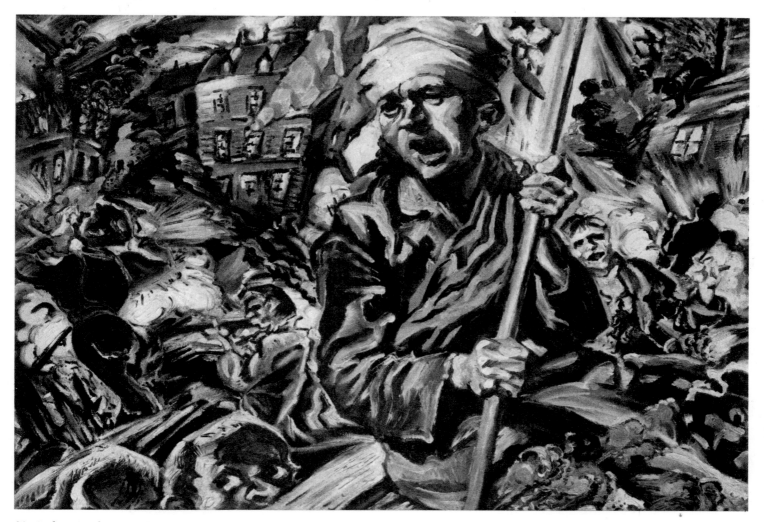

20. Ludwig Meidner. *Revolution (Fighting on the Barricades)*. 1913. Oil on canvas, 31 1/2 × 77 1/4". Staatliche Museen Preussischer Kulturbesitz, Nationalgalerie, Berlin

The paintings of Christian Rohlfs, who is wrongly classified as Westphalian, were more of a corroboration than a stimulus. Strong contemporary influences also had a direct impact on Wilhelm Morgner—probably the most notable figure. A member of the generation born after 1890, who had studied with Georg Tappert in Worpswede, he was fully receptive to the impressions he had gained at the Cologne Sonderbund exhibition when he was 21. His glowing color, alternating between expressiveness and symbolism, his whirlpools of form lying somewhere between ornament and emotion, and his excitable, sometimes ecstatic, temperament are the hallmarks of an artistic output that reflects the work of the first generation of Expressionists (colorplate 35). Such were the effects at that time of ten years' difference in age.

Westphalian Expressionism contributed nothing decisive to the movement's goals, especially as Morgner, killed at 26 in World War I, was unable to attain full maturity. Yet his art and that of others near him showed a real willingness to help foster that desire for expression that characterizes the work of the first generation. Nor did their work lack intensity. Even more vehemently than in the first Brücke period, an insistent pathos is manifested, based on color harmonies that seem to be influenced both by Brücke Expressionism and by Blaue Reiter symbolism, in the desire so persuasively formulated by Morgner: "I now want to see the God who made the world, the power that turns the earth and brings organisms into being by creation, harnessed into color. . . . I want to convert existence into a symphony of color and form, into a living chord."

THE BLAUE REITER

Whereas formerly the Blaue Reiter, and with it the development of the new art in Munich, was sweepingly attributed to Expressionism, today we can see how different its origins and aims really were. The art of this circle was undoubtedly expressive in essence, but not Expressionist in the sense of the Northern and Central German developments. Nevertheless, Munich's contribution to the art scene at that time was so authoritative that without it no precise definition of the concept of Expressionism would be possible.

In Southern Germany we find various counterpoints to the Northern and Central German modes of expression. These include subjective, imaginative insights into patterns of existence for which new symbols and color-musical harmonies had to be found; a pantheistic outlook which also required symbols for its interpretation; and a tendency to mystical inwardness, with a decidedly Eastern flavor. Here Kandinsky's notion of the "intellectual in art" could be used as an argument to reject that objective world which the Northern and Central German Expressionists never relinquished. As well as Russian Art Nouveau, which influenced the early period—not just of Kandinsky—it was the French scene, including the Orphic Cubism of Robert Delaunay, that most stimulated the Masters of the Southern German region. What was accepted in the North as an opportunity to enrich the vocabulary of form, as a stimulus to stepping up the intensity of color, became in Munich the basis for that fruitful debate as a result of

which the art of the region gained its unmistakable features. It was characterized by an ordinariness and intellectual openness that were as alien to the introverted Expressionists, intent on their own problems, as the numerous literary outpourings of the Munich artists were to the taciturn Brücke. Even a comparison between the works of Nolde and Paul Klee would be enough to reveal the differences in their artistic attitudes. Nevertheless, while recognizing their obvious differences, we should not overlook those common features that linked the two as contemporaries.

In 1908 the young professor Wilhelm Worringer stated in his book *Abstraction and Empathy* that art could also be inspired by a desire for abstraction and was not tied to the phenomena of the objective world. The basis of his view, bold for its time, was "that the work of art as an independent organism stands on an equal footing with nature and in its deepest innermost being has no connection with it." Ideas like this were as eagerly welcomed in Munich as the stimulating insights of science, to which the painters there repeatedly referred. Franz Marc, under the influence of Alfred Einstein's space-time continuum and Max Planck's atomic theory, ventured the prognosis: "The art of the future will be our scientific convictions structured into form." What was under discussion here was not the existential situation of the individual which the North was debating, but man's existential relationship to the cosmos. For Marc the "mystical inner construction of the world picture" was "the great problem facing our present generation."

If we now look for the artistic personalities who not only formulated the tendencies of their time theoretically, but also embodied them in their work, we should include the Russian Wassily Kandinsky and the German Franz Marc, the initiators of the Blaue Reiter.

Kandinsky stands at the head of this development. In 1901 he had founded the artists' group and painting school Phalanx in Munich, which continued until 1904. In intimate contact with developments in France—he traveled regularly to Paris from 1902 onward—his early work displays a whole range of developments from Russian-influenced Art Nouveau via late French Impressionism to Fauvism. Kandinsky intended the Phalanx to be a rallying point for the European avant-garde, and to this end he organized a number of remarkable exhibitions. These did not carry any real weight until 1909, when the Neue Künstlervereinigung (New Artists' Association) was founded, with Kandinsky once again as chairman.

There were several illustrious names among the members: Alexey von Jawlensky (a Russian like Kandinsky), Adolf Erbslöh, Gabriele Münter (Kandinsky's pupil from 1902), and Alfred Kubin, together with the German Neo-Impressionist Paul Baum, Karl Hofer, Vladimir von Bechtejeff, and Moissey Kogan. Their circular presented some daring ideas:

"We proceed from the idea that apart from the impressions he receives from the external world, from nature, the artist is constantly gathering experiences in an inner world. It is the search for artistic forms, freed of everything superfluous, and powerfully expressing only what is essential—i.e., the struggle toward artistic synthesis—it is this search which seems to us to be uniting more and more artists intellectually."

Statements like this show Kandinsky's restless mind—perhaps the only one at that time capable of seeing, however dimly, the possible artistic consequences. It was a view resisted by those members of the New Artists' Association who, as painters of the Munich school proper—a mixture of symbolism, Art Nouveau, and nature lyricism—rejected the whole idea of abstraction. Kandinsky's only supporter was Franz Marc, a still unknown painter who instinctively recognized the other man's superior creative potential. Although involved with ideas he was not yet able to incorporate into his painting, Marc still grasped those implications of Kandinsky's ideas that might fertilize his own art.

The Rhinelander August Macke, a friend of Marc's with whom he exchanged ideas and letters, followed the new developments with some scepticism. Macke was not inclined toward Expressionism. His lively, colorful painting, influenced by the art of Matisse and Delaunay, remained a metaphor of a pure and organized beauty in the world, and was untouched, despite his personal commitment, by the stimuli from Munich. He was perceptive enough to recognize the problem. His suggestion in a letter of 1910 that "the means of expression are too big for what they want to say" is a precise description of the gulf between theory and practice that was yet to be bridged.

In 1911 a breach opened between the innovators and the traditionalists in the New Artists' Association. Kandinsky and the painters close to him, Franz Marc and Gabriele Münter, left. They were followed shortly afterward by Jawlensky and Marianne von Werefkin, who had once again tried to iron out the differences. This was the end of the Association, which was dissolved soon afterward.

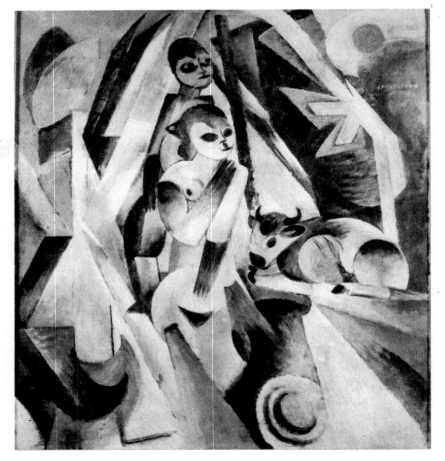

21. Heinrich Campendonk. *Landscape with Cow*. 1913–14. Oil on canvas, 32 1/4 × 27 7/8". Kurpfälzisches Museum, Heidelberg

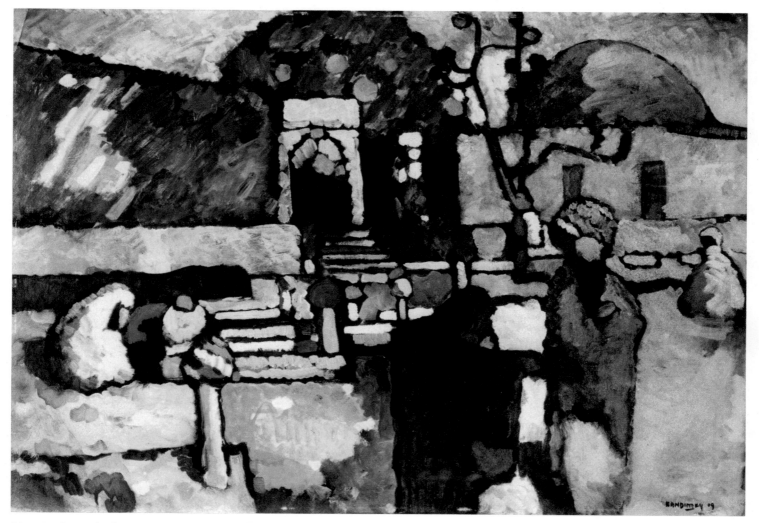

22. Wassily Kandinsky. *Arab Cemetery*. 1909. Oil on cardboard, 28 1/8 × 38 5/8″. Kunsthalle, Hamburg

In 1910 Kandinsky had already produced his first abstract composition, a watercolor. This was still documenting experimental notions, to which the artist was not able to give substance until a few years later. But it did at least indicate the solution—the goal was clear, and not only in Munich. In 1911 Mikhail Larionov completed his first abstract work in Moscow, and the next year in Paris, work by Delaunay and Franz Kupka followed. At first Kandinsky stood alone among his circle of friends with this daring advance. Unlike the artists' association the Brücke, in which the togetherness of the early years gave rise to works of striking similarity (sometimes making it difficult to know what work was by which artist), the painters around Kandinsky went their separate ways, and at no time did they share more than a common intellectual outlook. It was not until the last years of his life that Marc crossed the threshold to abstraction. Jawlensky and Paul Klee, who joined them later, initially still felt a firm commitment to visible reality, although for different reasons.

In 1911, amid all the difficulties over the New Artists' Association, Marc and Kandinsky had begun work on the journal that was later to be called *Der Blaue Reiter*. In fact, there never was an association of artists' group by that name, and Kandinsky reaffirmed this later. Strictly speaking, the Blaue Reiter consisted only of its two editors, Marc and Kandinsky. All the other artists invited to take part were to a greater or lesser extent collaborators, who took part in the joint exhibitions and discussions,

or contributed to the planned publication. Among them were the tirelessly supportive August Macke, Paul Klee, Alfred Kubin, Gabriele Münter, and Marianne von Werefkin, as well as Jawlensky—names most familiar to us from the New Artists' Association. The famous composer Arnold Schönberg must also be counted among them. His début in Munich in 1911 had so impressed Marc that he reported it at once to Macke. ''Can you imagine a music in which tonality (that is, adhering to a key of some kind) has been completely done away with? I was constantly reminded of Kandinsky's great compositions, which also admit no trace of key . . . and also of Kandinsky's 'dancing specks' as I listened to this music which allows each note to speak for itself (a kind of white canvas between the specks of color!).'' Schönberg is mentioned as an author and a painter in the Almanac and as a contributor to the first joint exhibition.

Der Blaue Reiter appeared in the same year, 1912, in which Kandinsky also published his fundamental work *Concerning the Spiritual in Art*, on which he had been working since 1910. Both books had as their keynote the intellectual situation of the decisive year of revolt, 1911. At first sight the multiplicity of texts and illustrations seems confusing. The contributors were painters, scientists, musicians, poets, and sculptors; contemporary art stood alongside works of classical antiquity, or children's drawings, or the works of the primitives. Daniel-Henry Kahnweiler had sent in photographs of Picasso's paintings. Matisse refused to

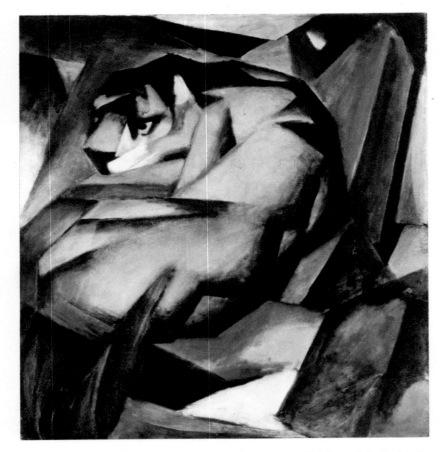

23. Franz Marc. *Tiger.* 1912. Oil on canvas, 43 3/8 × 40″. Städtische Galerie im Lenbachhaus, Munich (Bequest Bernhard Koehler)

contribute but allowed his works to be reproduced in any way desired. Grouping text and illustrations according to attitude, one soon senses a common intellectual outlook, based on the idea of the "total work of art." This outlook unites music and the graphic arts, leads from Bavarian glass pictures to Russian folk art, sets children's work against the masks and sculptures of Africa and the Pacific, and links the classical works of East Asia, Greece, and Egypt with those of the German Middle Ages.

The vitality this unusual conglomeration generates, even for a present-day viewer, illustrates its initiators' determination to set up intellectual warning signs for a period which—in the eyes of the younger generation—suffered from what Marc called "the general indifference of people to intellectual assets." What a sense of mission lies in his words: "But we shall never tire of saying this and still less of expressing our new ideas and showing our pictures until the day comes when we encounter our ideas on the open road."

Among these ideas was the notion Kandinsky advocated in *Der Blaue Reiter* of the two poles: "great abstraction" and "great realism," which he saw uniting in a common goal. Believing that "form. . .was the external expression of the inner content," the painter turned away from the outside world of objective reality and now conducted a dialogue with the inner world, which had no need of traditionally structured symbols of reality. It was no longer form in itself that mattered but—in Kandinsky's phrase —"its inner resonance, its life."

The idea of a compelling inner necessity, independent of abstraction and realism, underlying a work of art is the basic theme of all the contributions. Understandably enough, the two editors each contributed a number of papers. Marc was the author of the following articles: "Spiritual Treasures"; a commentary on the general situation of "The 'Savages' of Germany," in which for the first time, if only marginally, he mentioned the "Brücke Expressionists"; and "Two Pictures." Kandinsky wrote the important paper "On the Question of Form," which is essential to an understanding of his painting. The range of his activities emerges from his article "On Stage Composition," which is a preface to his stage piece "The Yellow Sound," published in *Der Blaue Reiter*. Arnold Schönberg wrote "The Relationship to the Text." The composer and painter Thomas von Hartmann, who was born in Moscow and later emigrated to America, wrote "On Anarchy in Music." One could also mention Erwin von Busse and his article "Robert Delaunay's Methods of Composition"; David Burliuk's contribution "The 'Savages' of Russia"; "Masks" by August Macke; the studies by Leonid Sabaneiev on Alexander Scriabin's "Prometheus"; the essay "Signs of Renewal in Painting" by the Frenchman Roger Allard; and finally, quotations from Robert Delacroix and W. Rosanov—a list of unusually wide scope for a publication of that time.

The fact that musical problems took up so much space in the Almanac was no accident. The links between music and graphic art—the color harmonies adopted in Kandinsky's painting and the analogies between tonal vibrations and color chords, for example —preoccupied both painters and musicians. In "Prometheus," Scriabin had tried to express music in terms of colored light and to allot certain visual sounds to the musical notes as a preparation for the subsequent color piano. Kandinsky's bold theatrical opus "The Yellow Sound" also belongs in this context as an experiment in the interreaction of color, pantomime, and music set in a mystical-romantic basic mood. Ideas like these were behind the Blaue Reiter circle's attempts to set down the musical properties of their pictorial vocabulary, and to develop a doctrine of the harmony of colors and forms which could be used in the same way as in music. This release from the tyranny of the object did not jeopardize the emotional character of painting, which neither the Germans nor the Russians wanted to sacrifice, but it did free it from the deadweight of allegory and content. Here then, expressiveness took on a different note from the Expressionism of the North. If we turn from Munich to Brücke Expressionism, then the difference in outlook is immediately apparent. Both schools were working on the assumption that they must find the point at which outer and inner meet—the common root in German Romanticism, although they incorporated the theory into their pictures differently. Painters in the North took the elemental rather than the aesthetic approach. They tried to shatter the shell of external pseudoreality to get at the true core of existence; whereas painters in the South proceeded more subtly, treating the picture as a symbol of that "mystical inner construction" of which Marc had spoken. This also affected the character of the colors. The North painted with strong color but weak tone, because the artists were less concerned with the optical pictorial value than its expressive function. The painters connected with the Blaue Reiter developed a sensitive palette full of values, the illuminating power of which depends on the purity of the tonal layers, corresponding, as we have just seen, to musical tones. This did not stop Marc from giving his ideas increasingly symbolical

forms (colorplate 24), which also increased the risk of their carrying an emotional charge, a danger against which Macke had repeatedly warned him.

The problems besetting the weaker works were much the same in both regions: in the North, an exaggerated depth of significance or an undisciplined explosive outburst, which ultimately destroyed the effectiveness of color and form; in the South, an emotionally charged aestheticism which could verge on the sugary or the purely decorative. It is understandable, therefore, that North and South were deeply sceptical of each other. Franz Marc certainly visited the artists of the Brücke in Berlin and was fascinated by the strength of their artistic statements and their energy, but no deeper understanding of their different outlooks resulted. Kandinsky roundly rejected the work of the Brücke. Their direct commitment, their spontaneous and impulsive reactions, the explosive intensity of their self-expression seemed to him to be insufficiently filtered, insufficiently intellectual for him to see in them a decisive contribution to the development of contemporary art as he viewed it. Thus he refused to accept any reproductions of Expressionist painting in the Almanac, which contains many illustrations of the works of Matisse, Delaunay, Cézanne, and Le Fauconnier. "These things must be exhibited. But to immortalize them in the document of our current art—which is what our book is intended to be—as somehow decisive, or epoch-making, is to my mind not right. For this reason I would certainly be opposed to big reproductions . . . the small reproduction says: this is *also* being done; but the big one says: *this* is being done."

Kandinsky's argument won the day. The Expressionists did take part in the graphics exhibition of the Blaue Reiter, but the text originally planned by Max Pechstein was not accepted for publication. Nolde, Pechstein, Mueller, Heckel, and Kirchner are represented only by illustrations of graphic works.

Both publications, *Concerning the Spiritual in Art* and *Der Blaue Reiter*, represent milestones in the history of the German Moderns. They had shown artists that they were free from the traditional tyranny of the object, and that nonrealistic art was in keeping with the spirit of the age. Everything encouraged them to find a pictorial form for their vision of an expanded creation, with ideal as well as material elements.

Apart from the developments so clearly defined in *Der Blaue Reiter*, the two poles of the European art scene, which Munich now tried to synthesize, or crystallize, were the Expressive and the Cubist (or more accurately, the Orphic); these were seen by both German and Russian painters as valid points of departure for the painting of the future.

Under "Expressive" we can include German Expressionism which extended from the primitive to the cosmic-romantic, and which sought, through a passionate scrutiny of the visible world, to heighten reality into a pictorial counterreality. The work of both Matisse and Kandinsky confirms this: Matisse united the ego and the world in the intellectual synthesis of the picture; Kandinsky's newfound symbols pushed out the boundaries of visible reality and touched on the borderline between man's existence and the cosmic order. He could scarcely convey discoveries of this subtlety by a less sophisticated expressive technique, hence Kandinsky's mistrust of Northern Expressionism. Marc's German pan-emotionalism, which was rooted in Romanticism, and Kan-

dinsky's synthesis of color harmonies found in contemporary French Orphic painting the inspiration they needed for the theoretical and practical cultivation of the resources of color and form. The aesthetics of the Blaue Reiter, with elements of both Expressionism and Constructivism, were directed at the picture as an independent organism and formal unit. This makes it easier to understand the powerful influence Robert Delaunay had on the artists connected with the Blaue Reiter. His discovery that color can, of itself, evoke movement and rhythm in the same way as form, his *sens giratoire* of color, led him to abstract painting in pure color, which no longer meant anything in objective terms, but meant much in terms of content and expression. It stands for the overall rhythm that determines existence and the world, and that is capable of embracing and expressing the harmony of the whole. Such a concept of painting as pure orchestration of color and light had to be combined with the speculative ideas of the Munich painters into a convincing synthesis.

The exhibitions organized by the editors of *Der Blaue Reiter* were supposed to confirm theoretical principles through the work of art. Two exhibitions, held in 1911 and 1912, typified the contemporary situation at that time. On November 18, 1911, the circle of friends connected with the subsequent *Blaue Reiter* exhibited for the first time in the Thannhauser Gallery. The show

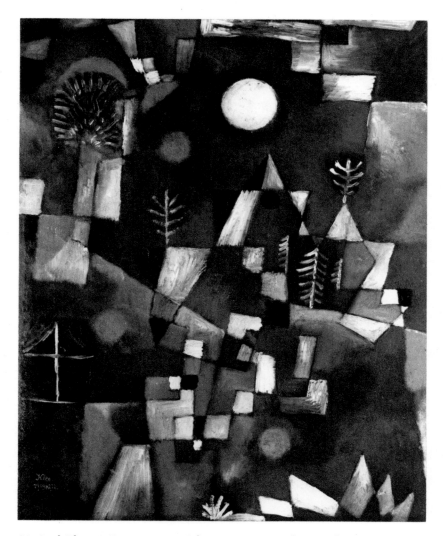

24. Paul Klee. *Full Moon*. 1919. Oil on paper mounted on cardboard, 19 1/4 × 14 5/8". Private collection

was intended to be a demonstration and was therefore opened at the very moment when the New Artists' Association was showing works by its members in the other halls of the Gallery.

Naturally, Kandinsky, Marc, Macke, and Münter were represented. Other contributors were the Rhinelander Heinrich Campendonk, the Russian brothers David and Vladimir Burliuk, Albert Bloch, Eugen von Kahler (who died prematurely), Jean Bloé Niestlé, Arnold Schönberg, and two important Frenchmen: Henri Rousseau and Robert Delaunay. Kandinsky's influence on this exhibition was unmistakable. The two French guests, in particular, embodied in his eyes the pair of opposites already mentioned: the "great abstract" and the "great real," a duality he had always pointed out.

The exhibition then traveled across Germany. It was shown in Cologne in 1912, where it influenced the Rhineland scene which already had intimate links with Munich through Macke and Campendonk. In Berlin, Herwarth Walden opened his Sturm Gallery with it, showing his artistic foresight by adding works of Paul Klee, Alexey von Jawlensky, and Alfred Kubin. The exhibition also visited Bremen, Hagen, and Frankfurt.

The second exhibition in 1912 was not intended as a spontaneous event but was carefully prepared. Under the title "Black and White," it restricted itself to graphic works but it accepted watercolors and drawings as well as prints. "Marc and I took everything that looked right to us, which we chose freely, without bothering about any particular opinions or desires." Once again, artists from many other nations took part: from Germany, aside from members of the Brücke (without Schmidt-Rottluff) and the Blaue Reiter, these included Georg Tappert from Worpswede, the Westphalian Wilhelm Morgner, Paul Klee, showing seventeen

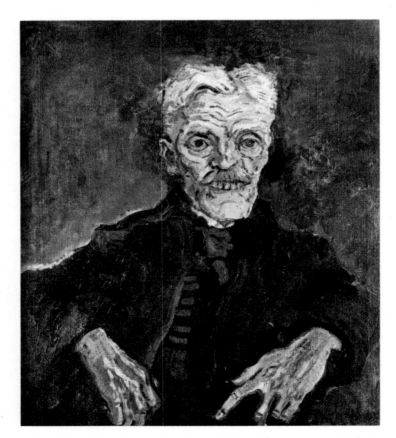

25. Oskar Kokoschka. *Father Hirsch*. 1907. Oil on canvas, 27 3/4 × 23 5/8". Neue Galerie der Stadt Linz, Wolfgang-Gurlitt-Museum

works produced between 1911 and 1912, and Alfred Kubin. As expected, the French contribution was extensive. There were works by Georges Braque, Robert Delaunay, Roger de la Fresnaye, André Derain, Pablo Picasso, and Maurice de Vlaminck—giving an overall picture of the artistic state of affairs halfway between Fauvism and Cubism. Switzerland was represented by Hans Arp, Moritz Melzer, Wilhelm Gimmi, and Oskar Lüthy. Russia had sent its avant-garde: Natalia Goncharova, Mikhail Larionov, and Casimir Malevich.

Wide-ranging surveys of this kind were not held subsequently. The painters of the Blaue Reiter did take part in the famous Sonderbund exhibition of 1912 in Cologne, which brought together the young artistic generation of Europe; in the same year Herwarth Walden exhibited in Berlin those works by Kandinsky, Jawlensky, Werefkin, Marc, Münter, and Bloch that had not been in the Sonderbund.

In 1913 the Sturm Gallery organized the First German Autumn Salon (a reference to the famous Paris *Salon d'Automne*), at which the Munich painters were once again represented, together with parallel international developments. Walden showed it as a traveling exhibition in the Scandinavian countries in 1914. Then war broke out and put an end to the common struggle, even in Munich.

Measured against the time allotted to the Brücke, the Blaue Reiter constituted only a brief episode. This did not, however, lessen its importance to the European scene; its influence on the future exceeded that of Central and Northern German Expressionism. The artists saw themselves as the pioneers of a new era of intellectual culture with the motto "the revival must not be formal but a renaissance in thought." In their vision of life, art was the central point, if not the exclusive goal. They saw art as part of an overall existential connection between temporal and spiritual nature, between the inner and the expressive world of the human being. The artist himself stood at the crossroads, and it was his task "to create symbols of the age that belong on the altars of the coming intellectual revolution."

A trail had been blazed and where it would lead only later generations would realize.

VIENNA

When considering the various facets of German Expressionism, we should not overlook developments in Austria. Kokoschka's art added a unique element to the Berlin Sturm Expressionism of 1910. Turn of the century Vienna, the intellectual home of both Kokoschka and his fellow Austrian Egon Schiele, played an important part in their development. Indeed, neither painter can be thought of without taking into consideration the intellectual climate of the Austrian capital. When Karl Kraus later called it the "experimental laboratory for the end of the world," he was describing an environment in which, even more sharply than in Germany, the symptoms of a doomed era were revealed. It is no accident that Sigmund Freud's psychoanalysis had its origin here. Viennese Art Nouveau, inspired by influences from Paris, Munich, and England—English aestheticism and Aubrey Beardsley's morbid linear art, in particular, had more impact here than elsewhere —could be interpreted in its hyperrefinement as both the apoth-

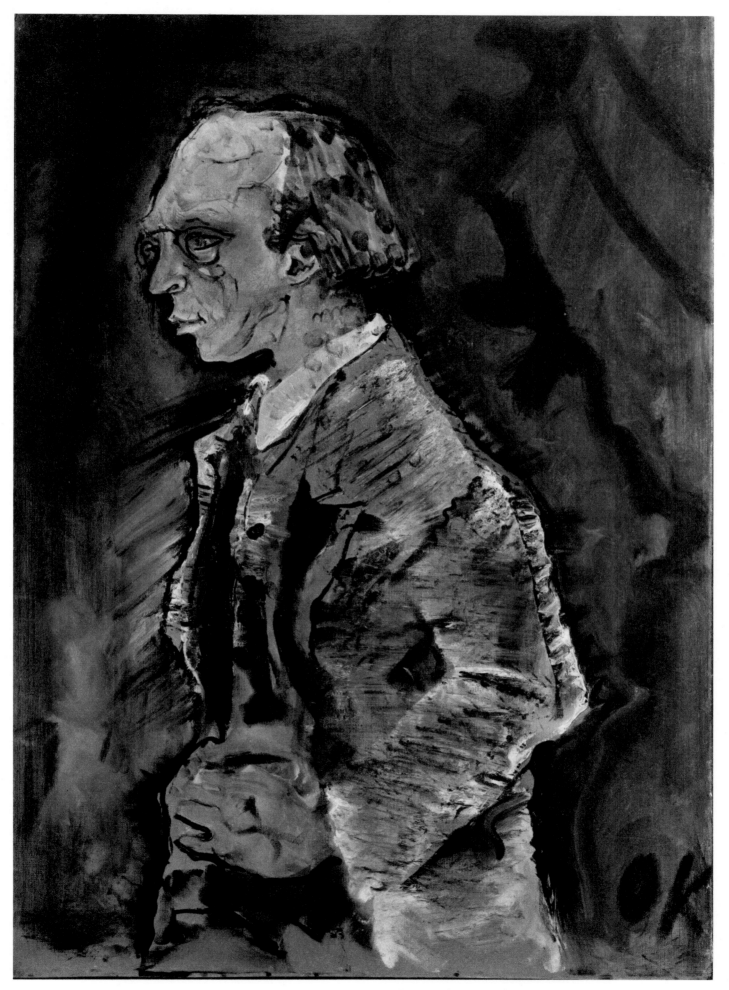

26. Oskar Kokoschka. *Herwarth Walden*. 1910. Oil on canvas, 39 3/8 × 27 1/8″. Staatsgalerie, Stuttgart

eosis of the traditional development and the seismographic symbol of the approaching collapse. In the art of Gustav Klimt both possibilities were manifest and his influence on other artists was correspondingly great.

The pioneer of the Viennese development was undoubtedly Oskar Kokoschka. In 1904 he began his studies at the Viennese School of Arts and Crafts which, unlike the tradition-conscious Academy of Fine Art, gave its students an intentionally contemporary training, and thus became a focal point for the avant-garde.

Kokoschka soon made it clear that he was aiming beyond Art Nouveau toward expression. Even the early drawings show a personal style which, in its hard line and structure, is markedly different from Klimt's descriptive style of drawing.

For an era that probed man's spiritual condition with a positively scientific precision, Kokoschka's portraits are absolutely in character. Even here he is concerned less with external resemblance than with the identity of the artist in the pitiless analysis of his vis-à-vis, in which brush and crayon assume the functions of a scalpel. Artistic vision replaces visual effect and manifests itself in the hectic expressive gesture of the line. Thus for both Kokoschka and Schiele, drawing is not peripheral, even to painting; in fact, it carries the psychological momentum of the picture. This also explains their striking difference from German Expressionism: Nolde's comparatively coarse caricature, his theatrical gesture and mimicry, for instance, are carried almost entirely by the strength of a color not suited to this purpose. This also applies to the majority of the other Expressionists, in whose painting psychologically effective or even convincing portraits are rare. It was the Expressionists' special relationship to color that, initially at least, precluded more subtle psychological effects, although in their graphic art their concern with a more finely structured form led to a number of extremely impressive heads or portraits.

Here too we find breaks with tradition, exaggerated self-expression, the capturing of experience directly, not indirectly, through content, and the destruction of traditional formal patterns—carried out with perhaps even more vehemence and becoming, therefore, more disturbing in their effect, since here the subject matter is man.

It seems logical that Herwarth Walden (fig. 26) brought the Austrian artist to Berlin and asked him to produce illustrations for his journal *Sturm*, whose very name symbolizes independent energy. The fact that the Austrian so quickly felt at home in this fermenting intellectual climate, and rapidly became an inseparable part of the Berlin Expressionist milieu, confirms the similarity of thought and feeling that transcended national frontiers.

The Austrian representatives of the "latest movement in painting," as it was called in the foreword to the 1912 Sonderbund exhibition in Cologne, included both Kokoschka, who showed six paintings, and Egon Schiele, who made an impressive contribution of three works. This art was subject to the same influences as that of his fellow countryman. Schiele, 16 years old at the time, had probably seen the 1905 Van Gogh exhibition in the Miethke Gallery, which showed forty-five paintings by the Dutchman and so profoundly impressed Kokoschka that it gave rise to the famous portrait *Vater Hirsch* (fig. 25), the start of the series of analytical portraits mentioned earlier. The eleven Van Gogh paintings shown at the International Art Exhibition in Vienna in 1909 certainly made a lasting impression on the young student

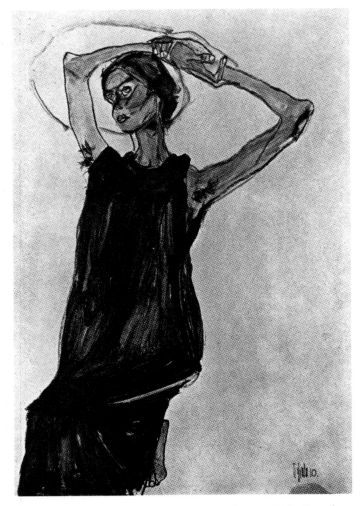

27. Egon Schiele. *Kneeling Woman with Raised Arms.* 1910. Gouache and crayon, 17 1/4 × 11 7/8". Serge Sabarsky Gallery, New York. Reproduced from Vogt, *Expressionismus*

Schiele, who had just begun his studies at the Academy of Fine Art in Vienna. But the influence of Klimt affected his art more than it did Kokoschka's. It was his encounter with this master that pointed him toward Expressionism.

The breakthrough came in about 1910. It is a mark of Schiele's independent self-expression that his paintings always remained involved with the intellectual situation of Vienna and especially with the Secession, to such an extent that G. Schmidt could define his art as the "Espressionist transformation of art of the Secession." As well as the customary expressive spontaneity and directness, coupled with an uncompromising self-exaggeration, Schiele showed markedly verist tendencies in his fanatical drive toward the sharpest possible realism, which was manifested in graphic traits similar to those of Kokoschka. In both artists' work the human figure stood at the center: the body wrung by spiritual pressure and inner tensions, the face betraying a morbid tenseness reinforced by gesture (colorplate 32). The symbolism of Viennese Art Nouveau played a decisive role in this. In Vienna, no really clear line could be drawn between Art Nouveau and Expressionism, which may explain the variation of accents we notice in Schiele's work.

Having looked at the fundamental points of agreement and difference between the art of the two countries, we can summarize Austria's contribution to the Expressionist scene as the psychological element, which is little in evidence elsewhere, since more subtle tensions of color came within the grasp of the younger German generation only later.

THE GRAPHIC ART OF EXPRESSIONISM

Whereas the work of the French Fauves was dominated by painting, all the German Expressionists left behind a graphic oeuvre that was generally broad in scope and certainly important. Some artists are remembered mainly for their prints: Käthe Kollwitz; Ernst Barlach, despite his great sculptural oeuvre; Walter Gramatté, who died young; the founding member of the Brücke Fritz Bleyl; the young Max Kaus and the members of the Dresden Group 1919; Christoph Voll; and Bernard Kretzschmar.

Even Beckmann's engravings were, at that stage, superior to his painting in sharpness of expression and accuracy of mood (fig. 57).

The woodcut, a medium that had already had one golden age in German sixteenth-century art, was regarded as the real symbol of Expressionist graphics. It was more suited than any other method of printing to expressing the restless movement of the current situation. No other technique had been developed so creatively since 1890, no other possessed such dark power and expressiveness, none of which is lost even today. The woodcut was already playing a pioneer role in the work of the young Brücke artists (figs. 48, 51). It was the keynote of the art of the early period, although at that time it still took the form of a painterly distribution of black-and-white surfaces that echoed the decorative line of Art Nouveau in the flexibility of their contours—Munch's work being at that point still unknown.

Tentatively, the pattern of nature was transposed into a black-and-white composition of surfaces. It was not until the young students decided to shelve the traditional predominance of the line, which they knew from their study of old German prints and blocks, and abandon the calligraphy of the outline that the inimitable woodcut language, which we describe as Expressionist, began to crystallize.

From that point on they were determined to demand no more of the wood than its nature was capable of giving: scarcely any lines and no line systems, but instead carved surfaces and broken outlines, which, historically, would most resemble the partially unskilled works of the fifteenth-century epistolary and card artists. In both, the artist-craftsman's struggle with the brittle, splintery material is the basis of the form. Black and white now met each other in sharp contrast without painterly tone values. Abandoning all illusion of body, shadow, and space, the model was translated from its tactile existence as an object into an abstract surface structure, no longer a copy but a new creation.

That which artists in the fifteenth century had tried to correct, by refining the coarseness of the outline, now became a virtue. Design and execution remained, as before, in one hand. The twentieth-century artist actually printed his blocks himself in order to make sure the pulls had a personal stamp. To revert from cross grain—blocks hard enough for fine sets of lines to be cut across the trunk—to long grain, the texture of which could be exploited as an additional medium, was a logical step. The new "artist's woodcut"—at first often just a linocut—possessed a robust rawness and barbaric vigor. Kirchner aptly remarked at

28. Ernst Ludwig Kirchner. Title woodcut of *Das Stiftsfräulein und der Tod* by Alfred Döblin. Berlin, 1913. 8 7/8 × 7 1/8"

31

29. Ernst Ludwig Kirchner. One of forty-seven woodcuts from *Umbra vitae* by Georg Heym. Leipzig, 1924. 5 1/2 × 3 1/3″

the time that the young people had felt the resistance of the material not as a hindrance but as a help. The working method became a medium both of style and of expression.

No other artistic medium was able to produce such strong tension between black and white or two basic colors, or to allow so much concentration on basic essentials—popular in its toughness and darkly instinctive in its crudity. Whereas at first painters were still trying to lighten it by incising the surface with lines and spots, they soon came to recognize the woodcut as an opportunity to be primitive in the simplest way.

For the movement around the Blaue Reiter, however, there was a difference. Although the woodcut was of some importance to Marc and Campendonk (figs. 40, 42), it was always used more decoratively and never with that harshness and power that were taken for granted in the North.

It is natural that with a commitment of this kind even painting sometimes fell under the spell of the woodcut—the colors pushed their way to the surface, which was banded by heavy black outlines; yet the Expressionists did not hesitate to use color as a means of structure or to increase the inner content of a print.

The Berlin years of the Brücke constituted the apotheosis of the Expressionist woodcut. Through it, even the artist's links with

the contemporary literary scene in the capital of the Reich were confirmed. One example is Schmidt-Rottluff's headpiece for the program of the Neopathetisches Cabaret, that creation of the New Club, where important Expressionist poets such as Georg Heym, Jacob von Hoddis, Ernst Blass, and Kurt Hiller gathered in 1909 to recite their poetry. Herwarth Walden not only published Kokoschka's portrait lithographs but also the prints of the Brücke members. Georg Tappert produced the title woodcut for Franz Pfemfert's *Aktion* in 1914; Kirchner illustrated Alfred Döblin's *Das Stiftsfräulein und der Tod* with his woodcuts (fig. 28); and in Heckel's print for the pantomime of W. S. Guttmann we find the name of Sidi (later to be his wife), who danced the leading role. Obviously the subjects then being dealt with in painting also appeared in the graphic work. A wealth of single or series of prints marked a high point in the art of printing such as had not been achieved for centuries. Both in quality and importance, painting and graphics stood shoulder to shoulder. One could even say that at times the woodcut outstripped painting in the suggestiveness of its surface as well as in its ability to express psychological traits, previously conveyed by color.

If we see the woodcut not only as an aesthetic technique (something the Brücke artists by no means ignored), but also as the expression of a consistent involvement with topical events, we can understand its particular role in the Berlin scene. There it once more assumed its former historical task as a poster, a leaflet, and a political pamphlet, although now chiefly in the hands of the young artists who were politically active.

Pfemfert's *Aktion* (fig. 13) attracted many young artists who were using the woodcut as a weapon in the turmoils of the World War years. Conrad Felixmüller, César Klein, Ludwig Meidner, Moritz Melzer, Wilhelm Morgner, Georg Tappert, and Heinrich Richter in Berlin were at that time producing a number of extremely topical prints which convey the profound personal emotion caused by events as well as the artists' desire to participate actively in the struggle (figs. 31, 33). The fact that after their return from the war the Brücke artists held aloof from this circle or took part in it only halfheartedly can be put down to the age difference. Some of them later reappeared in the circle of the Novembergruppe, hoping thereby to influence the shape of the postwar period. As we have already mentioned, this association of late Expressionist social critics foundered on their self-imposed sense of mission. By that time no torrent of print could unleash revolutions. We can acknowledge these artists' desperate longing for a much needed new start, and applaud their efforts to take the lead in an aimless period. But their powers were not sufficient; Expressionism had long since been shattered on the rocks of reality. Pathos took the place of emotion, cynicism of caution, true and false notes intermingled. With the end of Expressionism, the woodcut lost its leading role and, apart from a brief flowering after 1945, has never regained it.

Despite the woodcut's predominance, etchings and lithography also played an essential part in Expressionism. Lithography, entirely dependent on the draftsman's line, whether produced with brush or pen, or with chalk on stone, whether printed in color or black and white, was by around 1907 fully developed in the work of the Brücke painters. The Berlin scene, with its numerous publications, was later to take advantage of the fairly large editions that could be drawn from lithographs.

30. Emil Nolde. Title woodcut of *Der Anbruch*. Berlin, 1919. 16 1/8 × 11 1/8″ · Reproduced from Vogt, *Expressionismus*

31. Conrad Felixmüller. Title woodcut of the journal *Menschen*. About 1917. 18 7/8 × 12 5/8″. Reproduced from Vogt, *Expressionismus*

32. Karl Schmidt-Rottluff. Title woodcut of the journal *Die rote Erde*. Hamburg, 1920. 12 5/8 × 9 1/4″. Reproduced from Vogt, *Expressionismus*

33. Title page of the fortnightly *Revolution*, with a woodcut by Richard Seewald. Munich, 1913. 12 × 8 1/2″. Reproduced from Vogt, *Expressionismus*

Color prints generally appeared as equivalents of the watercolor. Nolde's large color compositions retain all the freshness of his energetic brushstroke, as do his famous heads, self-portraits, and landscapes. In his lithos, Otto Mueller displayed the whole treasure of the painter's experience (fig. 39). His idyllic landscape scenes and his famous gypsy subjects are rated as highly as the paintings. Käthe Kollwitz and Alfred Kubin used them to translate chalk and pen drawings directly into print; for Barlach, lithography came next in importance to the woodcut (fig. 43). Kokoschka made his entry into the Berlin art scene with lithographs; neither Heckel's nor Kirchner's work is conceivable without their many lively street scenes, landscapes, or theatrical paintings, in which colored and black-and-white prints are of equal value (figs. 36, 37).

If lithography is close to painting because of its particular character, this is only partly true of Expressionist etching. In comparison to the woodcut, of course, it has more tonality, especially in the hands of one of its great masters at that time, Emil Nolde, who was intent on that very quality. Linear and painterly etching exist side by side in his work. The tendency common to all the Expressionists, not to remove irregularities in the plate from the finished print, or polish them up, but to leave them to enliven the surface and make the personal style emphatic, appeared at an early stage in Nolde's work; in his woodcuts, in the same way, the material not completely excised in the white areas sometimes plays a structural role. By 1910 at the latest, with the well-known series *Hamburg Harbor* (whose creation the artist wrote about in his autobiography, fig. 38), his etching technique had achieved a masterly quality. In his etchings, Nolde consciously aims at the atmosphere and the illusion of space, which even his woodcuts capture. The

34. Lyonel Feininger. *Cathedral of Socialism*. 1919. Woodcut, 12 × 7 1/2"

35. Max Pechstein. *Varieté*. 1909. Colored lithograph, 11 × 14 3/4"

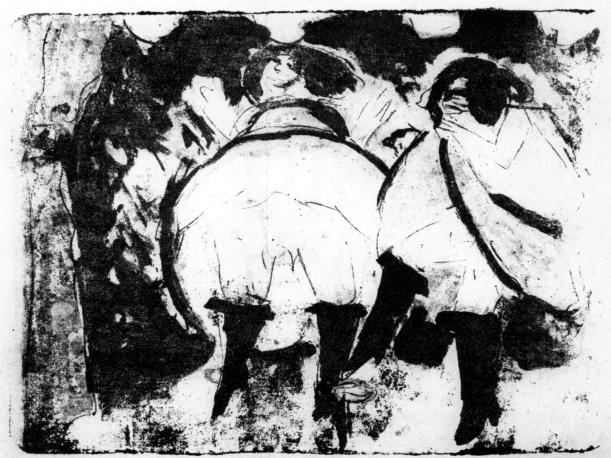

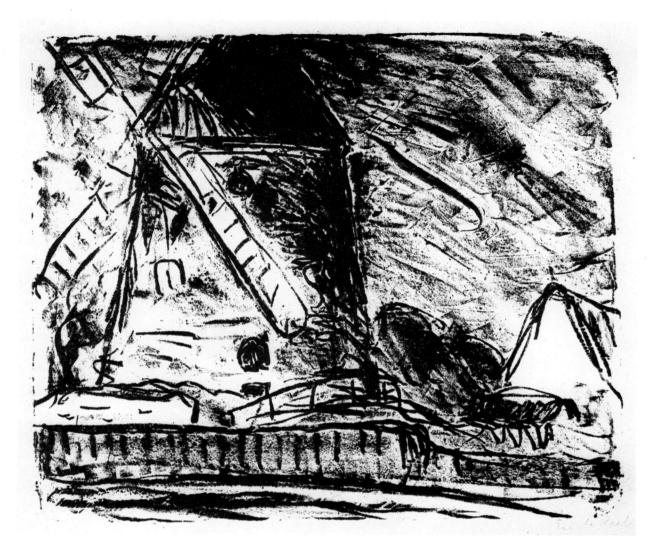

sensitive, circumscribing line becomes evocative in itself as well
as focusing the dark areas. Deeply etched, printed in full black on
an aquatint ground, or contrasted with sharply incised dry-point
lines, these prints convey to the viewer a completely pictorial
effect. At the time, Nolde stood alone among the Expressionists
with this type of composition. Only Kirchner (in around 1920)
produced etchings that, in their gradual rapprochement with
nature, aim at a similar tonality and pictorial fullness, which could
be further enhanced by color printing and achieve real perfection
in the contrast between deeply etched line and loosely treated
surface area.

The other artists were more inclined to exploit the medium's
graphic potential, with angular breaks in form and hard pointed
lines the outstanding stylistic features. Here we also notice the
influence of French Cubism, which, as we know, the Germans ex-
ploited only in terms of form. It nevertheless helped Erich Heckel
to achieve crystal-clear landscapes of cool beauty (fig. 37), while
Schmidt-Rottluff attempted the most extreme hardness and
sharpness of form by reducing even his etchings to a broken sys-
tem of lines.

Feininger's etchings, with their distinct personality and graph-
ic refinement, are among the most beautiful examples produced
in the years following 1910. In them it is not only Feininger the
draftsman who is expressed, but also that search for clarity in the
formal structure of the composition that distinguishes his works
(fig. 49). In conclusion we should also mention Max Beckmann,
whose hard realism found a corresponding rigor in etching (figs.
55, 57); and Otto Dix, who returned from the war tormented by
his visions of its horrors. Thus in its coming golden years, etching
was already touching on the problems of the 1920s.

37. Erich Heckel. *Park Lake.* 1914. Drypoint, 9 5/8 × 7 7/8''

38. Emil Nolde. *Hamburg, Inner Harbor*. 1910. Etching, 12 1/4 × 15 7/8"

39. Otto Mueller. *Five Yellow Nudes Near the Water*. 1912. Lithograph, 16 7/8 × 20 1/2"

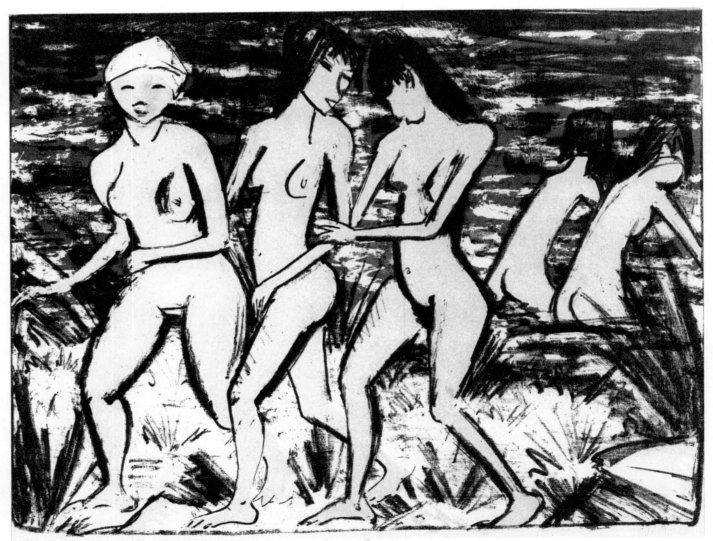

40. Heinrich Campendonk. *The Fairy Tale*. 1916–17. Woodcut, 8 5/8 × 8 5/8″

41. Christian Rohlfs. *Street in Soest*. 1911. Linocut, 9 1/4 × 9 1/2″

42. Franz Marc. *Genesis II*. 1914. Color woodcut, 9 3/8 × 8″

43. Ernst Barlach. *Anno Domini MCMXVI Post
Christum Natum*. Lithograph from *Der
Bildermann*. 1916. 7 5/8 × 9 1/4″

44. Käthe Kollwitz. *Mother and Dead Child*.
1903. Etching, 16 1/4 × 18 3/4″

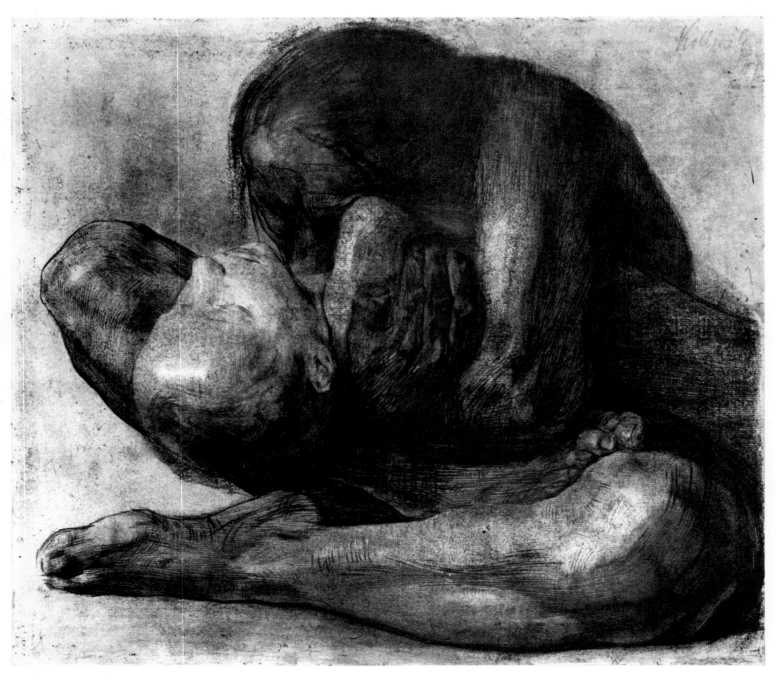

45. Christian Rohlfs. *Prisoner* (first state). 1918. Woodcut, 24 3/8 × 19 1/4 ''

46. Karl Schmidt-Rottluff. *Has Not Christ Appeared to You?* 1918. Woodcut, 19 3/4 × 15 1/4''

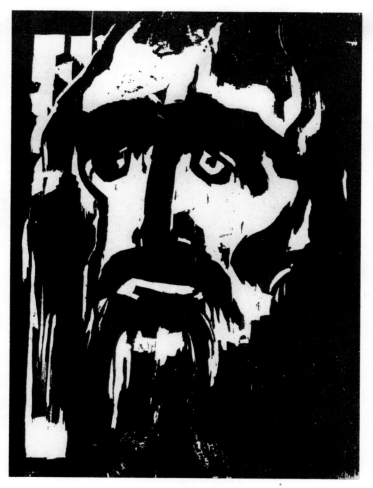

47. Erich Heckel. *Portrait of a Man*. 1919. Woodcut, 18 × 12 7/8''

48. Emil Nolde. *Prophet*. 1912. Woodcut, 13 5/8 × 10 1/2''

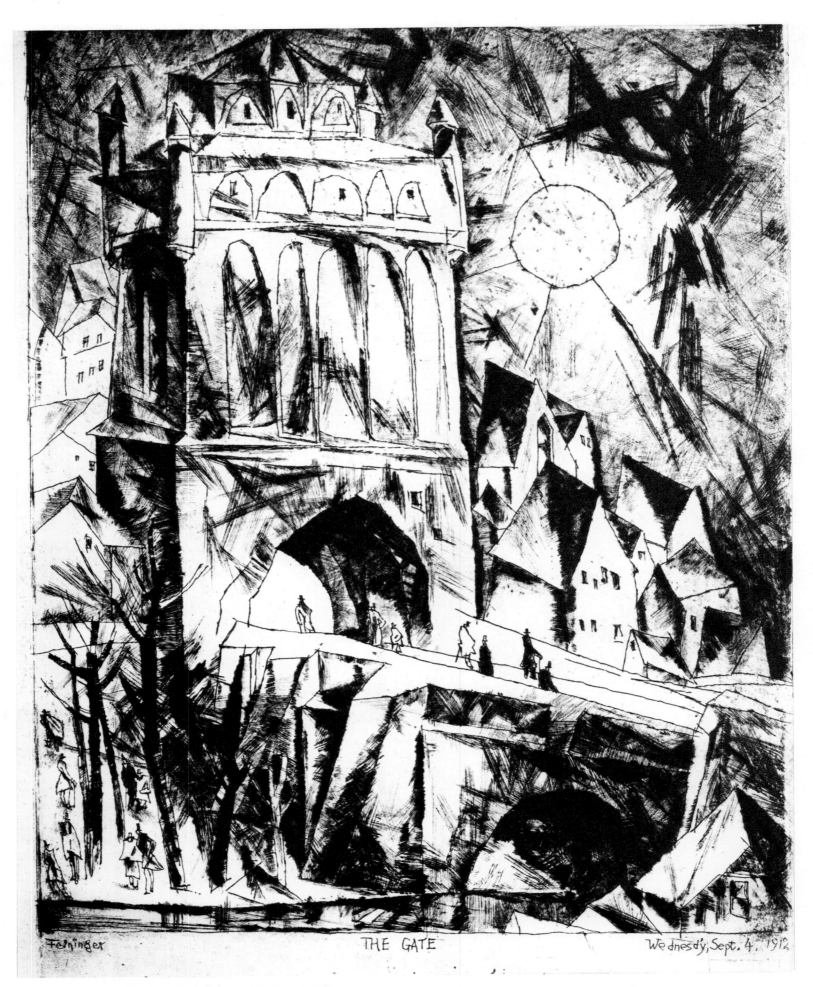

Feininger THE GATE Wednesdy, Sept. 4, 1912

49. Lyonel Feininger. *The Gate*. 1912. Etching, 10 5/8 × 7 5/8"

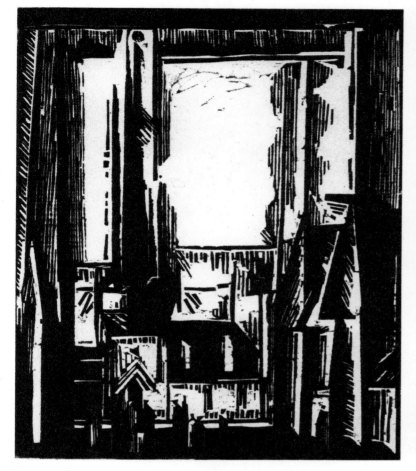

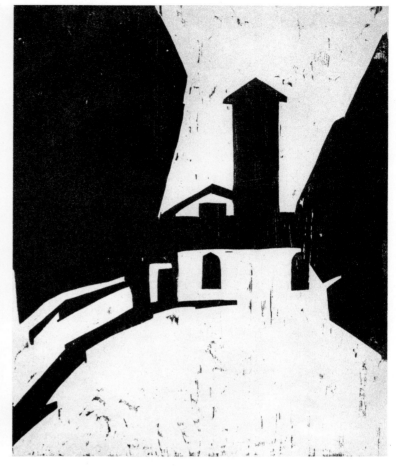

50. Lyonel Feininger. *Gelmeroda II*. 1918. Woodcut, 12 7/8 × 12″

51. Karl Schmidt-Rottluff. *Villa with Tower III*. 1911. Woodcut, 24 3/8 × 18 7/8″

52. Ernst Ludwig Kirchner. *Staffelalp*. 1918. Woodcut, 14 × 17 7/8″

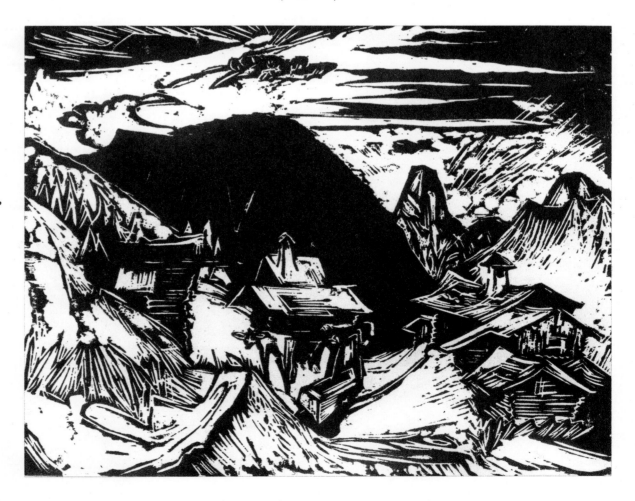

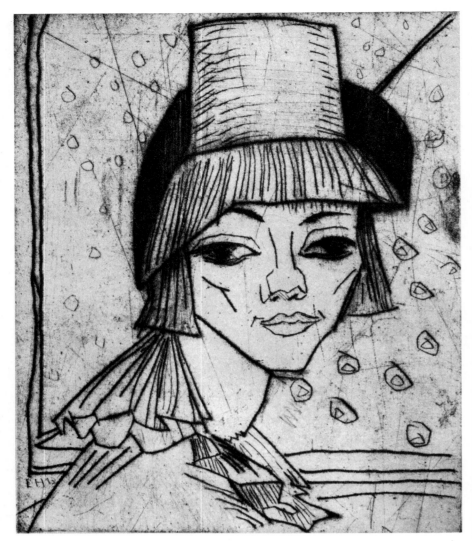

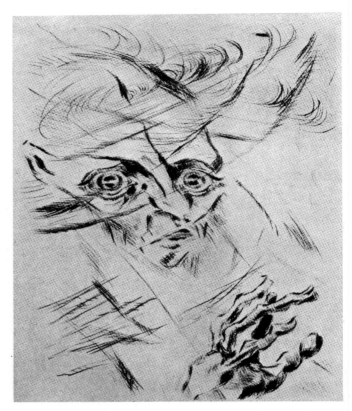

54. Walter Gramatté. *The Great Fear*. 1918. Etching, 11 3/4 × 9 1/2″. Reproduced from Vogt, *Expressionismus*

53. Erich Heckel. *Girl with High Hat*. 1913. Etching, 17 1/2 × 14 1/8″

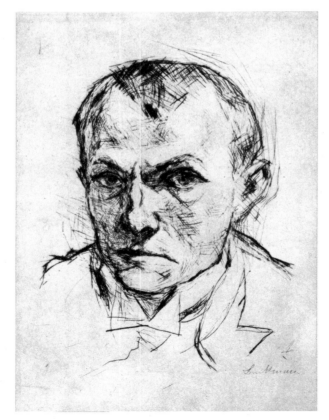

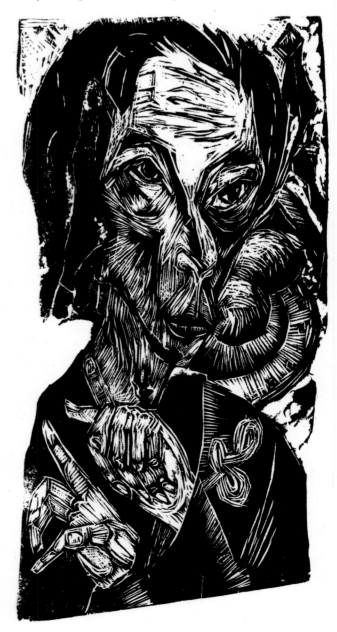

55. Max Beckmann. *Self-Portrait*. 1914. Etching, 9 1/2 × 7 1/8″

56. Ernst Ludwig Kirchner. *Head of a Sick Man (Self-Portrait)*. 1918. Woodcut, 22 3/8 × 10 5/8″

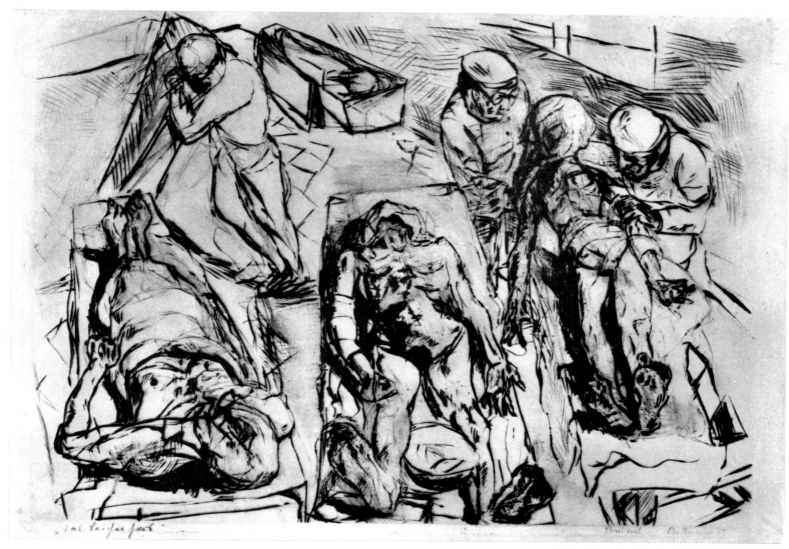

57. Max Beckmann. *The Morgue*. 1915. Etching, 10 1/4 × 14 1/8″

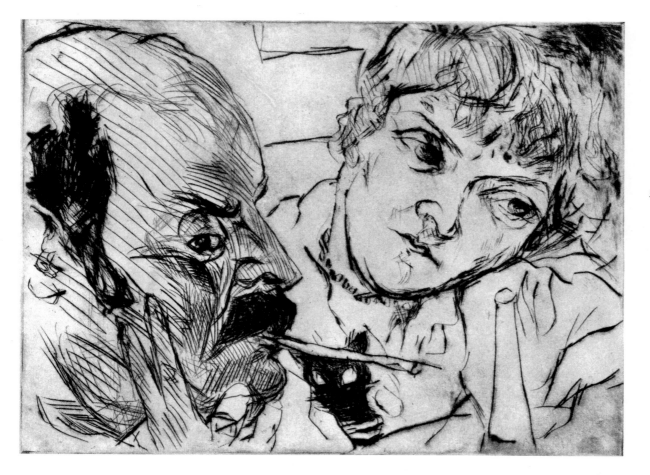

58. Max Beckmann.
The Battenbergs. 1916.
Etching, 7 1/8 × 9 1/4″

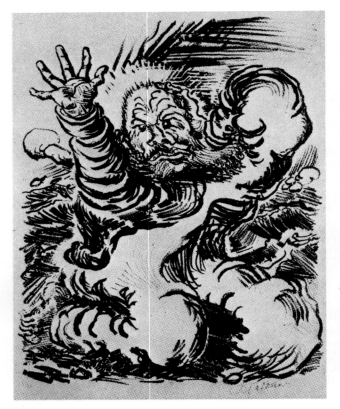

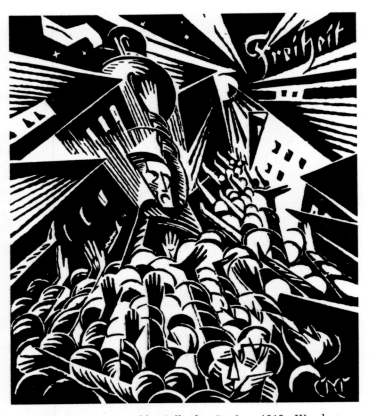

59. Ludwig Meidner. *The Prophet.* 1919. Lithograph, 15 7/8 × 11 1/2″. Reproduced from Vogt, *Expressionismus*

60. Constantin von Mitschke-Collande. *Freedom.* 1919. Woodcut, 7 1/2 × 6 1/2″

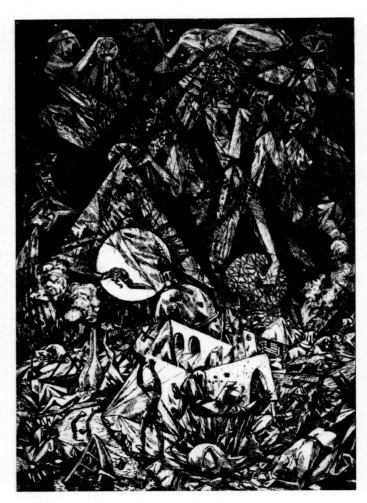

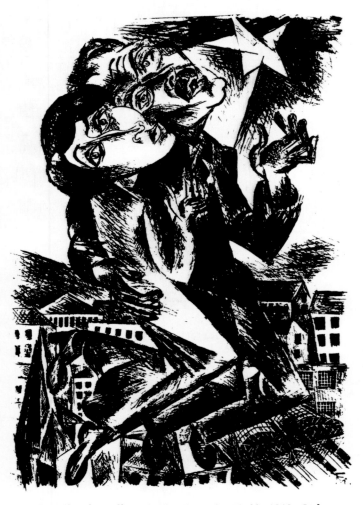

61. Heinrich Vogeler. *Inferno.* 1918. From the portfolio *Birth of a New Mankind.* Etching, 14 1/8 × 10 1/4″

62. Conrad Felixmüller. *People Above the World.* 1919. Lithograph, 27 1/8 × 19 5/8″

THE END OF EXPRESSIONISM

German Expressionism found both its climax and its conclusion in Berlin. Not long after its peak period, the lively international scene in Munich petered out: Kandinsky had left via Sweden for the USSR, Jawlensky had retired to Switzerland, Macke had been killed in 1914, and Marc in 1916.

Naturally, the events of the time did not go unnoticed in Berlin. In retrospect, we can see that by the end of the second decade Expressionism of the first generation had become very different from the Expressionist tendencies of its successors, who had meanwhile been maturing. Slight as it was, the age difference counted more than would normally have been the case. Their sense of artistic direction depended entirely on whether they belonged to the generation of the European upheaval around 1905 or to the subsequent one.

World War I brought a turning point for everyone, whether they had been in the fighting or had spent the decisive years at home. The brutality of the realities of war had degraded expressive emotion to an aesthetic formula and highlighted the gulf between the period before and after 1914. The achievements in art were not jeopardized, but for an Expressionist, especially one of the first generation, the question of future direction became paramount.

The works produced during the war show clearly enough the beginnings of this reorientation. Art was looking for a way out of the all-encompassing horror; it was receptive to any possibility of a healing process (colorplate 15).

Kirchner's pictures are a good example. His health ruined, poised for years on the brink of collapse—the disturbing portraits from the beginning of the war describe his situation more vividly than any words can—he sought and found healing in the unspoiled scenery of the Swiss mountains which he never left again (fig. 52). Heckel transformed his paintings and prints into a plea for compassion and humanity. One sign of this altered situation was the return of religious subjects and the desire expressed in them for the revival of the old symbols to help people overcome destruction and despair—as the underrated graphics of the years 1915 to 1919 testify. They also contain a bitter criticism of the war and its consequences at a time when this could not be publicly expressed. Barlach's lithograph *Anno Domini MCMXVI Post Christum Natum* shows Christ with the Tempter before an endless cemetery (fig. 43). It is just as eloquent as Schmidt-Rottluff's famous *Christus* sequence in which the year 1918 appears like the mark of Cain on the brow of Christ (fig. 46). Rohlfs' most important paintings and prints and Heckel's religious subjects are contemporary statements at a time of madness (fig. 45).

Fundamentally, these reactions to the war were still concerned with the old theme of the threat to man, of his confrontation with the outside world. After passing through the melting pot of personal experience, the first Expressionist generation by the end of the war no longer felt prepared to subject its art to the political demands of the day. All of them were, in the strict sense, nonpolit-

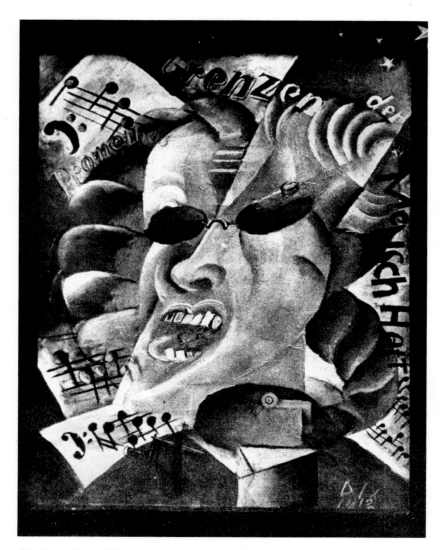

63. Otto Dix. *Self-Portrait or Prometheus*. 1919. Oil on canvas. Lost

ical. Naturally, their revolutionary ideas contributed to a general change in the psychological situation of their century—in fact, helped to produce it. Yet their struggle against the aesthetic preeminence of the court and bourgeois society no more implied a political act of will than their preference for the dark fringe areas of metropolitan life sprang from a conscious social concern for the rights of the oppressed. This implies neither a lack of sympathy with the fate of others nor total insensitivity to their problems; but it does illustrate the special concern this generation of artists had with contemporary life, although vehemently opposed to it.

64. Peter August Böckstiegel. *Singing Children Near the Ocean*. Oil on canvas. Lost. Reproduced from Vogt, *Expressionismus*

65. Lasar Segall. *Sickroom*. Oil on canvas. Lost

The younger generation did not feel satisfied, as their predecessors had, with the description of subjective experience, nor content with the role of art as they had seen it. Their reaction was belligerent, the shock effect of their outbursts disturbing. The brutal intensity of their aggression was still based on the desire for expression, in which, however, "classical" Expressionism no longer had any part. The age dictated such an art: if the committed outlook of the Pathetiker and the groups and individuals akin to them were to penetrate the confusion of the time and the chaos of divergent tendencies, then they had to shout louder than everyone else. Even the most intense exultations of the first generation appear muted by contrast to this hectic protest. Apocalyptic visions filled their pictures to the bursting point and called the very concept of "art" into question. "Pictures are supplementary broadsheets on the last stand of the spirit. Get out of the exhibitions! Into the streets! Sell intellectual telegrams in editions of millions!" Felix Stiemer earnestly demanded in 1918. Even the previously established Expressionist means of composition could not contain such an impetus. The principle of futuristic simultaneity, which they had encountered at the first exhibition of the Italian Moderns, struck them as particularly well-suited to the cultivation of their urge for expression. The inclusion of the passage of time in a Cubistically distorted pictorial design, i. e., the pictorial simultaneity of events taking place at different times, multiplied the dimensions of the happening and gave it a highly dramatic quality. Ludwig Meidner's *Anleitung zum Malen von Grossstadtbildern* (*Guide to the Painting of City Pictures*; 1914) outlines the new principles of form, among them that of dynamic movement, which vastly extended the scope of expression. Once again the restless, faceless, in their eyes inhuman city symbolized the newly recognized need to use art as the ultimate moral weapon, while completely releasing it from its former bonds. Something similar applied to the landscape subjects: apocalyptic landscapes were painted by all the Pathetiker.

Clearly an art of this kind, aimed at topicality, loses its foundations as circumstances change. Lacking any real development, and being a purely topical, albeit necessary, position adopted by the artists at a restless time, it departed from the scene as suddenly as it had appeared. Both as an Expressionist trend and as an individual outlook it had become irrelevant, although this did not mean that all its arguments were invalidated. The breadth they introduced, not least by their augmentation of graphic production, made Expressionism a symbol for the nascent Weimar Republic, thus achieving something that the first generation of the Imperial era could not have accomplished. Something similiar happened in the USSR, whose revolutionary beginnings were not stamped by socialist themes but by Constructivism.

Grotesquely enough, the collapse of Expressionism as an artistically viable phenomenon coincided with its recognition by the public: museums and scholars began to enhance its reputation—the artists who had returned from the war were transformed overnight into the representatives of German art.

New groups were formed, these too, even in 1920, under Expressionist banners. The origins of the Bauhaus are clearly characterized by the predominance of expressive tendencies; Feininger's *Cathedral of Socialism*, a woodcut illustration of the first Bauhaus manifesto, is a visible sign of this (fig. 34).

In Dresden, the Secession Group 1919, mentioned earlier,

66. Max Beckmann. *The Night*. 1918–19. Oil on canvas, 52 3/8 × 60 5/8". Kunstsammlung Nordrhein-Westfalen, Düsseldorf

was formed by painters such as Peter August Böckstiegel, Otto Dix, Lasar Segall, Conrad Felixmüller, and others (figs. 62–65). In the North, the representatives of late Expressionism gathered around Barlach; in Darmstadt around Bernhard Hoetger and Karl Gunschmann; in the Rhineland around F. M. Jansen and Heinrich Nauen. Berlin produced two more significant associations: the Arbeitsrat für Kunst (Working Council for Art), under the chairmanship of Walter Gropius (later to found the Bauhaus)—which Klein, Heckel, Feininger, Meidner, Pechstein, and Schmidt-Rottluff also joined—and the well-known Novembergruppe (November Group), whose members and aims were largely identical with those of the Arbeitsrat. The only new element here was the demand for an art for the masses, for "the most intimate mixture of people and art."

Judging by the intensity as well as the multiplicity of the various manifestos, at one time a new avant-garde arising from

Expressionism seemed possible. But this impression was misleading. The more important figures had already set themselves other goals, and the weaker artists could find no adequate form to embody the subject matter they insisted on pursuing. Even Feininger's *Cathedral* remained a symbol of an Expressionist Utopia, although it is remarkable both as a work of art and as a profession of faith at a time of increasing derivativeness. Expressionism had at last become a formula, the revolutionary impetus only a tinkling declamation.

This only marginally affected the former Expressionist leaders. They had become classics, their influence had spread and become independent, finding a new direction in the hands of their successors. By this time it had become clear that despite their revolutionary gestures, despite their truly trailblazing achievements, they had never stepped outside the framework of history as their art sometimes tried to make people believe. They had

been both innovators and perfectors, taking their place in the development of German art through the centuries. And so the undeniable return to nature in around 1920 did not represent a break but a consequence. The only exception was Emil Nolde, who continued undeterred to follow his course, once chosen, without ever deviating from it in this sense, the sole truly consistent Expressionist.

With its transformation around 1920, Expressionism was simply obeying the commandment of time, pointing it in a different direction, which the Expressionists' keen eye for the realities of life had already glimpsed.

It was joined by artists who, like the Pathetiker, had started on their road after 1910 and drawn their inspiration from related sources. They too were idealists who had to pass through the hell of total disillusionment. In the socio-critical verism of the 20s, in the new definition of reality, they found a legitimate field for traditional arguments. This transition from Expression-

ism to expressive realism is most strikingly embodied in George Grosz and Otto Dix.

One other painter was at the center of the late Expressionist verism at the end of World War I: Max Beckmann. The war had redirected him from pleinairism to the search for a new definition of reality, which at first still seemed possible through late Expressionism. But he soon realized that the tried and tested media of expressive distortion were incapable of conveying all the harshness and bitterness of the reality he had personally experienced (colorplate 40, fig. 66). Reality could not be reproduced; it must be created. At the end of the war, this artist therefore attacked the world as a realist with the utmost harshness, extracting from it symbols of hopelessness, horror, and destruction. The uncanny lurks in the guise of the ordinary. To capture it and find a valid basis for it became the task of the new decade, the first of Post-Expressionism.

COLORPLATES

2. PAULA MODERSOHN-BECKER (1876–1907)

Young Girl with Horn in Birch Forest

c. 1905. Oil on canvas, 43 1/2 × 35 1/2''
Ludwig-Roselius-Sammlung, Bremen

Against the light-pierced background of a copse of birch trees a young girl, really still a child, strides along oblivious to all about her, her pace set apparently by the tune she plays on the simplest of wind instruments. A homely theme, a picture without pretension: nature writ plain, set down in the large, and so steeped in a mood that only later does the question of its meaning as a work of art arise.

This is not one of those run-of-the-mill landscape or genre paintings so many local schools were turning out at the time. When measured against reality, it quickly proves that reality was not its aim. The artist avoided everything even hinting at what she rendered here was something seen in life.

True, there are the slender, pale birch trunks to assure us that this is a place of heath and moor. Each one carefully outlined, the trees fill the picture into its depth. Within the context of the entire composition, however, their function is clearly something more; they decoratively articulate and place a pictorial, ornamental pattern over the picture ground. The figure of the girl brims with force but is no less stylized than the tress. Her hair hangs loosely down her back, a simple dress completely covers her body. Although the figure scarcely contrasts with the basic tone of the picture, its surface is entirely covered with tiny brush marks, as if scored with a fine tool, making it appear almost tangibly solid. This is also true of the grass and tree trunks, where the paint is likewise applied haptically, but with a feeling for tactile values that do not set the composition into dynamic tension.

The insistent simplicity of every pictorial detail, the avoidance of everything "lifelike," the greater emphasis on ornamental as against realistic values—all these further enhance the depiction itself: everything is unmistakably aimed at expressing feeling, not at transforming form into pictorial organism. In this the painter evokes that realm of feeling in which the spiritual relationship with nature is emphasized and its quality in terms of mood—here still very much tied up with subject matter—can go over directly into expression and expressiveness. To achieve this required no greater effort but only a slight stylization of the still conventional form, a slight shift in accent to make color values take on new resonance: a process of evocation that can be recognized in the decorative flat scaffolding of the birch trees, the deliberate awkwardness of the childish figure, the tonal lay of the colors, as well in as the symbolism of the depiction itself.

This very much sums up the approach of Paula Modersohn-Becker, the only woman painter of importance among the North German Expressionists.

She was granted only a brief span—the six years between 1901 and 1907—in which to impart what she wanted so much to say.

Her name calls to mind the landscape of Worpswede, the loneliness of the northern German lowland, the reserved character of its people. All of that is present in her art, yet was not primarily what defined it. None were more critical of her work than the painters who specialized in heath and moorland, depicted melancholy birch trees rising in front of gloom-drenched farmsteads, lonely paths beneath the blaze of the evening sun. For them her work lacked intimacy, was posterlike in effect. What they criticized was the very otherness that in our eyes is her truly unique distinction.

This she already sensed when she was traveling about and educating herself in art. In Paris she was struck by the painting of Cézanne, recognizing in it the "great simplicity of form" she herself was striving to achieve (see fig. 2). She felt a kinship with Gauguin, whose symbolism evoked a responsive chord in her. And the aftermath of the German Jugendstil sharpened her sense for just where each form should be integrated in the total pictorial organism and led her to work toward flat planes of decorative color and exploit their symbolic and lyrical possibilities.

She repeatedly insisted that her aim was not to intellectualize about nature, which nonetheless is very much present in her works. In her pictures subject matter is meant to express only that which emanates from personal feeling: the perception of the hidden human worth of all things. To bring that out, she renounced everything to do with mere skill, everything "artistic," finished, and perfect. The hand with which she wrote in paint seems labored, the means almost stingy. Yet in all of her work lives her love for all creation.

There does exist a certain naiveté in this picture. But its function is to stir up the hidden power of communication of the artist's pictorial means. And that was exactly what she was after. True, all this has little to do with the wild impetus of the young Expressionists, with their intoxication with color and their emotion-laden language of gesture. It was not only in this picture that Paula Modersohn's palette was tuned to dark, restrained tones. It was never high pitched, never exotic, never out to be striking or different. That is why we feel an unusual measure of inwardness and stillness, summoned forth through a casual gesture, through the tone of a rustic shawm in the loneliness of a woods.

Painting for this short-lived painter seems often to have been an almost unconscious activity. But precisely for that reason what she did was so important at the start of our century. Following her instincts, she took up a position that, in its human warmth and deepness, would lie entirely beyond the grasp of a stormy generation of young revolutionaries.

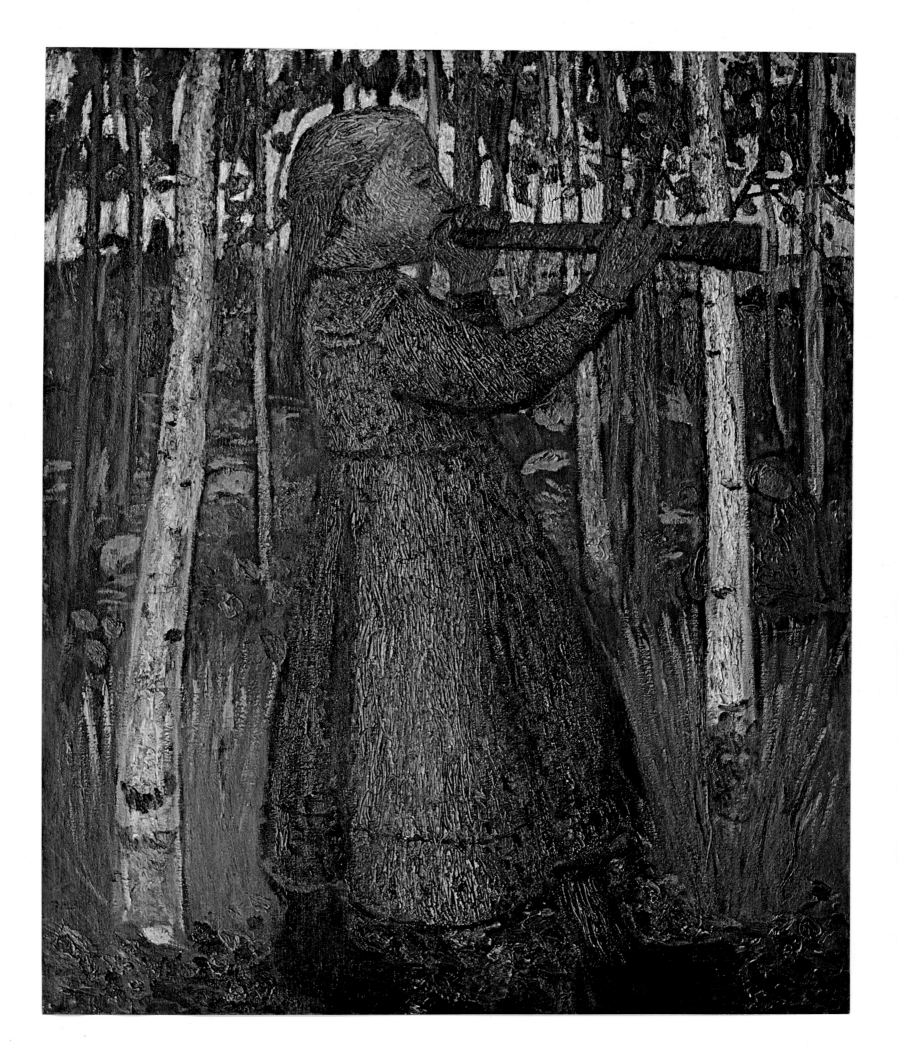

3. CHRISTIAN ROHLFS (1849–1938)

Birch Forest

1907. Oil on canvas, 43 1/4 × 29 1/2″
Museum Folkwang, Essen

Three decades of artistic activity in the orbit of the Weimar Academy before 1900 gave Christian Rohlfs' painting a basic foundation that stood him in good stead when, in 1901, he moved to Hagen where the Folkwang Museum was being organized. The revolutionary efforts at renewal, examples of which he found in the collection and new acquisitions of the museum's founder K. E. Osthaus, doubtless had their effect on his work. But these influences did not set him on any essentially new path, and for this reason he should not be termed an Expressionist in the same measure as his friend and countryman Emil Nolde. Even after he had come to grips with the new European art, his own hard-earned values remained important to him: sensitivity to color harmony and a feeling for pictorial composition similar to that of German pleinair painting. Yet, through his power, intensity, and gift of expression he soon left far behind the rather bland vein natural to that approach.

Instead, he shifted his chief emphasis to paint itself, to color, which was becoming ever more important to him. Here there are parallels with what was going on among the much younger contemporary Expressionist generation. Their exploratory efforts were bolstered powerfully by French Neo-Impressionism with its adventure into pure color; and their dynamism became even stronger when they succeeded in making their own the violent handwriting of the Dutch genius Vincent van Gogh. At that point, however, there was nothing in common between Rohlfs and the younger generation. What the latter understood as the first step toward a more concentrated expressive function for color, which was soon to burst apart all traditional ways of organizing a picture, served Rohlfs as a newly won value for a pictorial organism arising out of paint itself and behind which continued to live the experience of open-air and landscape painting— of Impressionism.

In this context Birch Forest of 1907 is a key picture. At the same time daring and classical, it unites convincingly the essential traits of Rohlfs' art that would remain valid even later, however modified they might be by his further development.

As much as this picture, with its delight in color and its liveliness, is based on the assumptions of the French Neo-Impressionists and the color dynamic of Van Gogh, so, too, is it remote in the final analysis from both these sources. The theme itself is frequent in Rohlfs' work. Precisely at the turn of the cen-

tury he returned to it repeatedly, although always alert to not losing sight of the overall effect in his concern for detail. Never before had the fifty-eight-year-old painter accepted so boldly the risks of color. Casting off in an almost violent impetuousness the punctilious stippling and restrained brushwork of his preceding works, he made color and free brushstrokes the essential content and occasion of the picture.

Although at first sight virtually abstract, the picture still clings to nature. In the swirl of colors we still make out the individual birchtrunks on which lies the warm light of a late summer's day. That Rohlfs should have chosen precisely these pale trees and not the beech-trees or pines he had favored before, emphasizes once again his conscious striving for something different.

The trees do not reflect the light reaching them from outside the picture; they themselves emerge as color and light together, in harmonious sonorities that reveal nothing of the explosive inner tension that is Van Gogh's hallmark.

One senses the felicity of a radiant day glowing from the picture as a pure visual experience. The rapid alternation of full-bodied tones, among which dominate the primary colors of a powerful red, a warm yellow, and a blue both cool and luminous, also brings into play the contrasting effects of the color spectrum. Along with the complementary contrasts, it is chiefly the tension between light and dark, as well as the oppositions between warm and cold tones, that is exploited in a symphonically coloristic manner. All of this serves to intensify the light and movement produced by forceful brushstrokes that communicate the impulsiveness behind them. Despite the domination of color, form holds fast. The verticals of the tree trunks work as organizing factors within the whirl of colors. It is plain to see how much Rohlfs' long experience with his art acted as a regulating factor even when he pushed ahead into unexplored domains. Precisely this is characteristic: the exercise of self-control in the throes of inspiration; color used in relation to what one sees no matter how its properties may be exalted; a bold and yet thoroughly calculated way of working.

The painter, with this picture and with certain similarly conceived works, made good his commitment to the twentieth century without breaking his ties with the tradition of German pleinair painting. With it, too, the direction of his work for the coming decades was fixed.

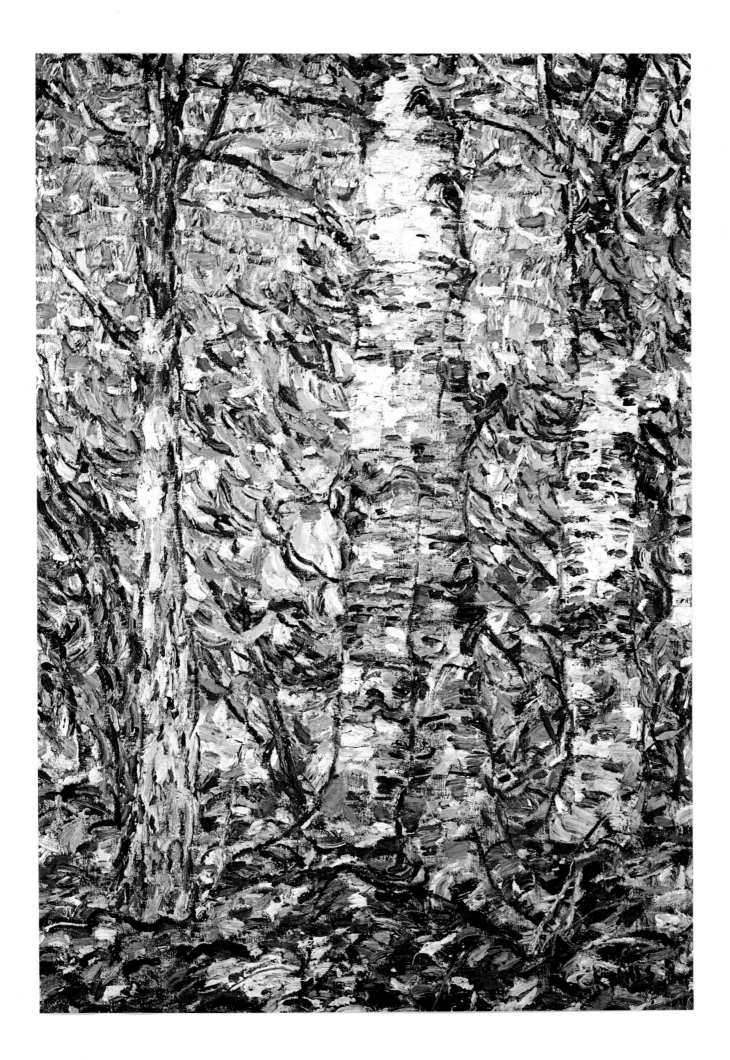

4. CHRISTIAN ROHLFS (1849–1938)

Red Roofs Beneath Trees

1913. Tempera on canvas, 31 1/2 × 39 1/2″
Staatliche Kunsthalle, Karlsruhe

The glowing, Late Impressionist color sense that remained the outstanding hallmark of Rohlfs' work to about 1908 was transformed in the next years into a new kind of image, something between abstraction and recognizable subject.

The change was not sudden but rather, as was typical for Rohlfs, a step-by-step development through various experimental stages. A tardy interest in Jugendstil elements aroused his sensibility to decorative surface effects. A theme entirely new to him, the world of high mountains, came to him during a stay in Bavaria between 1910 and 1912 and represented a new conquest for his art: to his partiality for surfaces was added a feeling for large form, strong contours, and color with all the glow of stained-glass windows.

Shortly before World War I Rohlfs produced a few paintings that were a virtual synthesis of all the experiments of the preceding years and at the same time represented his own sort of private parallel to what was going on in European art. Among them is this picture which, at first glance, might seem an abstract composition done under the impact of French Cubism or the musical color-compositions of Kandinsky. Similar works were being done at the same time by other German painters, those of the younger generation in particular, and scarcely anyone remained impervious to the stormy developments in art in those crucial years.

Closer observation of this picture shows it to have an inner affinity with the *Birch Forest* of 1907 (colorplate 3), and here again the differences from other painters' work are greater than what they have in common.

With Rohlfs, the image was a purely visual experience and in no way reflected a theoretical position or preoccupation with problems of construction. The basic principles of French Cubism, but also the cosmic visions of Kandinsky, continued to be as alien to him as had, previously, the methodology of Neo-Impressionism.

Color again lies at the heart of the picture as the single force creating form. Although on the verge of abstraction, it retains the characteristic associations with what is known and experienced. Yet here the linear elements that previously had dominated the image are once and for all left behind. In a vehement handwriting, the artist has translated what he has seen into surface forms of strong, dynamic movement.

The eye can easily disentangle what is represented among the color-forms: the gleaming red dominates the entire picture and, subordinating all other colors, belongs to the roofs; then we recognize the tree forms behind which the houses themselves are concealed.

The advance over the pictures of about 1907 is not to be underestimated: color was still linked to the subject matter, but it had gained greatly in independence, had become so free that at this point it could stand on its own without having to ape nature in any way. The way was open to pictures conceived entirely in terms of color sonorities and composition.

Yet precisely the fact that Rohlfs turned away from that ultimate step, which would have brought him immediately alongside the most advanced European avant-garde, is proof of his individuality and his rugged independence. If this picture marked a step forward, to the crucial limit for Rohlfs, it still did not turn away from his ultimate aim: the emotional identity of image and nature.

One must come to terms with this picture in a dual manner, accepting both possibilities it manifests. Its festive colorfulness still rests on the principles of composition that Rohlfs had put into play earlier. The basic colors, as full-toned sonorities, constitute the pictorial armature to be varied and enriched symphonically. Along with this goes the effect of the color contrasts, at one and the same time means and intensification. A system of stripes very much in the artist's personal style counteracts any tendency to stasis and serves to infuse the surfaces with dynamism. The risk of transforming the picture into a decorative ensemble through overly dense and powerful color accents is met by the artist with a procedure entirely typical of him: the brush partly washes away a color just laid on and lightens it by lessening its material weight without interfering with its sonorous effect. There remains a glowing web of variegated color-forms replete with joy, gleaming illumination, and temperament, the artist's panegyric of the Here and Real: painting as visual poetry.

5. EMIL NOLDE (1867–1956)

Tugboat on the Elbe

1910. Oil on canvas, 28 × 34 5/8″
Private collection, Hamburg

Of key importance for Emil Nolde's work were the years between 1909 and 1912 when his pictorial means, along with their power of psychological expression, were becoming more relevant to his own hallucinatory world of ideas. Seldom in one place very long, he was first in Ruttebüll in western Schleswig, on the island of Alsen, then in Berlin where in 1910 he came into open conflict with Max Liebermann and was excluded from the Berlin Secession. In that same year he spent a few weeks in Hamburg, working mostly in the vicinity of the harbor, and eventually producing some important woodcuts, etchings (fig. 38), and a few paintings. In these he once again came to grips with nature, but with the changed feeling likewise found in his large and important figure paintings of that time. Most of them were religious (fig. 3), on subjects from the Old and New Testaments, beginning with the *Last Supper* of 1909 and culminating in the nine-part altar on the life of Christ done in 1912. All these works testify to the new importance of color from which, in the future, he would give form to his visions. This was a passionate process of conjuring up his powers out of spiritual depths, out of unschooled instincts which, he said, were worth "ten times more than knowledge" to him. Color made up the matrix of evocation out of which, in some magical process, form emerged. Painting became an unceasing struggle for control of the pictorial element which, in the ecstasy of creation, forever threatened to slip from his grasp: no other painter of that time more unequivocally represents classical Expressionism in all its perilousness and its greatness. All color values were intensified to utmost brilliance and urgent expressive power, every traditional principle was denied except that of contrast. Later, in his *Jahre der Kämpfe* (*Years of Struggle*), Nolde wrote: "Everything that was borrowed, learned, was nothing, everything had to be invented as if from scratch. . . . I also wanted to paint not what I wanted but only what I really had to paint. . . . The color scale and a blank canvas confronted me like a battle." The brush no longer sufficed for the demands of the urgent stream of images that clamored for immediate realization in pictorial form because every instant lost in conscious reflection risked diverting the flow and drying up the capacity for direct and virtually intoxicated creation: "A couple of nails hammered into the board wall were a substitute easel, often my fists and fingers, a scrap of leather or cardboard, replaced the brush."

In both conception and use of color this *Tugboat on the Elbe* of 1910 is in line with what Nolde was doing in figure paintings. In landscape as well, vision was replacing likeness. With this Nolde at last had washed his hands of the Impressionist point of departure that he had always allowed for until then. But what changed was not really the pictorial means—despite all the unprecedented freedom or, better, disdain for everything traditional we may find in them—but the painter's inner relationship to nature. This constituted the starting point for a dramatic color event in whose symbolic power the painter placed his trust. The result was a picture of "inner" nature that was no longer oriented toward rendering details, but aiming at the original, primitive motive force behind them. Only thus can one understand this wildly excited way of painting that reflects an emotionality heated to fever pitch, and this pictorial structure whose pathos exceeds everything that a landscape might arouse in an artist.

Yet one is surprised by the simplicity of the means. The painting takes its life from a basic color, the effulgent yellow that fills water and sky alike with a luminescence that wipes away the boundaries between the two realms. Only in his brushwork does Nolde distinguish them: a swirling, thick impasto in the zone of the waves which identifies itself with their movement; for the sky, a flatter and more broadly brushed treatment, not without tension.

A heavier, blackish-violet tone makes a powerful, simultaneous contrast to the yellow. Whorllike motions of the brush give rise to the oily banner of smoke streaming from what is no more than an indication of a tugboat hauling a barge. The smoke whirls with an outright emotional uprush to the very top of the picture. Repeated as shadow in the lower half of the picture, shape and mirror image make two fantastic ornaments that are torn to shreds by the dynamic of the waves at the lower margin.

As a magical, flat surface the picture conjures up uttermost tension and exacerbates the coloristic quality to the limits of the possible: no one is likely now to think of it as mere visual impression. Nature, transformed entirely by the artist's vision, is presented in a higher dimension, not codified into a pictorial composition by some process of filtering out visual impressions, but by being embedded literally into the human psyche—instinct versus intellect.

Such radical intensification has often led to a distortion of the objective image in Expressionist art, and Nolde did not always escape that danger. Here the effect is rather different: an everyday sight is heroized, pried loose from its usual visual context. Landscape is no longer perceived as a human domain, as within the province of the civilized. Nolde thought of it as *Ursituation*, as primeval, and unsullied by the rise of cities and technology: here even the technical progress represented by the tugboat is transformed back into a part of that indomitable primeval force that symbolizes to mankind the vaster interconnection of all existence.

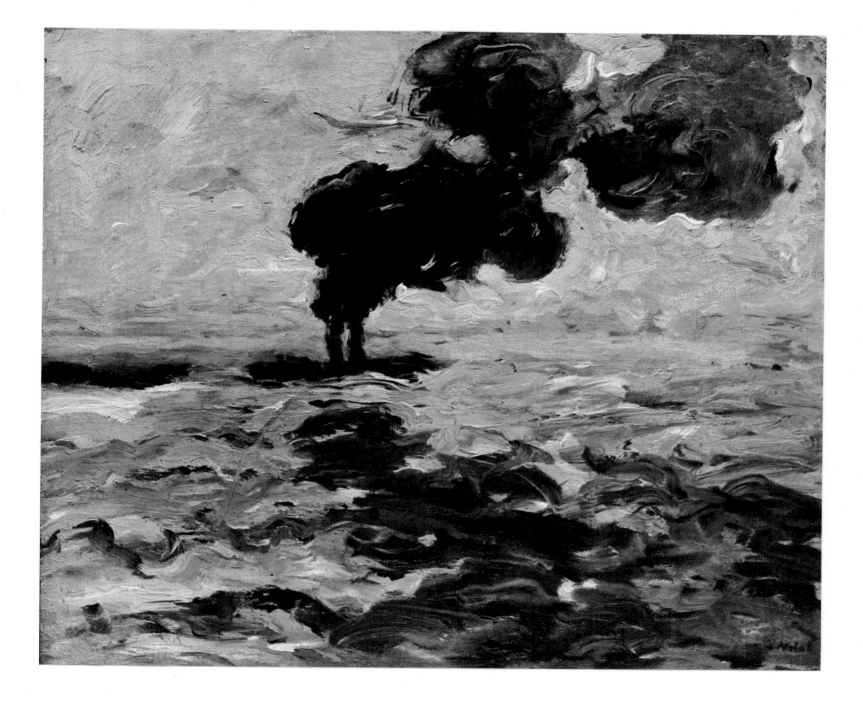

6. EMIL NOLDE (1867–1956)

Candle Dancers

1912. Oil on canvas, 39 3/8 × 33 1/2"
Stiftung Seebüll Ada und Emil Nolde, Seebüll

The so-called Expressive (Modern) Dance, whose foremost interpreter was Mary Wigman, was one of the typical art forms of the Expressionistic decades. As in the visual arts, it aimed at aesthetic mediation of a state of utter tautness, and what it expressed was unrestrained passion and primal abandon, at one and the same time Dionysiac and Orphic. As in painting, dancing signified for its artists the direct transposition of ecstatic excitement into expressive gesture, reflecting that latent stimulation whose impulses directed the entire body and not only a hand guiding a brush.

It goes almost without saying that this archaic means of self-expression aroused the interest of a painter such as Nolde, rooted as he was in the passionate world of personal visions. He tried to explain that experience in his own unsophisticated manner: "I had always taken pleasure in dance as artistic expression, or even just as movement, as life, had already spent entire nights in the village of Weissig near Dresden, sitting in the dance hall, drawing, drawing. Later, it was more the solo dance, the art dance, of which I was an especially eager onlooker. My first dance experience may have been with the Australian dancer Saharet, wild and whirling in her turns, her streaming black hair suggesting a fantastic primeval creature. . . . In Paris, I saw Loïe Fuller in her iridescent serpentine dances, in green and silver, with her broad many-folded drapery phosphorescing into colors." "The dancers furnished the stimuli to my pictures," he said in a later section of his memoirs in which he described his acquaintance with Mary Wigman and Gret Palucca, whose art he specifically opposed to "the usual saccharine ballet and toe dancing."

None of Nolde's many dance pictures refers to a specific model. When he painted the dance, it signified a primeval state of divine transport and total abandon that could never be conveyed through a particular person's likeness. His works took form "without any sort of prototype or model, even firmly defined conception. I was very good at imagining a work down to the tiniest detail, and indeed often much more beautifully than it could subsequently be done in paint—I became a copyist of the conception. For that reason I avoided all thinking and planning beforehand, a vague notion in no more than glow and color was enough for me."

This may also have been the point of departure for this work of 1912, which was preceded by others on the theme such as the *Wildly Dancing Children* of 1909 and *The Golden Calf* of 1910.

More clearly than in the *Tugboat on the Elbe* (colorplate 5) where there is still a vestige of illusionistic pictorial space, in the dance picture of 1912 the new conception of the pictorial idea has taken shape, has become the magical ground, the "place of apparition" for the images that take shape out of it and on it.

The gap between picture and objective reality has grown, although Nolde, like the other Expressionists, never rejected the symbol of real existence as excitant to their imaginative capacities. Here the dancers are identifiable as exotic creatures, rather like Nolde's description of Saharet. But they are not the sole pictorial motif: the entire composition is in bacchantic tumult, shot through with a flickering rhythm that sweeps into itself every detail and dominates the total picture. The colors—a blazing red, a throbbing yellow, over them a sharp green contrasted with reddish-violet refractions—would have sufficed to incarnate the theme. The dancers sum up the dramatic melopoeia. On the agitated ground they make intricate pictorial ornaments, and their ecstasy gives scansion to the ground melody of the surface. Scarcely indicated, their faces are imprinted with surrender to their dancing frenzy: eyes shut, they seem to be obeying some inner drive and are exalted into those "fantastic primeval creatures" whom the artist fancied he was seeing on the stage.

Such a picture shows what possibilities are inherent in direct self-expression in paint. Apparently Nolde made only a quick outline sketch on canvas (fragments of it can be detected under the paint), and everything else, as called for in his conception, was entrusted to the power and evocation of color. The exotic habitus of the figures also points to their origin in the world of fancy: his South Sea journey still was before him, and any acquaintance he may have had with alien cultures could have been gleaned only on visits to ethnological museums. Yet he always thought of the exotic as "really very closely related" to him since it sprang from the same primeval ground close to creation that in his eyes was the guarantee of the "pristine unspoiledness of nature."

Instinct and passion, embodied in powerful color and lapidary form, an "intense, often grotesque expression of strength and life": a new myth was born.

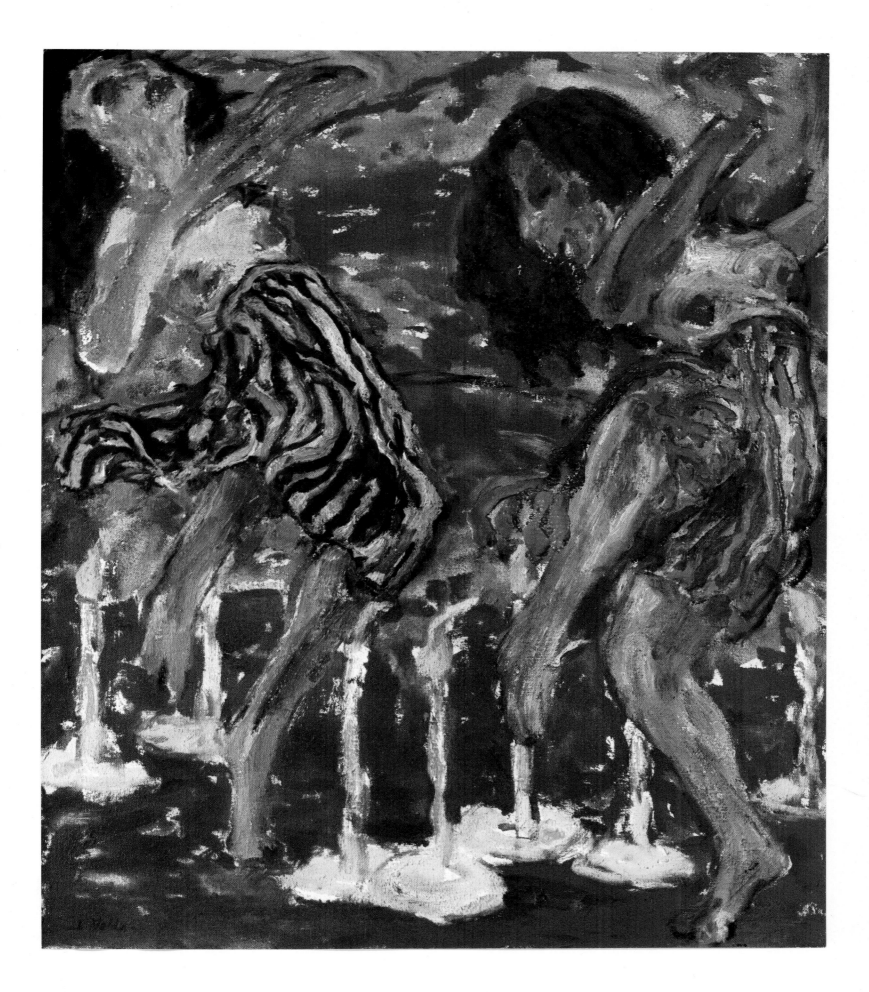

7. EMIL NOLDE (1867–1956)

The Sea

1913. Oil on canvas, 26 3/4 × 35″
Stiftung Seebüll Ada und Emil Nolde, Seebüll

More than other painters, more than Christian Rohlfs or Paula Modersohn-Becker, Emil Nolde had his roots in the northern German coastal landscape. The flat land between the North Sea and Baltic Sea, the high sky, the eternally restless sea, the lurking background and legendary aura of this Nordic world where fate holds sway—these were always to play a decisive role in his pictures: his native place as fount of dread and personal mythology. Often the feeling of belonging to such a world, a sudden and dismaying identification with the powerful forces, frightened him: "One afternoon, in a blaze of passionate urgency, I painted a picture, waves breaking against cliffs. In the very moment it was finished I took the palette knife and scratched it out. As if distracted I stood there and asked, 'Why?'—Never again have I been able to paint sky and water so wildly" (*Years of Struggle*).

About 1910 he for the first time concerned himself intensively with the sea. The result was a series of twenty *Autumn Seas*, a theme that thereafter never lost its hold over him. Water and surging waves were for him more than an interesting motif which, through the intensity and expressive power of color, could bear witness to the unspoiled state of his native landscape. With this painter the sea came to be personified with the earth's powers, with those deep-lying zones behind the surface of visible existence in which a similar sensitivity comes up against the myth of uncorrupted Nature.

Soon the sea was no longer filled with ships; it became more and more the sole subject, in its endless breadth and loneliness, in the dramatic close-ups of waves, in their quiet breathing beneath flaming skies as in their seething, storm-lashed tumult. Always the same motif varied a hundredfold, a preoccupation of the painter and of the man as well: "I stood on the shore facing the sea with broadly bared chest, and then again wrapped in the rags and patches we call clothes. I stood in the storm with sand grating between my teeth. . . ."

Certainly no one except the Englishman William Turner experienced the unconquerable power of nature with comparable intensity. Nolde was like him in that he was not merely a passive observer of the sea from his shoreside studio on the island of Alsen, but sought direct confrontation with it on stormy days, as if immediate contact with the untamed element would intensify even more the ecstasy of creation. In his memoirs he describes a trip to the island of Anholt: "On the return trip the water was wild, our ship small indeed. . . . I stood close up, convulsively holding on to the stair railing, staring and marveling, with the ship and the waves tossing up and down. That day has remained so vividly in my memory that for years I painted my sea pictures from it, the pictures with surging, wild, green waves and at the upper border a bit of yellowish sky. If a sudden wave had swept me overboard, and I had had to fight between life and death against the element, could I have painted the sea even more powerfully?"

This experience from around 1906 was still having its effect in our picture of 1913, which is very like his description. The "wild, green waves" with their white foaming combs give the picture its menacing power, and even the bit of yellow breaking through the narrow strip of the sulphurous green sky can be traced back to the painter's reminiscence.

Here nothing separates man and sea. The viewer finds himself in the very midst of the roaring waters that surround him on all sides, and his eye can catch only the smallest slice of the endlessness about him. From the elemental surging of the waves sounds a subterranean emotion, and because of it the marked simplicity of all forms, the rejection of content and pictorial anecdote, filter out the essential: the core of experience that the painter was striving to embody.

It is this close-up vision, the heightened metaphor of an untranslated color taken not as aesthetic value but directly as expression, the crude massiveness of the composition, the sheer weight of the pictorial volume—in short, the anti-intellectualism of it, the "absolute primeval originality"—that characterize Nolde's feeling about the world, and not in this work alone.

It was enough for him to have "a vague notion in no more than glow and color" to undam the pictorial stream of his fantasy. And this sea picture shows that it was fertilized through the experience of the eye and yet took its origin from deeper psychological realms, from the imagination. This is true because in his sea pictures Nolde did not use the typical Expressionist deformations which, in his figure compositions, he exploited to intensify the expressive content.

The sea pictures remain very close to nature, and the often undifferentiated emotion appears in them as a great simplification. Waves and clouds need not be stylized into symbolic forms. Elemental power was no fictitious quality, as in so many other Expressionist works, but was the product of a passionate effort to fit into a vaster context of existence. This remained beyond the grasp of the metropolitan painters, who were lacking in the naiveté that enabled Nolde, almost unconsciously, to surrender himself to the excitement that, in the passion of creation, carried over into the picture something of the painter himself.

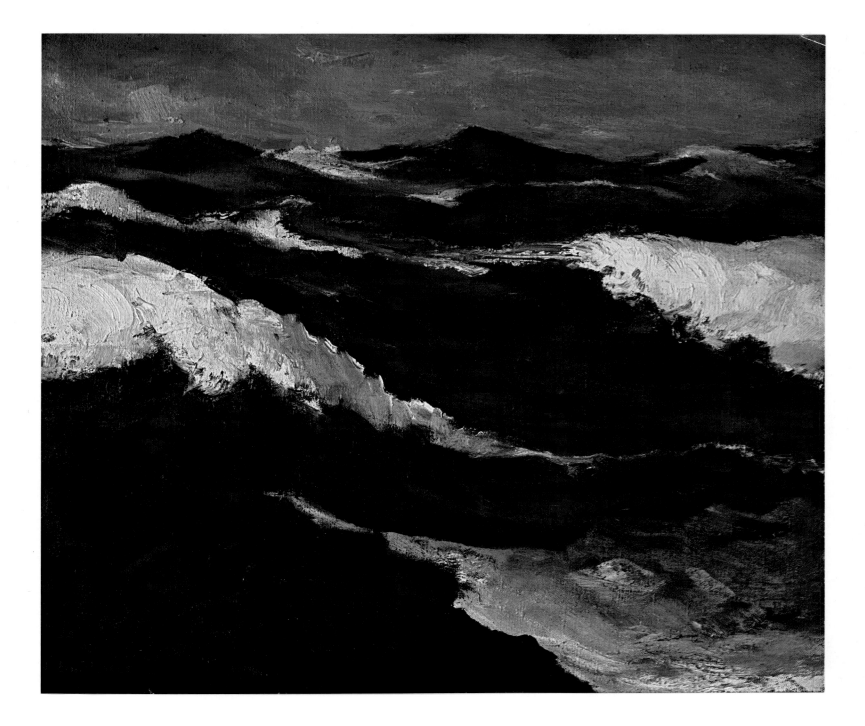

8. MAX PECHSTEIN (1881–1955)

River Landscape

c. 1907. Oil on canvas, 20 7/8 × 26 3/4"
Museum Folkwang, Essen

For a long time Max Pechstein was to the public the leading force in the new German Expressionism. Earlier than his friends of the Brücke he won the public interest and moved to Berlin, where he found a circle of companion spirits and could offer a foothold to the Dresdeners who followed him.

Pechstein encountered the Brücke group in 1906. For the Saxon Pavilion in the International Interior Decoration Exposition he had done a daring ceiling painting which, by order of the architect, had to be immediately toned down in color. His understandable indignation was shared by Heckel, whom he did not yet know, but who soon drew him into the Brücke circle where his ideas met with a response denied them elsewhere. He proceeded to take part in the life and work of that circle. Like them, he did nude studies in nature as well as in the atelier, and despite his rather different earlier training he soon became scarcely distinguishable from the others in his way of working, at least in those initial years.

As we know, the Brücke's chief concern at the time was in experimenting with color. In that first phase, color was the real discovery, and image and composition were entrusted to its power and intensity, and not to its aesthetic values or capacity for expression.

Retrospect shows that the young artists of the time were drunk on color, throwing themselves directly and without restraint into the adventure of color. Only Kirchner was an exception. A presentiment of the problem that lay ahead gave his strongly colored works of that period a more rigorous control of line, an overall rhythm.

Pechstein, who later became a more conciliatory painter (therefore more successful), and for whom the sensuous charm of real things and a decorative approach to composition and color harmony continued to mean much, about 1906–7 still subscribed wholly to the fury for color. In those first years neither a preordained subject nor any specific notion of the picture seemed called for. It was enough to have the igniting spark of intuition to set off a creative process, which then blazed away without a pause, and burned itself out in a wild explosion of temperament.

Such a volcanic approach to painting, which in its desire for utmost intensity and incandescence of expression smacked of genius at any price, could almost by accident lead to a satisfactory pictorial solution. But that was the way the younger generation wanted it. Painting in the classical sense, directed to the preconditioned final goal of what everyone recognized as a "picture," was in their eyes strictly for the academicians. Not the perfectly finished, the enduring, the eternal value, rather the most intensive expression of the fleeting moment seemed to them what mattered. Pechstein once tried to put these feelings into words: "Drunkenness! Shatter the brain! Rapturous birth pangs! Smash the brush; best of all, tear through the canvas. Trample the paint tubes underfoot!"

His important early work of about 1907, *River Landscape*, probably a view of the Elbe at Dresden, exemplifies that outbreak of spontaneity, of creation for the one fleeting moment of fulfillment.

At first glance, the surface seems a swirling flood of color, whirling aimlessly, the paint laid on impetuously, hard in tone. Only with a closer look can one make out a few forms: a triangle in the foreground with a group of figures, three boats, a distant shoreline, the lurid circle of the rising or setting sun. There are no outlines, only the accumulation of raw matter evokes an association with something recognizable, which is immediately sucked into the general maelstrom.

But visual effects are not excluded, such as the path of sunlight across the agitated surface of the water. But try to interpret the picture as a riverside experience and you will misjudge its effect. The subject itself is only secondary: any other subject could just as well have touched off the active treatment, which is and remains the only content and subject of this picture.

Obviously only the strongest contrasts and color values could do for this sort of creative process. The color scale is restricted essentially to primary and complementary colors and to the tensions arising from their combination: for the artist to mix subtle differentiations would obviously interfere with his impetuous painting process. Difficult as it is to speak of the artist's "handwriting," there is endless fascination in the fresh devil-may-care approach, the boldness of what he does, and the dynamic potential. Nor can such a picture be evaluated by the traditional standards cut to fit classical, academic art.

A picture like this may bring to mind Van Gogh, but any such comparison has to look beyond the external similarities for the differences. Where Van Gogh's hand was guided imperiously by a thought and concept, and his process of painting directed to a goal, here violence is a revolutionary principle, disorder becomes deliberate, expression an act of liberation from tradition and constraint. Even in retrospect one will grasp that this driving power is a necessity, that the radical intensification of the picture surface must be accepted as an expression of restless agitation for a generation that mobilized its unused energies to smash the tradition that stood in the way of their building a new world of their own.

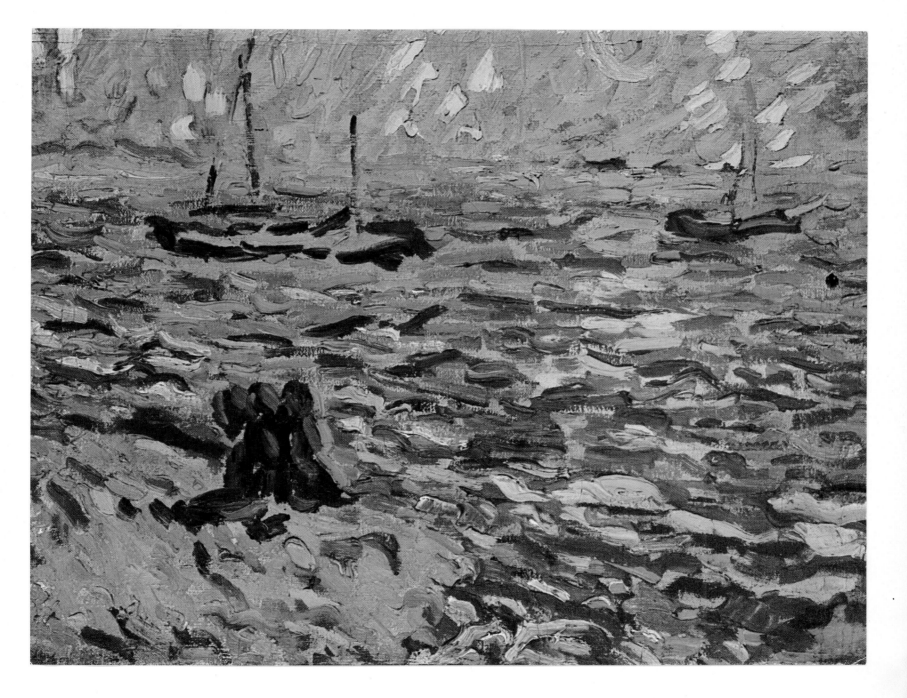

9. ERICH HECKEL (1883–1970)

Brickyard in Dangast

1907. Oil on canvas, 26 3/4 × 33 7/8″
Collection Roman Norbert Ketterer, Campione, Italy

When Kirchner designated the early works of the Brücke as "monumental Impressionism," he doubtless meant that a new generation was seeking to master their visual impressions in a wholly new way, no longer by merely depicting what they saw, but by intensifying it into a pictorial organism determined by color. To compare that early phase with Fauvism, as is often done, leads to error. There were later contacts between German and French artists, between Kirchner and Matisse for instance, about 1906–7 when the Brücke painters were first taking up their radical artistic positions, but the Fauves, for all their daring, remained firmly implanted in the soil of French tradition.

Heckel's painting of 1907 inevitably brings to mind Pechstein's *River Landscape* we have just seen. There is the same driving force behind them; in both, the artists aimed to use the subject merely as tinderbox, so to speak, and then stake everything on an unrestrained use of color—color as material in itself, an as yet undirected force, a dynamic element capable of plunging the surface of a canvas into seething excitement.

None of this meant that color as yet had any expressive quality in itself. Its first role was purely material, with no implication of symbolism, and without the wealth of expression that was to constitute its special function in later Expressionism. Its sensuous value still outweighed all intellectual effect; the sheer intensity of color values was still so great that it hindered the development of more sensitive harmonies: painting was felt to be a physical act, a revolutionary action, and the artist saw himself as a modern primitive.

But this is already a program. Such an unlimited frenzy, as many pictures wish to make us believe, may have been the product of an excess of unutilized forces, of an initial lack of direction within a general notion of going somewhere. Yet the pictures of Heckel and Kirchner in that period do show one thing: return to the primitive, shattering of form, intoxication with color were not simply consequences of being unbridled, uncontrolled, inexperienced—although certainly such moments also played their part—but expressed a deliberate stand against tradition, and aimed at art as symbol of revolt against authoritarian systems of value. The whole point was to break down the subject by means of activized color, by brushwork at fever pitch, and by a dramatic conception in such a way as to make the viewer, once he hit on the key to the picture, immediately perceive its *modus procedendi* (what Hartung called later "the painting of painting"), and thereby fall into a state of ecstasy comparable to that of the painter: the first step, therefore, toward Expressionism.

No traditional hierarchy of values could stand up against that impetus, any more than the furiously wrought-up use of color could be explained by academic logic. The very way of painting was meant to be provocative and shocking, a picture to be no longer felt as a final product but rather as a moment of heightened consciousness. Archaic art was evoked along with the primeval forces that the artists claimed to recognize in the art of primitive Africa and the South Seas as seen in the Dresden ethnological museum.

Nevertheless—unconsciously and perhaps even unintentionally—in the excesses of these first years the groundwork was laid for everything that followed. Composition as such was not aimed at but grew almost intuitively out of the artists' feeling for harmonies and contrasts, for the value and effect of harmony and dissonance.

This painting sums up that step in development. Not only does it attest to youthful excesses, but it demonstrates at the same time the onset of a new awareness, the mastery of the problems of painting that would soon become a primary concern. Certainly this came about only gradually. There were often more steps backward for every bold one into unexplored territory. But gradually strength took the place of radicalism, intensity that of wildness, sensitivity that of the overt scream. So too in this picture.

To Pechstein's temperamental lack of restraint Heckel opposed a well-directed dynamism that permeated the entire pictorial surface. The subject here, a brickyard, is still pretty much a pretext, but the way the young painter worked out his visual impression speaks of thoughtfulness and the will to shape a form.

With the power of a train shooting out of a station, the chain of buildings surges out of the depth into the foreground. The brushwork supports the rushing impetus, transforming the foreground into a swift current that sweeps the color mass along with it. The flaming sky coruscates in the refractions of the colors—again primary—but its own upward movement cannot arrest the great surge out of the depths. The basic complementary contrast of red to green sets the keynote. The other contrasts, such as those of warm and cold blue against red and of yellow against green, tend to take a somewhat second place. Part of the strength of the impetus of the form is drawn from the way the heavy paint is laid on. Color as matter sets up its own dynamic statutes, and Heckel clearly strove to bring those into play at the same time as the tensions between the colors themselves. That the picture never gets out of control, as did so many others from this period, and that it strikes us today as a masterwork of that initial revolutionary phase of a dawning Expressionism, is due to Heckel's sensitive feeling for the possibilities of his means. In the next years he would exploit these possibilities without pushing them beyond what they could do.

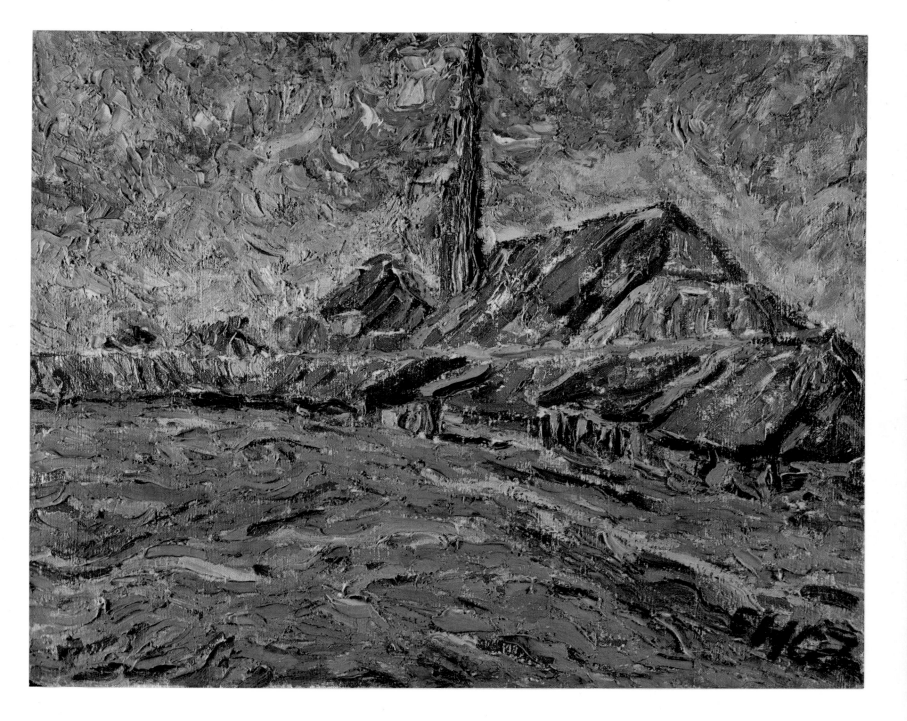

10. MAX PECHSTEIN (1881–1955)

Dance

c. 1910. Oil on canvas, 37 3/8 × 47 1/4"
Collection Max K. Pechstein, Hamburg

In 1909 the Berlin Secession accepted three works by Max Pechstein and one was even sold: "I was the first among my Brücke comrades to reach that goal," he could boast with understandable pride.

Pechstein was already living in Berlin at the time, although without losing his ties with his Dresden friends. In 1910 he visited Heckel and Schmidt-Rottluff in their favorite workplace at Dangast on the Jade Bay off the North Sea, and in autumn of the same year he went with Heckel and Kirchner to the Moritzburg lakes. But he could not repeat his success of the previous year, and the Secession turned down everything he submitted. As an open challenge to the old organization, Pechstein and other *refusés* organized the New Secession. Nolde too, through his famous quarrel with the president of the Secession, Max Liebermann, had become involved in the conflict between two generations. The young Expressionists took up cudgels against the Establishment artists who, in this case, as representatives of the so-called German Impressionism, were themselves still being damned as avant-gardists by the general public.

Pechstein was able to enlist the other painters of the Brücke as comrades-in-arms in the New Secession. Others who were like-minded joined, and through it contact was made with the Blaue Reiter group in Munich.

For all their agreement on the right path and the goal, from about 1910 on the individuals within the Brücke can no longer be overlooked. Although all were agreed on an experimental approach in the first years of revolt, a personal style soon became evident that could not be confused.

From the start of his membership in the Brücke Pechstein showed himself more interested than his friends in what was going on elsewhere. He had been in Rome and Paris and had kept his eyes open to everything that might be useful to his own art whose essential goal began to deviate from what we can call classical Expressionism. Although the initial unconcerned expressivity of his painting did not end up in any self-stylization as "wild man," he still aimed at elevating artistic violence into an imperative or at placing his art entirely at the service of a rather overdone desire for expression and communication. Without giving up the Expressionist vocabulary, he sought to translate it back into the purely objective. In so doing, he arrived at the particular pictorial quality, both exotic and decorative, so characteristic of his work. He avoided the hazards of violent innovations, an often fatal aggressive monumentality, and the danger of uncontrolled emotional expression. His point of departure remained the external world with all its differences, and he contented himself with translating it into the two-dimensional world of the picture surface.

Around 1910 he too tended to pull his forms together, to articulate the composition in color-rhythms, and to get beyond the use of paint as pure material. His works mirror the vitality of a man who experienced the world sensuously, who insisted on understanding it not as a symbol but as an intensified present.

The *Dance* of 1910 documents that situation very clearly. If one compares it with the frenzy of Nolde's *Wildly Dancing Children*, the powerful masses of color of Schmidt-Rottluff's Dangast paintings (colorplate 11), or Kirchner's works that are Fauvelike in color but also fraught with a deeper psychology (Frontispiece), the differences we have been stressing become evident. The picture looks like a solid stage set in which the two women perform. The background is not merely sketched in as so often elsewhere, but is laid out with details, though in their vivid diversity the colors and forms are carefully bound to the surface. The somewhat crude clumsiness of the dancers, and the face and figure of the one at the right, reveal the influence of exoticism but only as a formal garnish.

The horizontal oscillations of the lines of the figures' movements are more static than dynamic in effect, especially since they are countered by vertical color structures in the background intended to block the dramatic excesses so frequent in Expressionist images of dancers. In his use of color Pechstein went back to the tried-and-true recipes: complementary color tensions whose intensity is further exacerbated by simultaneous contrasts. That aim is fulfilled in the left dancer by the black outlining that serves also to make her bright yellow modulated surfaces stand out from the background. The red line of the belt not only takes up the tonal level of the floor but also carries the eye to the right figure with its similar modulations in color: the bright red of her stockings contrasts with the dark tonality of the knickers, which are decoratively enlivened by wavy lines of yellow. The color of the floor has a kind of mediatory function as a ground against which the color scale can unfold. Spatial illusion and even effects of shadow are retained and testify to the picture's origin in real visual experience.

The *Dance* confirms what we have said: Pechstein steered clear of the perils of an uninhibited use of color. Refractions and gradations of color keep it from the intensity found around this time in the work of Nolde as well as of Kirchner, Heckel, and Schmidt-Rottluff. Pechstein's personal climate is temperate, and his dance picture illustrates an action rather than symbolizes a state of passionate intoxication.

This helps to explain why his works won the approval of the public while those of his fellow-fighters in the Brücke did not, and, conversely, why they were received with a certain skepticism by the advocates of an ecstatic Expressionism. The wish to sublimate an impassioned, expressive style by painterly means was, in any case, a proposition that, as we know today, could be brought about only with the greatest difficulty, given the psychological basis of Expressionism.

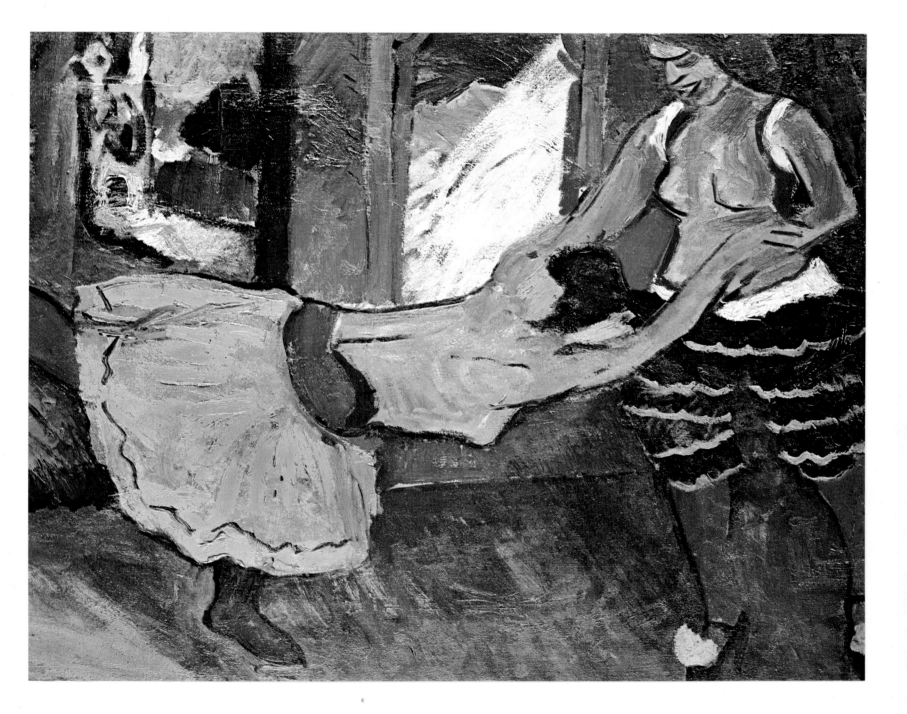

11. KARL SCHMIDT-ROTTLUFF (1884–1976)

Estate in Dangast (Gramberg Houses)

1910. Oil on canvas, 34 × 37 1/4"
Staatliche Museen Preussischer Kulturbesitz, Nationalgalerie,
Berlin

"The brisk air of the North Sea brought forth a monumental Impressionism, especially in Schmidt-Rottluff," wrote Kirchner in his chronicle of the Brücke, with specific reference to the works produced by that artist during repeated sojourns in the small fishing village Dangast on the North Sea.

Heckel later made much of the great pleasure the young painters took in escaping from the confines of the city, in the loneliness of the countryside, and in the simple, uncomplicated life among peasants and fishermen. But one should not expect to find romantic sensitivity to nature in Schmidt-Rottluff, nor to take from his work any sort of blissful delight in nature or feeling of the cosmos such as is found elsewhere in Expressionism. A very different spirit speaks from his turbulent works of this time: a spirit of audacity and refusal of all preconceptions, a contempt for tradition, a passion for everything elemental. A special relationship to color was beginning to impose itself as the dominant factor in his pictures, and a lack of concern with everything not directly aiming at an effect of monumentality. Kirchner's slogan of "monumental Impressionism" pinpoints the difference between Schmidt-Rottluff and his friends of the Brücke, and Pechstein meant much the same in speaking of the painter's "overwhelming power" and of how difficult it was to come close to him.

Intensity of color is not something one associates with the grim coasts of the North Sea. Nor could nature be the source for the monumental and unbroken color sonorities used in this painting. True, there is still a connection with something seen and the subject still determines the form of the composition. But the painter negates all true-to-life representation, does not portray objective reality, but makes it his own in a violent process of transformation that ends in a stupendous explosion of color whose meaning lies solely in the insistence on its own value.

This relationship to color with all its vast potentiality had already appeared in his earlier works and remained decisive for what followed. He was very much tied to the outward effect of color, and it was some time, and not in the same measure as with Kirchner or Heckel, before color became for him a psychological, expressive means.

Works like this reveal their origin in pure instinct—the fount relied on also by Nolde, whom Schmidt-Rottluff visited on the island of Alsen. Yet for all his unconcern with such matters, he soon ran headlong into the problem of dealing with the inherent rules that must govern color if it is to remain of any use pictorially. It was his mistakes that made him aware of those rules: at the outset he was incapable of combining color values into a closed pictorial form and thereby into what is ultimately an aesthetic value. This painting shows that critical phase of the development when the Expressionists came to understand a picture as a new organizational form compounded of color value and color form, a point at which the revolutionary, initial phase of Expressionism ended, and its art drew closer to its first period of maturity.

Here Schmidt-Rottluff did not rule out the traditional means of perspective and illusionistic pictorial space, but exploited them crassly. He resorted to sharp foreshortenings, as in the house at the left and in the alignment of the other houses, as a way of imposing forcibly an emphatic effect of depth, and this out of the need to provide some balance to the color he was now using untraditionally in relationships of such disconcerting directness that they no longer demonstrate anything but that color has an independent life of its own.

Nuances or gradated tonal values simply do not exist. No color is too brilliant, no contrast too harsh to be used. Such rudimentariness and monumentality exclude sensitivity and renounce the decorative organization that Fauvism still offered. Not subtlety shapes the picture, but blunt power from contrasts that clash with each other or are worked into hitherto unknown chords.

The picture lives on fever-pitch tension. Warm and cold zones (red and blue, blue and yellow) are wedged into each other. From them arise spatial tensions as well: a red that pushes forward, a blue suggestive of depth forced to the fore. A broad, warm yellow holds its own behind the dramatic foreground, and its warmth is heightened further by its harmonic relation to the red and its refraction to orange, the latter at the same time serving as complementary contrast to the blue in the same way as the green to the red. As was usual with this artist, the objects depicted are articulated by outlining, which, however, is not carried through consistently. The light value of the colors, their intensity, is relatively equal and is in opposition to the spatial effects achieved through perspective and color. Tensions wherever one looks. Such dovetailing of color values and the solved and unsolved problems arising from it creates forcibly even greater drama. The painter made little of textural values, simply spreading on his paint flatly and thinly. Devoid of any psychological feeling, the picture expresses the unconditional autonomy of color: elementariness as a direct, not an intellectual, solution.

Faced with such uncompromising works, the public was slow to take interest in their artist. Today, their great worth is as examples of the transitional style in which the subject was translated into a pictorial conception without any intellectual attempt to solve the inherent problems. This style marked the end of the revolutionary phase of Expressionism.

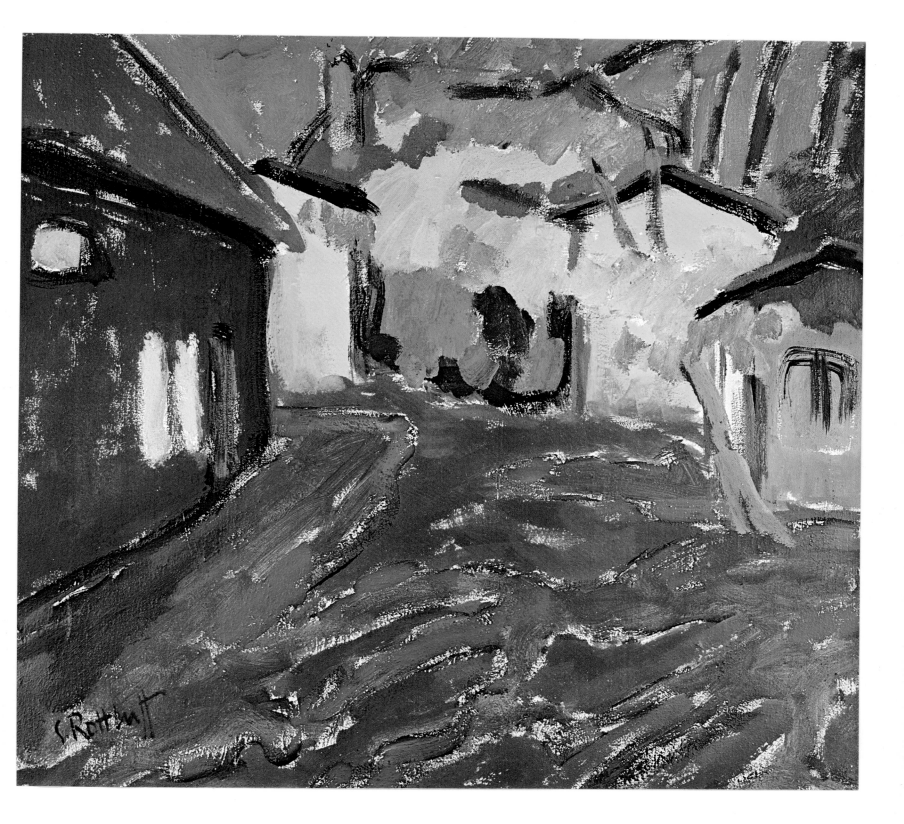

12. ERNST LUDWIG KIRCHNER (1880–1938)

Fränzi in a Carved Chair

1910. Oil on canvas, 27 3/4 × 19 5/8''
Collection Thyssen-Bornemisza, Lugano-Castagnola

Here we have one of the earliest artistic high points of the Expressionism of the Brücke group in its Dresden phase, when its members were walking on air with the excitement of ideas from French Fauvism and the first clear signs that they themselves could stand on their own feet. The subject is Fränzi, an orphan between ten and twelve years old, who with her sister Marcella was a frequent and fond guest in the Brücke studio. Both girls are familiar to us as models in a number of pictures.

Kirchner depicted the child rigorously *en face*, but shifted from the center of the picture to the left so as to instill the scene with a certain tension. Her face is not so much that of a child sitting for her portrait, or even of a roguish youngster as in the works of other painters, as that of a girl burdened with care and experienced beyond her years. The color alone suggests this: out of an intensely green face stare eyes made prominent by a deep black and set into a strong red that, though repeated at several other points in the picture, climaxes in the exaggerated lips. The hair changes color, black going through green to ochre. All in all, it is a highly unconventional and decidedly unrealistic juxtaposition that has little to do with visible reality. In opposition to what goes on in the front, the background is relatively quiet. It is broadly brushed in, painted in markedly flat zones, and the painter took such special pains to prevent the colors from flowing into each other that unpainted canvas can be seen as narrow strips between them. The colored forms at the upper margin must come either from a batik hanging that Kirchner had made or from the wall paintings with which the painters of the Brücke had decorated their studio walls.

If the girl's face is masklike, it is certainly because the artist wanted it so since he did everything possible to intensify the effect of alienation. One aid is the anthropomorphic, high-backed chair on which she sits. Although its "head" repeats hers, its broad, rectangular shape makes a marked contrast with the oval of her head and throws a frame of salmon pink around her. The values seem inverted: Fränzi looks like an exotic mask, the chair like something human despite the exaggeration in the color of the hair and skin. The chair plays such an important part in the composition of the picture that one might think it is something the artist dreamed up for the occasion. However, from an interview of Kirchner's biographer D. E. Gordon with Heckel, it appears that Kirchner had carved it himself in the winter of 1908–9. Moreover, it was the first piece of the extensive studio furnishings they made for themselves to be influenced by the so-called primitive art of Africa and the South Seas. If we recall the lasting impact that the cult work of "primitive" peoples made on the Expressionists, the chair no longer seems so bizarre. The young painters repeatedly carved Negroid sculptures, not to copy prototypes, but to experi-

ence for themselves their inherent archaic qualities through a personal process of evocation. As research has shown, the painting must date from 1910, thus two years later than the date the painter himself gave later. It reveals the very spontaneous method that Kirchner developed around 1909, which enabled him to paint a surface quickly but with more sparing means than before and, especially, with a reduced emphasis on paint as such. For him as for his friends, it was important not to allow the swift realization of pictorial ideas to be slowed down by a tedious, traditional process but, instead, to be able to dash them on the canvas just as they came to mind. Broadly laid-on paint filling the surfaces with a basic color was an obvious aid in this and could be done by liberal use of paint thinners, turpentine in particular. This was a method Kirchner took over from Heckel, who had already exploited it during his Italian travels, and which Schmidt-Rottluff was also to use a little later.

Yet Kirchner's paintings of 1910 no longer had the immediacy of those done earlier. One senses that he was not trying to paint spontaneously something experienced but, instead, was considering the rapid process of painting as an intellectual challenge.

This picture is a borderline case. It is still within the sphere of influence of French Fauvism and its leading master, Matisse, yet its colors seem a mere decorative surface ornament thanks to their uniform intensity. Kirchner did not attain the pictorial formula of high aesthetic perfection championed by Matisse, but he deliberately rejected it. As a result, he makes us conscious not of the effort at methodical organization, as do the Fauves, but of an imperious insistence on communication that speaks from the psychological depths of the picture. This is sparked by the elementary tensions between colors that are overly sharp and have an intensified hue, thereby counteracting the purely decorative use of paint and, instead, setting the pictorial surface into expressive vibration. Here is already the Expressionists' idea of the potential expressive power of forms and surfaces that are simplified or else ecstatically charged, and, along with this, their belief in the painter's capacity to liberate forces from the ensemble of color that can depict the subject not only by its form but also psychologically, to create something passionate, unbridled, often even violent in human expression.

If Fränzi looks so very strange, unchildlike, and more experienced than her years, and if Kirchner stylized her face into a colored mask and brought into play strong tensions in color along with an arsenal of forms pregnant with implications and meaning, this tells us that the period of authentic Expressionism had begun. Its high point, however, would be reached not in Dresden, but in Berlin, to which the Brücke painters had moved.

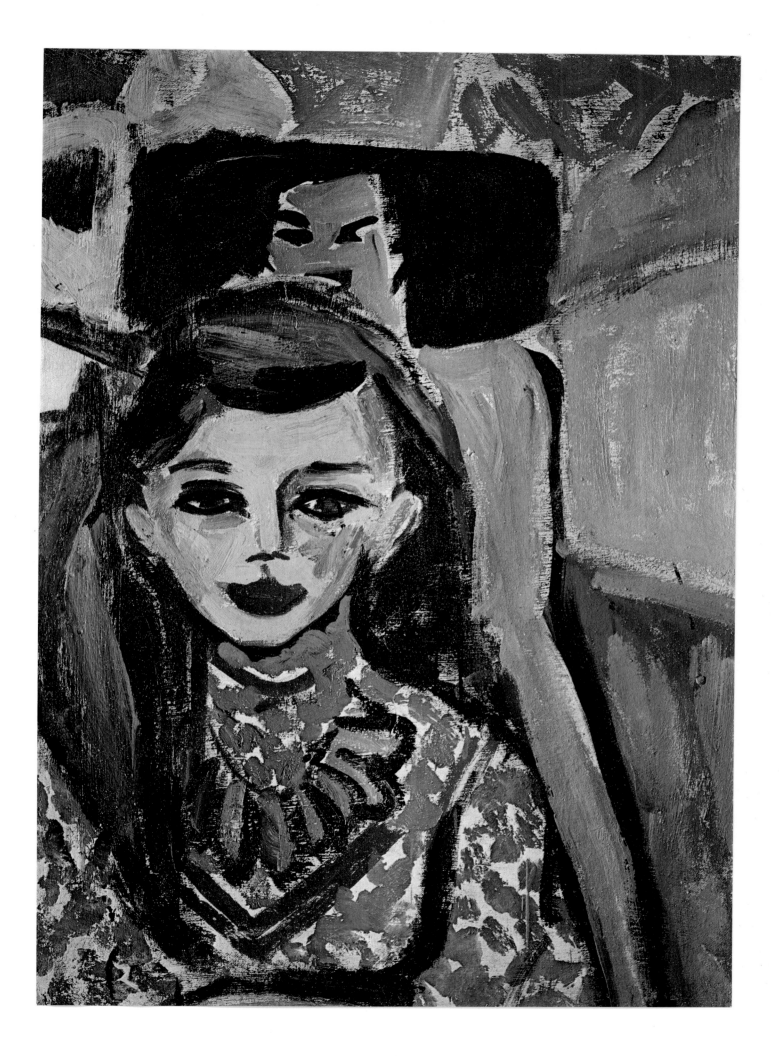

13. KARL SCHMIDT-ROTTLUFF (1884–1976)

St. Peter's Tower, Hamburg

1912. Oil on canvas, 33 1/8 × 29 7/8"
Private collection

The *Estate in Dangast* of 1910 (colorplate 11) showed Schmidt-Rottluff striving to use color to shape his forms and demonstrated how the visible object could in that way be filtered into a monumental extract of nature. To make color psychologically effective still was beyond the grasp of the young painter. Fascinated by their intensity, he used colors as values in themselves and inevitably reached the limits of what he could control. Not sovereign skill, but confidence in his own abilities and in the irresistible effects of that kind of color explosion set the tone for his works. But these works also show how hard the young Expressionists were trying to arrive, by way of such unmethodical impulsions as inspiration, frenzy, or emotion, at a pictorial order that presupposed a conscious pictorial treatment.

That Schmidt-Rottluff in his *Estate* nonetheless had struck the right course is proved by the works of the next years, including *St. Peter's Tower, Hamburg*. Here vague notions have become conscious principles, emotion becomes form.

It is among this painter's few city pictures. He was living in Berlin at the time, but his work shows few traces of the hectic life and activity in the metropolis that swept his companions of the Brücke into its whirl, in their art as in their lives, and even had a deep fascination for so inveterate a North German as Nolde. Concentrating on his own problems, he limited himself in architectural subjects mostly to separate large buildings, houses, a tower which, brought sharply into the foreground, signify less depictions of something seen than demonstrations of his personal conceptions.

Thus this *St. Peter's Tower* may be identifiable as architecture, but it is not in any sense a "view." The artist had seen the church during a visit to Hamburg, the city where he found his first patrons and admirers (still all too few). His interest was not in the architectural style, but in the tower in itself, a steep spire bursting with dynamism, which zooms to the very top of the canvas and thereby rips open the background, while the sky replies with a parallel, gleaming, night-blue wedge.

The time of day mostly plays no role in such pictures. They are not reminiscences of particular hours, but events beyond time, monuments whose elementals aim at something universal. Here, though, it is nighttime: if nothing else, there are the two spheres of color one recognizes as lamps even if they are not conventional light sources. What pictorial light there is comes from the colors themselves and has nothing to do with problems of illumination.

A few rigorously simplified house forms make a contrapuntal accompaniment to the accent of the tower, which the painter shifted well off the middle axis to heighten the surface tensions even more. Symmetry as organizational principle is replaced by problems of equilibrium and of distribution of color masses within the surface plane according to their respective weights. Here, too, perspective is nonexistent. Depth is suggested only by the spatial value of the colors, which are so used as to offer an almost "natural" aspect: blue as both sky and background.

Heavy, blackish-brown outlines surround the separate color surfaces, and their contrast serves to increase the color intensity —a not very subtle, but remarkably effective, device often used by Nolde also. The course of the outlines and the rather angular color refractions may remotely suggest French Cubism, which was having its impact on all the Brücke painters at the time, though, as we have seen, only as a formal garnishing. More influential seems to have been woodcut engraving, which always played an important role in Schmidt-Rottluff's work (fig. 51). It was in that medium that he first tested out the play of highly contrasting surfaces and the effect of contours in inducing tension that he subsequently translated into paint. Here they underscore the blunt forcefulness of the vigorously reduced forms that even Munch found alarming.

The color is held in an equilibrium of contrasts full of tension. Again, complementary values are immediately juxtaposed, and all the intensifying possibilities of the limited color scale are exploited. And yet, for all the unleashed power, there is an element of thoughtfulness and an attempt at reconciling conflicts. Through its yellow refractions the green becomes more related to the red and only shifts toward a blue-toned coolness in the point of the spire. Yellow and red work together harmoniously, and there is a balancing factor in a warm and deep brown varied by tones of ochre. By these means the process of release of energy is softened and harmonized. Something new has been arrived at: contrasts and even dissonances can in fact be smoothed into harmony and effectively incorporated into a pictorial whole. The image is no longer a symbol of the ultimate in tension and release, it takes its place as organizational form in the very core of artistic concern.

Painting that is still so harsh and uncompromising can scarcely be called unpsychological. Schmidt-Rottluff simply eluded that great emphasis on feeling characteristic of one part of Expressionism, and in so doing arrived at a use of color that is strong in expression but poor in information. This distinguishes him from painters such as Heckel or Kirchner, and underscores the distance between one personality and another that finally led to the breakup of their association.

Yet both ways are Expressionist. Indeed, one must concede that in the works of this period Schmidt-Rottluff not only grasped the potentialities of the new style that was beginning to take shape, but he also exploited them to the limits inherent in it. The proof lies in the impact of these works still today on the viewer.

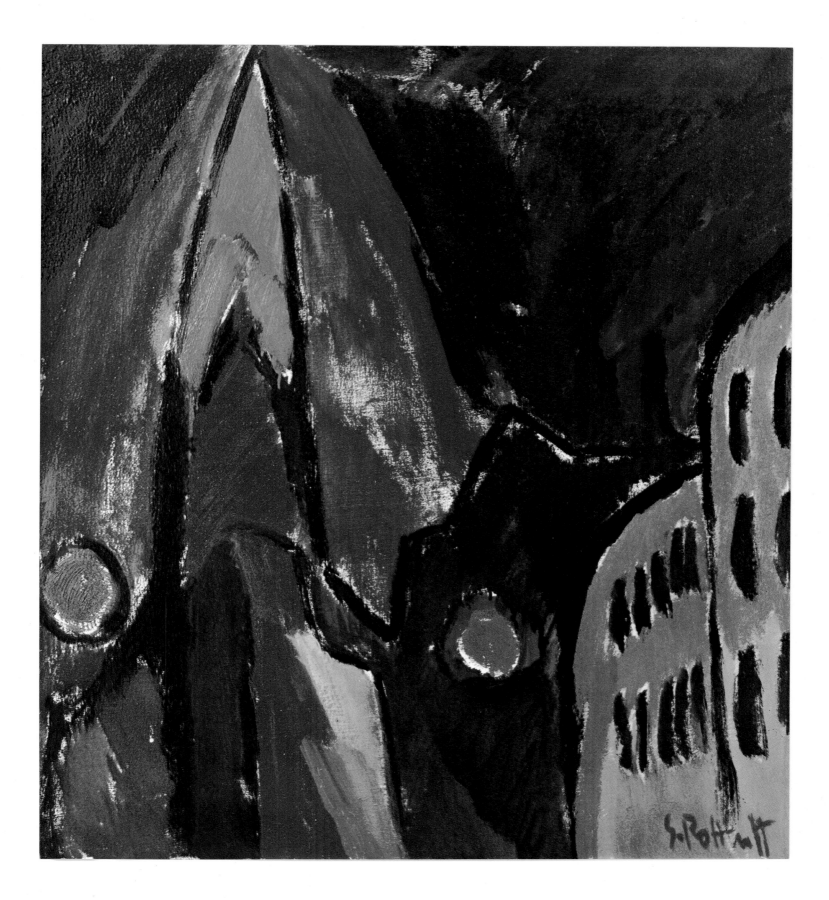

14. ERNST LUDWIG KIRCHNER (1880–1938)

Red Tower in Halle

1915. Oil on canvas, 47 1/4 × 35 7/8″
Museum Folkwang, Essen

It is in the nature of Expressionist art that its strongest manifestations not only reflect the human commitment of the artist but also—and as a consequence—take on the character of self-portraits. This is true of Kirchner, especially of the works done after 1914, where his own profound personal crisis left its imprint. This crisis was already implicit in the paintings done in Berlin between 1912 and 1914, during one of the most productive periods of his art (Frontispiece).

It was then that Kirchner raised his painting to an extraordinary pitch of communicativeness. The great city with its riffraff, its hectic hurry, and its monstrosity became a symbol for the human condition of an entire generation, for the impending collapse of seemingly firmly established social orders, the destruction of traditional conceptions of value, even for the increasingly more critical situation of the painter himself.

The outbreak of the war and military conscription did not precipitate his crisis but helped unleash it. The loss of spiritual equilibrium, his inability to solve the conflicts of the time and of his own life through art, led the already unstable artist to the brink of collapse: the well-known *The Drinker (Self-Portrait)* of 1915 shows how far the artist had by then lost control over himself (fig. 19). After an extended stay in a sanatorium in the Taunus Mountains, he moved to Davos in 1917 still seeking a cure. Only there did the long slow process of recovery finally begin which, in his grandiose Swiss mountain landscape paintings, brought in a new artistic era now no longer Expressionist in purport.

Thus, after the start of the war, he produced relatively few, although important, works. In 1915 there was a brief, almost feverishly hectic period of creation: besides the self-portrait as drinker and another as soldier, he did a cityscape, this *Red Tower in Halle*, a masterly work still linked with those of the Berlin period but already of an unmistakably different character.

The painting goes back to a pen drawing done at the start of 1915 when Kirchner was a soldier in Halle. Thus it was painted from memory and was therefore open to all the burden of feeling with which the painter, a sick and already doomed man, encountered the world around him. Compared with the temperament of the Berlin pictures, at first glance it seems almost conventionally stiff. Further acquaintance reveals that the seeming repose of the outward forms is a lie, that it masks only with the greatest effort the inner tensions expressed in the composition and use of color.

The subject is clear: it shows the so-called Red Tower, a free-standing Late-Gothic bell tower with its Neo-Gothic brick base, which with the Market Church and cathedral (visible in the left background) is one of the landmarks of Halle. Like a giant, it rises out of the depths of a market square entirely devoid of human beings: the first of Kirchner's city pictures entirely without a living creature, unless one wants to count as such the diminutive streetcar. The tower is viewed from an unusually high standpoint, almost a bird's-eye perspective, and the impression is reinforced by the foreground, which seems to plunge down precipitously before the viewer: a moment of instability powerfully stemmed by the edifice itself. The perspective is so laid out as to presuppose another viewing point than that of the person looking at the picture, but this comes about precisely because of the unusual spatial construction of the central position of the tower, whose tip is almost at our eye level. This explains D. E. Gordon's notion that such a viewing point is only possible from the top of the tower, and so the artist does not leave us viewing his picture at its border, but bodily transplants us into the middle of it. Yet for all the emphatic spatial contrast, the depiction is not without points of rest. When looking for principles of organization, one quickly recognizes that at the basis of the composition are the rhomboid shapes of the tower base and the lurid red streets, a schema that Kirchner had already used in a number of pictures. What is striking here is that such a basic ground plan corresponds to the marked geometry of all the house forms with their sharp angles and corners. The tension may be concentrated in the center, but is reflected and intensified on all sides: a daring principle.

The color takes up this same vein. The overall effect is cold, and it is further stressed by the greenish-blue and violet tones of the sky, while the tower itself remains uninvitingly dark. In crude contrast is the flaming vermilion of the base and of the streets streaming across the foreground like forceful lines. In both cases, the colors have no direct connection with the object depicted and are explainable only in the overall context of the composition.

The picture aims at hardness and coldness as principles of a lifeless, antihuman world. The emptiness of this cityscape evokes isolation and loss in almost Surrealist fashion. Gordon's question as to whether this might not be a night picture seems off the point, since Kirchner was clearly concerned with something other than a view of a city at some particular time of day. It is clear that colors and construction were decided on in genuinely Expressionistic manner, as aids of communicating the existential plight of mankind and of the artist himself. Thus an almost ghostlike isolation in the midst of the evidence of a great past: the picture as metaphor.

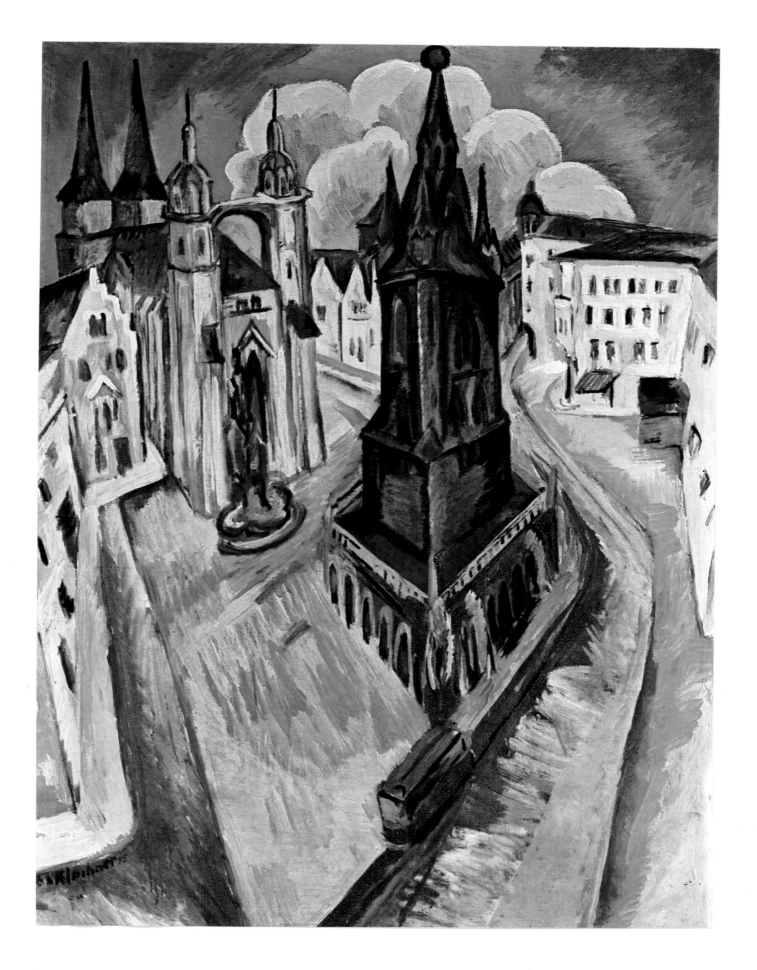

15. ERICH HECKEL (1883–1970)

Spring in Flanders

1916. Oil on canvas, 32 1/2 × 38 1/8″
Städtisches Karl-Ernst-Osthaus-Museum, Hagen

Brücke Expressionism reached its high point in Berlin between 1910–11 and the outbreak of World War I. The breakup of the group in 1913 changed nothing, because from the time its members began to win prestige on the art scene, a process of maturing that had begun some time back, it had increasingly served no real function. The works of this period offered the ultimate proof that the overemphasis on form and, in consequence, the world of appearances characteristic of early Expressionism were no longer enough to provoke a direct reaction. Only the "inner image" summoned up within the artist by the visible world, the vision that took fire from a subject, "the experience, not the thing" could generate "psychograms" of extreme expressivity in which painting would become the vehicle of spiritual distress, form the means of speaking aloud secrets drawn from the depths of the human psyche. Thenceforth the way would no longer proceed by destruction of form but directly from the idea.

The tension-laden situation immediately before the war had its part in making Expressionism appear as something necessary in the unceasing conflict between man and world: the hectic and unnatural life in great cities was diverting the artists' gaze from romantic swooning over nature to the true problems of living, to what was sick and evil, to eroticism and the crisis in human relations, to the bright but even more the dark sides of existence. And these inspired the artists of the time to grasp at symbols of such allegorical power that their works could define and give voice to the existential dilemma of their generation.

From the standpoint of form, Heckel's work just before the war shows the usual influences that go back to a brief contact with French Cubism. As once before when they came to terms with Fauvism, what interested the German painters in those prototypes was neither their rigorous logic nor their constructional principles. The French ideas merely enriched the pictorial vocabulary: objects were given crystalline structures by a facetlike breakup of their contours, landscape and architecture in particular became pithier and more powerful through simplification and geometrization. Heckel, moreover, was inclined less to Picasso or Braque than to Delaunay, whose Orphic Cubism he had encountered in Herwarth Walden's famous Autumn Salon of 1913, and whose usefulness to himself he had promptly explored. It was not, however, the Orphic use of color that he took over, but the Cubist form, which he identified with the refractions of natural light and which gave his pictures of that time their luminous power and great transparency.

The war put a stop to this felicitous and, on the whole, untroubled period of activity. In terms of the development of Expressionism, though, it must also be seen as an interruption of another kind: once the artist came face to face with the grimmest reality, all the earlier Expressionist pathos faded into the background. Now for the first time it became a matter of seeing if art could master lacerating tensions, if the power of the pictorial means could extend to expressing the inexpressible.

Little change in form was involved. Heckel brought into line with the new demands the artistic arsenal he had already built up. Form in any case was something that changed with changing psychological bases and was never for the Expressionists a pictorial value in itself. Essential still was the expressive function, though now with greater restraint than before.

It was above all the encounter with the high and broad Flemish flatlands and their unique light that left its deep traces on Heckel's work. Depictions of seen things appeared alongside outbursts mirroring the horrors of an apocalyptic world. Even landscapes, always a favorite theme with Heckel, no longer arose from direct observation of nature, although he studied it. The painter now understood painting as the summation of human and artistic experience in a picture; as such, it was above all visual impressions.

These new maxims are borne out by this Flemish landscape of 1916, a work that in Heckel's oeuvre marks a new high point of Expressionist thinking and painting.

From high above, the eye roams across the hushed foreground into the far distances of the landscape. A canal at the right, a broad road at the left further emphasize this very particular insistence on depth and infuse it with a certain restlessness. But then the eye is stopped short. Clumps of brush, trees, houses block it like an island lying across the scene, their starkness and gloom seem doubly menacing in such otherwise quiet surroundings. Nothing speaks of war, yet war seems present everywhere.

Over the landscape is vaulted a dramatic sky with a center of lurid light that is surrounded by heavy rings of clouds shaped like roundheaded arches. The restrained color in the foreground is cool in effect, leaving the tension to culminate in the sky. Brightness and darkness impinge harshly on each other, cold and warm tones aggravate the contrast. One sees immediately that Heckel has fallen back on the symbolic, linguistic possibilities of his pictorial means. Menacing eruption, high tension, the gloom of the broken-up colors ultimately no longer reflect impressions of a landscape, but the feeling of oppression. *Spring in Flanders*—in 1916 that could still mean a glimmer of hope in the midst of horrors, a touch of brightness in the dark.

Beyond question, precisely in such a situation Expressionism again made itself felt as the approach that could communicate spiritual and psychological experience, the desperation of a threatened human existence. With nothing in itself hectic, without pathos, Heckel depicted all this as drama of deepest significance.

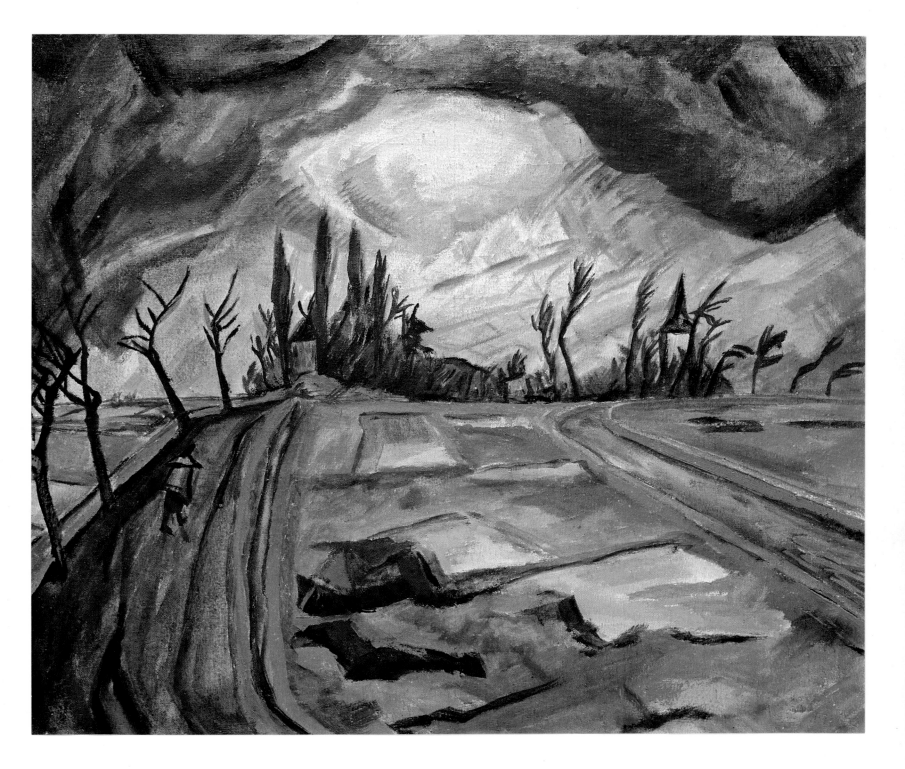

16. OTTO MUELLER (1874–1930)

Lovers

1919. Distemper on burlap, 41 3/4 × 31 1/2″
Collection Max Lütze, Hamburg

Otto Mueller's paintings tell no stories, are inactive: variations on a theme centered on the natural, unspoiled human being. From work to work he often merely changed the disposition of the figures, their movements, or accessories. He had nothing to do with the Expressionist emotionalism so important to the others, and yet he was an Expressionist: painter of lost paradises, of the indestructible innocence of man before the Fall. Today we know that that too was part and parcel of the Expressionist feeling for the world.

From the literature of the time we know that catchwords such as ''unspoiled nature'' and ''the original goodness of man'' repeatedly acted as stimuli for a nature worship heavily fraught with feeling. Implicit in it, as in German Romanticism, was the desire for a ''return'': a return to the archaic, to beginnings, to a time without care, to purity, the primeval experience and first creation, the pristine and immemorial—what in German is meant by the prefix *ur*—that the literati and artists had so frequently brandished like a torch over their own ecstasizing and wrought-up doings. The voyages to the South Seas and Africa that attracted all Expressionist painters, in fancy at least—here Gauguin was the symbol—were a part of that quest for the natural man in his original setting, still living in union with the world: the present surmounted through a romantic utopia. In that sense Pechstein's scenes from Palau and Nolde's South Seas pictures are parallels to the Saxon arcadias of Heckel or Kirchner in that man is shown to be part of a natural world—a sentimental notion only possible from the viewpoint of the intellectual and big-city dweller. This approach no longer has anything to do with Impressionism, since it accepted the objective existence of the present, metropolis and technology included. Its goal, instead, is that ''realm of peace in a utopian, exotic environment'' where all men, like the noble savage, can be left to their natural and therefore beneficent instincts. Seen thus, one understands what common ground united such very dissimilar artists as Marc, Heckel, Campendonk, and Mueller.

Precisely in the latter, whose paintings so often show lovers in nature, one is struck by the relatively slight significance of the erotic element. What he depicts is at first sight by no means innocent, as in these *Lovers* of 1919. While it shares with the ''cosmogonic Eros'' propagandized by Ludwig Klages the tendency to mystical rapture, here it does not come about by dissolving into ecstasy, in an embrace engulfing all heaven and earth, but in the harmony of a pristine earthly paradise. That theme is easy to read here. A youthful couple embraces with the simplest gestures. The figures are elongated, almost ''Gothic'' in their angularity and movement, and thereby quench whatever sexual provocation there might be in such close proximity of a clothed youth and a half-naked girl. Nor is there anything aggressive that might lend a note of greater tension to a scene like this. For all its seductiveness, what prevails is an indefinable passivity, a cautiousness typical of Mueller. With few exceptions, mostly in Nolde and Kirchner, Expressionism treated nudity as something natural and not as a provocation.

Verticals dominate the composition. They are taken up in the slats of the fence and reinforced by the trees in the background. The mat distemper is restricted to a few tones, variations of yellow and green with a bit of cool blue for contrast, while a brown darkly intensifies the warm yellow sonority.

Mueller never painted specific landscapes. In his pictures nature appears as symbol for solitude and remoteness from civilization, and therefore the setting needs no precise definition. A yellowish and consequently warmer green and a few merely indicated brushstrokes suffice to render foliage, bushes, and tree, with a touch of recessive blue for the sky or a lake: a summary formula for nature.

If his works nonetheless seem to have something of a parable about them, it is precisely because their colors and forms contain reality in disguise and therefore appear more valid than a direct citation of objects as such. From this stems the convincing, in his best works even alluring, oneness of nature and all living creatures: both from the same primeval source. Yet when the animating spark was missing, this identity eluded him, and in the unpretentious span of variation within his work he ran the risk of arid repetition. When, as was often the case, critics charged him with this he snapped back: ''People are too stupid—because one can simply vary a plant, for example, over and over again and give it ever new form, indeed, that it is even very much harder to remain interesting, is something they do not grasp and so believe that you are all washed up.''

Mueller was always a loner, even if he was one of the members of the Brücke who kept up his contacts with his friends after the group broke up. What distinguishes him from the other Expressionists is his closer dependence on nature, his reluctance to meddle with its shapes and colors for purely pictorial purposes. Not for him red trees or glowing blue or green nudes. Having a less exalted ego than his companions, he saw no necessity to subject the existing relation of tension between man and nature to the test of permanent laceration. His way was that of gentler tones, his goal a melancholy arcadia, the myth of a quiet happiness: an anachronism in that blaring decade, yet one thoroughly attune to true Expressionism.

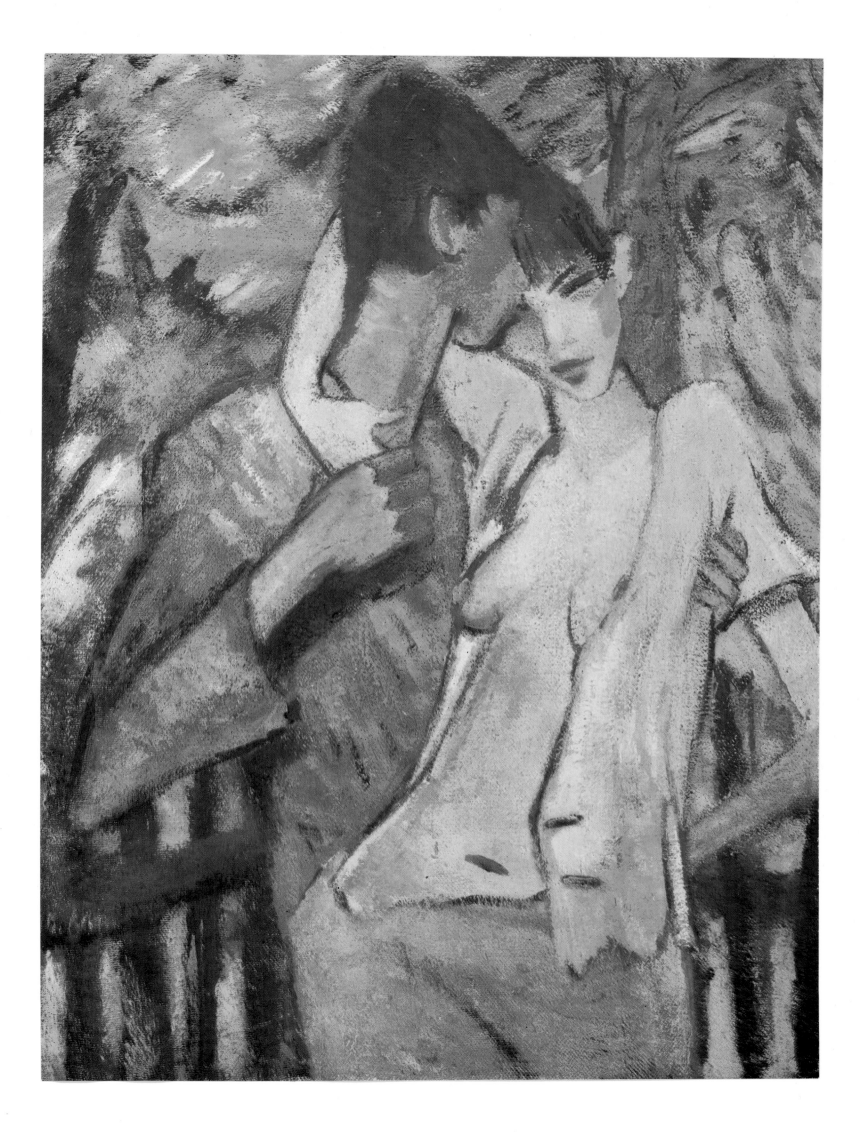

17. OTTO MUELLER (1874–1930)

Nude Girls Outdoors

c. 1920. Distemper on burlap, 33 7/8 × 43 3/4″
Von der Heydt-Museum, Wuppertal

Three girls or young women are lying in an uncultivated, wildly overgrown patch of nature. The rectangle of the picture format imposes a simple but rigorous compositional scheme on the figures. The one sitting at the right emphasizes the perpendicular with her torso, while the slightly oblique disposition of her lower body creates a feeling of spatial distance from the immediate foreground. The girl stretched across the background repeats the horizontal of the upper margin. The eye connects her feet with the head of the seated figure, and the contact of the two heads at the left makes a link with the midground figure seen from the rear, whose diagonal position in turn carries the pictorial rhythm back to the right-hand foreground figure: a closed form in which, for all its seeming looseness, nothing is left to chance, although that is the impression conveyed.

The viewer stands outside the scene. From a somewhat higher point one looks down on the three nudes, so closely linked and yet, despite the compositional bond, suggesting no human relationship, each appearing isolated in her own personality.

As always, Mueller was satisfied with a very summary depiction. Landscape is symbolized by a few broad brushstrokes of yellowish, warmer green. Here and there it partly conceals the bodies, embeds them, incorporates them into its own untroubled world, whose naturalness is expressly brought out by the exuberant vegetation. The nudes are not in a carefully tended park. A few accents in blue are distributed through the picture, suggesting in the background either sky or water—a question often left open by Mueller—and in the middle and foreground providing a few cool accents to enhance the warmth of the other colors.

The bodies are treated no less sketchily than the landscape. They represent the type of girlish figure Mueller favored and strike one not as individuals, but as embodiments of the human within a natural existence. Thus the painter could easily dispense with effects of light and shade, use the same color for all the bodies, and limit himself to contours that make the figures stand out from the luxuriant disorder of unspoiled nature.

Any question about illusionistic pictorial space must in this context be merely secondary. Certainly there is foreground and background, but no specific foreshortening or perspective foreshortening, and, as in most such cases, the landscape ground is very high, here almost to the upper edge of the picture, in some places even touching it. Delineated without any real substance, the figures do not give the effect of plastic volumes, and the very

limited space they lay claim to is contrived by dovetailing them obliquely into the picture surface; the forward and backward movement of the lines is enough to make the optical suggestion of space convincing to the eye. How little such problems bothered the artist can be seen at those sensitive points of the picture where individual forms or lines meet and intersect. Mueller sidestepped pictorially logical solutions, and the whole matter of these compositional points of contact is left up in the air: look at the lower body and legs of the figure sprawling at the left, and at the juncture of the two heads. If one accepts that approach of the artist and his sovereign disdain for compositional rules in accord with the Expressionist indifference to tradition and antipathy to academic teachings, there is no need to go into the question of anatomical correctness: the truth of the picture takes precedence over outer reality.

In this picture, too, we see how unequivocally Mueller's work brings out his individual, though also romantically tinged, expressive attitude toward the great All, toward the paradisiacal, the longed-for purity of everything natural: toward, as we know, utopia. These creatures disport themselves as natural beings, birth-naked, but for that very reason not erotic. That the artist identifies them with "youth" goes without saying in this general context. Such nudity carries no suggestion of discarded clothing, so the viewer does not feel as an uninvited observer or, worse, voyeur. Pictures like this have nothing to do with shame or sexual titillation. This comes chiefly from the fact that Mueller and most of the other Expressionists no longer painted their nudes in studios, but placed them in the midst of nature where they seem an integral part of the whole, not alien bodies. That quality is lost the moment one has a nude evidently undressed—as with Lovis Corinth—and posed on a sofa or some other piece of furniture, or embodying the well-known theme of the whore as symbol of a sick time and world. Expressionist painting made a distinction between these separate approaches. It is not the depiction in itself that arouses feelings; they are, instead, fixed on in advance through the artist's determination to express something specific—even when such an expression is often no more than an unrestrained scream.

And so in this painting these remote creatures act as symbols of hope and longing for great peace between all things created, in a time whose hidden goals already pointed in a different direction.

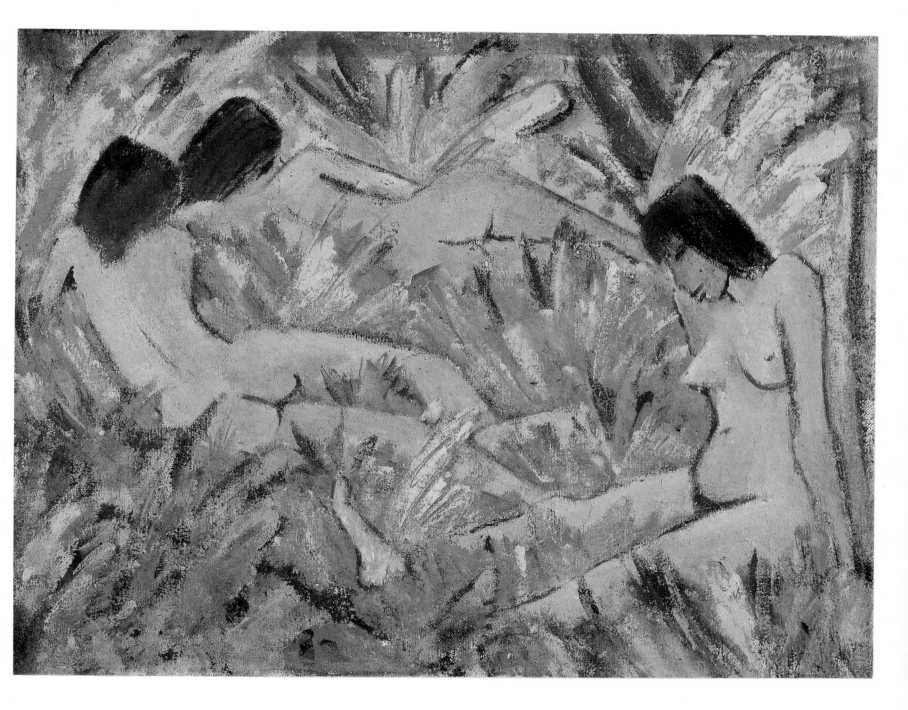

18. GABRIELE MÜNTER (1877–1962)

Courtyard with Laundry

1909. Oil on pasteboard, 17 3/4 × 13″
Private collection

The course of Gabriele Münter's life was decided by her meeting Wassily Kandinsky, in 1901, in the art school he had founded in Munich for the Phalanx group. It would be too much to say that she was caught up from the outset in the revolutionary, explosive force of the ideas of this outstanding artist. At that time Kandinsky, influenced by the Jugendstil, was painting romantic anecdotes, fairy tales rendered in a glowing, Eastern colorfulness. Perhaps that was what aroused the interest of this young woman of unsophisticated and naive sensibility, who, even later, never joined in his experiments or imitated them.

An overall view of her work shows that she arrived very early at the personal palette she was to cling to until the end, that "without grandiloquent intentions and free of provocatory self-assertion" (Roethel) she went her own quiet way. Certainly in her first years there was still some dependence on Kandinsky, but this was almost inevitable with pupil and teacher as well as with a couple who made their lives together until 1916. This holds especially for the impressionistic studies of the first years in which the young painter seems at times to have gone beyond her teacher. It was the natural bent of Gabriele Münter, in everything she did, to be entirely her own self and, true to her simple and clear nature, to remain within her own limits rather than plunge into spiritual problems virtually beyond solution, to act not as echo but as counterpole. In her art, she was in fact closer to Jawlensky than to Kandinsky—but precisely this triad left their unmistakable stamp on the Munich scene before the founding of the Blaue Reiter group.

In 1908 Gabriele Münter and Kandinsky visited Murnau for the first time, and the next year they took a small house there with a view, often painted, across the Moos to the southern Bavarian Alps. There, after years of wandering, she found peace. She now had a broad acquaintance with what the European art world in ferment had brought forth, and could set about translating these new stimuli into her own language.

Characteristically, she discovered and took to collecting Bavarian *Hinterglasmalerei*, folk paintings on glass that are simple in artistic means and naive in expression. Kandinsky subsequently published examples of these in *Der Blaue Reiter*, but ideas from such native sources were to become a constant in her own work.

Looking back to the first years in Murnau, Gabriele Münter later wrote:

"After a short period of torment I made a great step forward—from painting from nature, more or less impressionistically—to a feeling of content—to abstracting—to rendering something essential. . . . It was a beautiful, interesting, and happy time with lots of discussions about art. . . . I particularly liked to show my work to Jawlensky—for one thing he was ready to praise—generously—, and for another he explained many things to me. . . . Every one of the four of us worked hard and everyone made good progress."

In such a situation was this picture painted in 1909. Topical as it is, it takes its tone from personal feeling, not as an external landscape but as the expression of the simple and clear naturalness of its painter.

Although all the factual details can still be read, they are nonetheless already so recast into essentially pictorial form that depiction as such no longer appears to be the aim but merely the basis for freely modulated color harmonies that follow their own laws and so, forcibly, make real things larger or smaller, deformed or unexpectedly similar.

The basic compositional element is the color itself, straightforward and deep, perhaps a bit folkloristic in its debt to the local folk arts although, as actually used, very different. In its color sonority, it mirrors human warmth and joy, but its rigorously limited palette was obviously not intended to capture and reproduce the entire range of color of an impression of nature. Johannes Eichner tells us what colors were being used at the time: madder lake, cadmium red light, cadmium orange, cadmium yellow, viridian, oxide of chromium, Prussian blue, ultramarine, yellow ochre, raw Sienna, raw umber, ivory black, and zinc white—all powerful values that enabled Gabriele Münter to pursue the "synthesis" urged on her by Jawlensky, which meant going beyond the fortunate accidents of Impressionism through concentration of the multiplicity of nature into a larger, simpler pictorial conception. But this ruled out the spirituality of art—Kandinsky's ultimate goal and also one of the reasons why Jawlensky later declined to work with the Blaue Reiter group.

As to the question of influence from French Fauvism, certainly the general conception must be taken into account although it was neither imitated nor used as prototype. Gabriele Münter did not fall into line with any sort of preexisting rules. Her works were spontaneous and without ulterior concerns, and that was the way she made use of her pictorial means. A painting, therefore, did not signify the embodiment of an ideal—however that was to be accomplished—but a seemingly unpremeditated and effortless grasp of the visible, the expression of a sudden prompting without interference from the intellect, which played such a domineering role in her mentor Kandinsky.

In its rustic simplicity, Murnau—that brief pause for reflection before the explosive breakthrough to the revolutionary conceptions of the Blaue Reiter and to abstraction—was for both artists a felicitous interval when they were close in their work, as in their lives. For Gabriele Münter it meant even more: the breakthrough to her own artistic language.

19. ALEXEY VON JAWLENSKY (1864–1941)

Portrait of Resi

1909. Oil on cardboard, 31 1/2 × 21 5/8"
Private collection, Ghent

Around 1900 a colony of young Russians—Wassily Kandinsky, Marianne von Werefkin, the Burliuk brothers, Alexey von Jawlensky among others—settled in Munich and in the following years it was to be of great importance for the cultural climate of the Bavarian metropolis.

Jawlensky first came there in 1896 from St. Petersburg where, as an officer, he had attended Ilya Repin's painting classes. In an article about the "wild men" of Germany, published in *Der Blaue Reiter*, Franz Marc described the role of Jawlensky and Kandinsky in the founding of the New Artists' Association:

"In Munich, the first and only serious representatives of the new ideas were two Russians who had lived there for many years and had worked quietly until some Germans joined them. Along with the founding of the Association began those beautiful, strange exhibitions that drove critics to despair. . . . Later, the young Frenchmen and Russians who exhibited with them as guests proved a liberating influence. They stimulated thought, and people came to understand that art was concerned with the most profound matters, that renewal must not be merely formal but, in fact, a rebirth of thinking."

Like Kandinsky, Jawlensky had become acquainted with the new French art long before the New Artists' Association exhibitions. He was engrossed in the symbolic color resonances of Gauguin as well as the emotional tensions of Van Gogh whom he admired so greatly that in 1904, at great personal sacrifice, he acquired his *House of Père Pilon*. Jawlensky's works between 1904 and 1908 show him wrestling with the oeuvre of the great Dutch artist. But about 1907 the Fauves, Matisse in particular, exerted an ever more noticeable influence, and his attention shifted from the psychological tensions in color to the problem of the formal ordering and objective properties of pure color.

This shift in approach could not have happened without Cézanne's art and his idea that "when color is at its richest point, form too is at its fullest." This meant that the painted surface unifies itself and makes itself autonomous in an interweaving of colors independent of feeling, and while objective points of departure are retained, line and color fuse with each other.

Matisse had seized on this idea and made it accessible to the sensibility of his generation: a picture was appreciated as an autonomous entity; although it could take nature into consideration, it was not an imitation but a pictorial equivalent. As Matisse put it: "It is not possible for me to copy nature slavishly; I am compelled to interpret it and subordinate it to the spirit of the picture. Out of all my relationships between found tones, a living color harmony must result, a harmony analogous to that of a musical composition."

Such a conception made an extraordinary impression on the young Jawlensky: the picture not as interpreter of the relationship between man and world, but as equation, as organizational form. Herein lies the difference between the Expressionism of the Brücke painters—who at the time were influenced by the Fauves but, through them, were seeking their own world of expression and accepting that influence in terms of exterior forms only—and the efforts of the Munich artists around the New Artists' Association. But they likewise, especially as they were Russian, did not end up identifying with Fauvism. Besides, there remained some expressivity in their Eastern use of color which, despite the closeness to Matisse in other respects, retained its powers of suggestion.

Looking at this *Portrait of Resi* from the significant year of 1909 in terms of what has just been said, we see clearly all the personal accents that mark Jawlensky's dependence, but also his individuality.

The picture is painted as a purely organized surface, just as the French had urged. The paint and color web is dense, modulated, and rich in harmonic effects: flat areas of cool green tending to blue against modulations of red as principal accent, and between them, as contrast, a blue outline. The result is an elegant and precise order that takes in every detail and articulates them ornamentally on the surface. If the picture seems organized primarily around these pictorially decorative color-form arabesques, the colors nonetheless retain a decidedly Russian accent: their overemphasis and Eastern folkloristic timbre go well beyond the subject toward something naively emblematic. In this there was perhaps already a hint of that fervor and force that somewhat later would veer to the visionary and religious and produce something like a modern icon.

A further distinction between Matisse and Jawlensky at the time: set against the precious, decorative lightness of the Frenchman's compositions, the works of the Russian in their plainness seem a little ungainly, and the way the patches of color grow together into an orderly structure seems both forceful and emphatic. There is a breath of melancholy about it all, which masks the effort of the creative act, of the growing and ripening into a picture. One can understand why at this point in his development Jawlensky was deeply stirred by the way someone like Nolde used color, and although that artist's ecstatic outbursts remained alien to him, the two painters are akin in the deepest stratum of expressivity. Like his German colleagues, Jawlensky never arrived at, or even desired, a fully autonomous use of color, and his own developed midway between Fauvism and Expressionism. This early portrait shows this, the works of the following years confirm it.

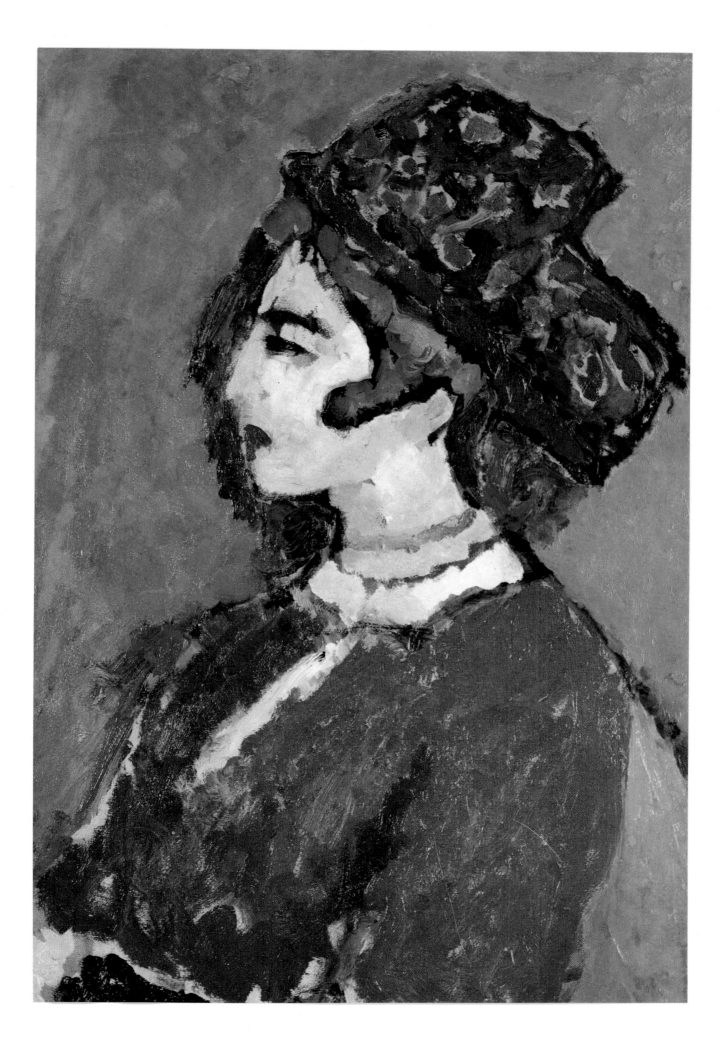

20. ALEXEY VON JAWLENSKY (1864–1941)

Still Life

1911. Oil on cardboard, 28 × 29 3/4''
Kunsthalle, Hamburg

The often repeated opinion that throughout his life Jawlensky stood as a weaker force in the shadow of Kandinsky's spirituality is not borne out by his work. Even if the Russian element native to both provided a common ground of affinity of feeling, they soon went their separate ways.

The *Portrait of Resi* of 1909 (colorplate 19) shows how Jawlensky's feeling for color burst into full bloom and took on strength and decorative richness which the confidence in the future aroused in the early days of the New Artists' Association. For Kandinsky, though, the group was constricting, and he soon broke away, doubtless feeling the refusal of the others to abandon subject matter as an unbearable obstacle to his own artistic intentions.

Kandinsky's first experiment in abstraction, the watercolor of 1910, casts a striking light on the different ways and goals of the two men. Jawlensky's work was quite unlike Kandinsky's, and the sureness with which he defined the limits of what was possible for him at the time demonstrates his rapidly increasing mastery. His goal was unequivocally the conception of the picture as a formed structure. The path to it led from the depicted object via its transformation and assimilation to the pictorial form as higher plane of reality. Color was raised to a visual sonority as expression of the autonomy he was striving for; in his works color is neither Expressionistically charged with feeling nor tied to the subject in any realistic way. Understandably, looking at works after the Impressionist period, one feels a desire for intensifying color, yet, at a particular point in the creative process, color turned inward, became suggestive, even mystical. With Jawlensky, its effect does not depend on heightened purity of the individual tone, on powerful harmonies, as with Nolde or Schmidt-Rottluff. Instead, he took the blend as a point of departure and modulated distinct color-forms with a preference for certain harmonies such as blue against violet, green against red. Certainly, there are many works in which he seems to have given himself over to an unbridled delight in color. But even in these, at closer acquaintance, the spontaneity is thrown into question by their emblematic character.

The year 1911, when this still life was painted, was a memorable one for the artist. The third exhibition of the New Artists' Association had given his pictures pride of place, and he had his first one-man show in the Ruhmeshalle in Barmen. Then he had another meeting with Matisse, in whose studio he had worked for a while in 1907, although this encounter added nothing new to what they already had in common. This can be taken as a sign that Jawlensky now felt able to stand on his own and not be led into stray pathways. In a letter he stated: ''In 1911 I arrived at a personal form and color.''

This *Still Life* documents the phase of first maturity. It does not deny a certain measure of dependence on nature: a potted plant in bloom, a table, bowls of fruit, a pitcher. But the impression that their beauty has anything to do with real things is deceptive. The red of the flowers does not define their species but blazes so brightly as to make an optical point of culmination. In this it contrasts with the dark, bluish green of the leaves as well as with the blue background that is infused with movement, is partly painted over with green, and made slightly turbid and toned down with touches of white. The table has sharper tinges: the red, violet, and green are markedly unnaturalistic, explainable only in terms of the color character of the whole. Equally contrived is the reddish-violet color-form at the lower margin, which has its part in setting the key of the composition.

The greenish blue of the bowls is laid on so thinly that one can see the raw canvas, and a counterweight composed of the pitcher's dark shape at the left and the flower pot makes a static central point. Again all details are drawn together into larger forms and vigorously outlined in black: the resultant simultaneous contrast heightens the intensity and defines the colors.

The subject seems to imply an expression of purest joy in living —a still life with no other content than delight in what is depicted and its color. But that does not even skim the true meaning of the work. It reproduces no reality. Instead, a higher, essential truth is embodied in the slow growing-together of all the color shapes, in their reduction to simple surface structures. The ''wonder'' of nature brought out in this manner is also evoked by the artificiality of the color accents and lies just as much in the tension between the values as in the softening of the tones, in their ''inner harmony.'' A certain melancholy permeates the cheerfulness of the ensemble of objects, perhaps even a trace of mysticism, but all the colors have the Eastern tang that Jawlensky never lost.

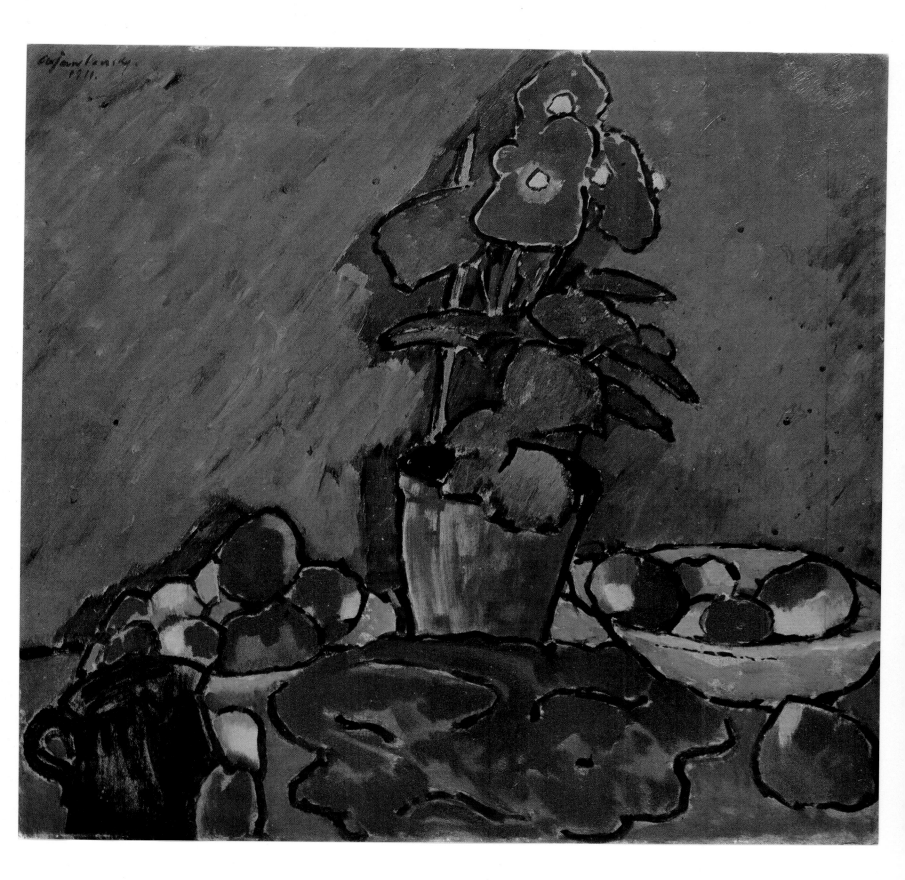

21. WASSILY KANDINSKY (1866–1944)

Improvisation No. 3

1909. Oil on canvas, 37 × 51 1/8''
Collection Nina Kandinsky, Paris

At the end of his essay *Concerning the Spiritual in Art*, Kandinsky explains the different categories into which his "new symphonic compositions" fall and puts them into three groups: "impressions, improvisations, compositions."

As primary source of the improvisations, of which the one shown here is among the earliest, he indicated "chiefly intuitive, for the most part spontaneous expressions of incidents of an inner character, or impressions of the 'inner nature'." At first the viewer may not find that characterization particularly applicable to this work. True, it comes from a time when the artist was already attempting to come to terms theoretically with the results of what he had observed and experienced. Yet it still has obvious connections with visible existence, and still very much in evidence are the memories linking him to the Russian brand of Art Nouveau, with its Eastern colorfulness and folk-tale atmosphere.

One thing, however, should not be forgotten when it comes to Kandinsky's fame as one of the first European painters of this century, perhaps the very first, to take the decisive step toward abstraction: he did not do it in isolation, and the development up to the point of changeover can be read clearly in his work. About 1910 the solution to the problem of abstraction was in the air almost everywhere. What it ultimately amounted to was working out a pictorial process that would enable the artist to let the human domain of feeling and expression become visible from the pictorial construction itself, without having to take into consideration the symbolic function of a depicted object. Color and form as autonomous pictorial values should stir the viewer in the same way as had been possible until then only by the detour of subject matter. In France, the terrain had been prepared with Analytic and Orphic Cubism. In the German Jugendstil, ideas had been brought out that pointed directly toward an abstract process of communication by means of the picture only. The autonomous use of color by the Fauves had opened a rich arsenal of possibilities to Kandinsky that had to do chiefly with harmonic values. Thus, if his first, abstract watercolor of 1910 was a boldly experimental step, it was not unexpected within the logic of what was developing in Europe. Like his essays, his pictures indicate that the goal could have been approached in a number of ways.

This *Improvisation* represents one of them. In its particular quality, in its coloristic as in its formal construction it alludes to a key point of departure: Russia and its art. Kandinsky has stated expressly that it was the fairy-tale vision of Moscow under a setting sun that early on had alerted his receptive imagination to the possibility of abstract expression. He was a man who felt himself at one with his country's tradition, with its brightly colored folk art as well as the mystical sign language of its icons. Even more, just as the romantic, all-embracing feeling for the universe had lived on in German art, so in Russia, too, the sentiment remained for that inner bond that comprehended the object as meaningful sign and therefore broadened and elevated it in its very essence. Added to this was Kandinsky's own exceptional sensibility for color not as an element that defines things, but as something that could be used to undo material reality and could be integrated into compositions not unlike those of music. Hearing Wagner's *Lohengrin* as a young student, he had suddenly felt that "I could see all my colors, I became aware that painting possesses the same power as music."

To purify the picture of realistic reminiscences proved far from easy. Over and over, step by step, he forced himself to try to go beyond pictorial conceptions that still had much to do with the decorative arts. The fairy-tale atmosphere was both tempting and risky, as he noted in the seventh chapter of his already mentioned theoretical study: "The 'unnaturalistic' objects and their colors may achieve a literary appeal, in which case the composition assumes the effect of a fairy-tale. . . . Once the observer believes himself to be in a fairy-land, no sooner does his soul become immune to any strong vibrations. Thus, the real aim of a work of art is void."

Therefore only the liberation of color and form from their associations with objects, from the function of reproducing real things, could bring about that "pure" harmony that gives rise to "vision," to the pictorial core of truth in the seen and the experienced as precondition for a new artistic development. In Kandinsky's works between 1909 and 1912 it was still almost always the subject itself that, for all its gradual retreat from reality, had the power to elicit these "vibrations." One sees that here. House and hill, rider and trees are caught in the moment of revolutionary change from thing to sign. The contours of real things are visibly inscribed on the picture surface as linear arabesques and so are still understandable in terms of narrative content, but they are already part of a pictorial fabric on the way to becoming autonomous. Color is already more emancipated. True, it has not yet lost its peculiarly Eastern, folkloristic character. But there are no more local colors, and they are used in accord with the necessities of the picture itself. Even the way the paint is laid on, varying from dynamic to flat, aims to emphasize the intrinsic pictorial value of the colored shapes. The harmonic character is brought to the fore so as to give the impression of a resounding sonority. The onlooker's eye was beginning to turn away from the exterior world, and the inner and outer nature of the work to evolve in intimate interrelationship.

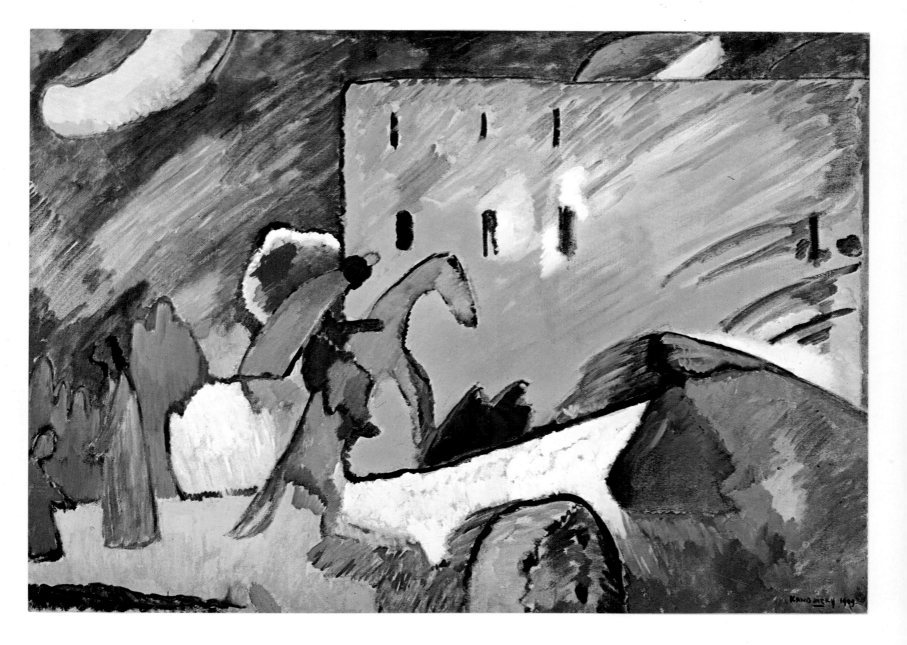

22. WASSILY KANDINSKY (1866–1944)

Landscape with Church I

1913. Oil on canvas, 30 3/4 × 39 3/8"
Museum Folkwang, Essen

It is characteristic of Kandinsky's art that one finds works typical of different transitional stages produced at the same time, and this even years after his first venture into the abstract. Yet he never lost sight of his goal, of the idea that the harmony of color and form he was seeking "must be based on the principle of appropriate connection with the human soul" and that "composition is an assemblage of colored and drawn forms which exist on their own, are to be derived out of inner necessity, and, in the mutual life they thereby take on, constitute a whole that we call a picture." In other words, his expressive model of thought.

Measured against more abstract works, this "landscape" may still seem rather conservative. It occupies that particular position between objectivity and abstraction that confirms the cogency of the definitive turn to the nonobjective: while one can still recognize that all the details originate in an experienced landscape, the pictorial construction is already emancipated from the compulsion to depict things and is already dealing with form from the standpoint of the pictorial autonomy that the artist was striving for. Its inner logic is further underscored by the fact that it was not an isolated work, but part of a series done over several years in which Kandinsky played ever new variations on the theme of the Murnau landscape, ranging from direct visual impressions to the freest echoes, much as Piet Mondrian was doing at the same time in his famous apple-tree series.

Living in the village of Murnau at the foot of the Oberammergau Alps up to the outbreak of the war, Kandinsky was naturally fascinated with the local panorama. Comparison of works from his first phase with this canvas shows the change that came about: the earlier, still recognizable forms of the Alpine peaks have become triangles, pure compositional forms; the local Baroque church, initially still characterized by its onion-bulb tower, has become a system of parallel lines that has grown beyond the upper margin and makes a vertical counterrhythm to the horizontals of the landscape and the bold curvature of the rainbow. Kandinsky applied this procedure to other material objects that he translated into his pictorial vocabulary: colored, oval forms were once haystacks, graphic accents were houses or sheaves of grain. The less each pictorial form involved a likeness of nature, the more important it became as component of an autonomous pictorial organism, as part of a free composition of full, glowing tones whose individual timbres could be united into those musical chords that had become for Kandinsky the quintessence of his conception of composition.

From about 1912 on there were mature works clearly revealing his new approach. But the change from object to pure form brought into play a further problem, that of pictorial space. In this painting, as in others of the time, illusionistic, pictorial depth is not abandoned. It no longer comes simply from traditional perspective, but from the spatial values of the different colors that combine into a system of interpenetrating spatial strata, thus into the same sort of nonperspective pictorial space the Cubists had promoted. Yet a comparison with the works of Braque or Picasso shows immediately that Kandinsky opposed to the French rationality a conception that was essentially unreal, not calculable, but guided by emotion. By means of abrupt, spatial breakthroughs no longer identifiable with the notion of "depth" but at the most with that of "infinity," his pictures acquire the expressive tension that ultimately aims beyond the canvas to the cosmic, something to which the linear dynamic also contributes. But this transformation into signs also aims to elicit new impulses to movement: the lines oscillate, sweep upward or downward, take on the appearance of kinetic symbols that unite with the spatial tensions of the color to make dramatic accents. Look at the emotional feeling with which a "rainbow" spans the upper half of the picture, how brutally it is broken by the intersecting lines of the "tower," how individual accumulations of color come together as staccatos in an overall orchestral texture.

Here again is the Northern and Eastern world of expression with its mixture of sonority, pathos, and mysticism that lets the painting become the source of the "vibrations" with which man communicates the experiences of his own inner world.

It has been proposed to define Kandinsky's position as "abstract Expressionism," but the notion easily leads to error if not evaluated from two sides—that of France, but also of Central and Northern Germany with which he was linked by a common ground despite all evident differences. With Kandinsky, as with the Northern painters, the work of art constitutes that mysterious point at which human experiences and insights are put to the test. But the Northerners kept up the dialogue with the outer world, sought a confrontation with it in order to break through and arrive at the limits where the "universe of the inner man" reveals itself. Kandinsky turned his gaze away from that outer world, shifted the interest to the pictorial means suitable for a vehicle of communication in the autonomous organism of the picture, sought the spiritual formula by which the tension between man and world could be held in equilibrium. Thus, for all its expressivity, his painting remains aesthetic—a notion decidedly contrary to the Northern Expressionism of the time. But it is precisely this contribution of the expressive element that separates Kandinsky's art from that of the French, that measure of subjectivity which does not coincide with the quest for objectivity. It was the Russian tradition, if you wish, that resisted a closer approximation to an objective approach.

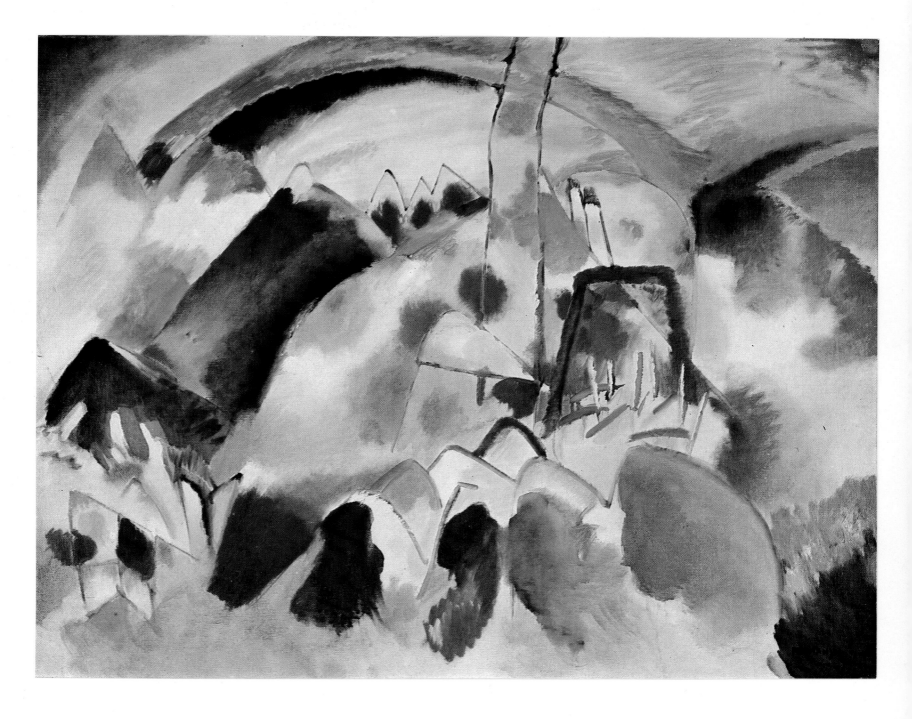

23. FRANZ MARC (1880–1916)

Foxes

1913. Oil on canvas, 34 1/4 × 25 5/8″
Kunstmuseum, Düsseldorf

The path taken by Franz Marc from young hopeful in the Munich tradition to a great exponent of symbolic Expressionism corresponds to the evolution of his color from a means of defining objects to a means of expression in its own right. That span touched on all the problems that the champions of the new expressive German art after the turn of the century had to face up to within the context of the European development.

In 1913, when *Foxes* was painted, Marc had already arrived at the point where his color became emancipated from nature and raised to symbolic function, thus that moment of experiencing reality that he once called the "mystical-inward construction" of the image of the world, the feeling for a higher order of coexistence of everything in nature in which subject matter nonetheless still gets its due.

With Marc, as with August Macke, both French Fauvism and Orphic Cubism provided stimulus and also reassurance. Marc was a fervent believer in the basic idea that in the harmony of color-forms resided possibilities of establishing a bond between man and the totality of all things existing in the world. Such an idea could signify a spiritual law transforming all, with art viewed as the fundamental principle of order. But it could also involve the expressive and emotional value of color that could be used for symbolic purposes, as with most German painters. Here, obviously, was the point at which Marc broke with his French friends and from which, for all their basic agreements, he had to take his distance: "I am German and can only plow on my own soil," he wrote in 1914 to Macke. "What has the *peinture* of the Orphists to do with me? . . . You know how I love the French— but that is no reason to turn myself into a Frenchman. I explore within myself, always only in myself, and seek what it is that lives in me that can embody the rhythm of my blood; I truly believe even now that I shall paint my good pictures only at the age of forty or fifty."

Such a deep sense of the unanimity of all living things within the higher sphere called for a symbolic sign, a metaphor through which that concord could be expressed. Marc chose the animal, not man who for long had seemed to him suspect: "Uninnocent man around me . . . did not arouse my real feelings, while the unspoiled vitality of the animal brought out everything good in me" (April 12, 1915).

With the animal, not as individual creature or as species but as expression of an existence still caught up in creation in the original sense, a fundamentally romantic feeling was exalted to even higher pitch: "I saw the image reflected in the eyes of the moorhen when it dives under: the thousand rings that enclose each small life, the blue of the rustling heavens that the sea drinks in, the enraptured emergence at the surface in another place—

know then, my friends, what pictures are: emergence at another place" (Aphorism No. 82).

The years between 1912 and 1914 were marked by an ever greater artistic maturity. Gradually the inner conception of the appropriate pictorial form expanded, and that in the measure in which Marc increasingly distanced himself from objective reality. There is his famous saying: "One no longer cleaves to the image of nature, but destroys it so as to reveal the powerful laws that rule behind the lovely semblance." This meant neither renunciation of pictorial content nor a break with the old conception of reality. It characterizes the line of separation past which the particular form of an object dissolves so as to be taken up, spiritually and compositionally, into that all-embracing reality that the work of art represents symbolically.

The *Foxes* testifies to the rapid strides Marc made in that direction, the *Tyrol* of 1914 (colorplate 24) to the subsequent conversion to pure vision. The outer guise of the animal form is burst apart here, its insulation from other things given up in order to make clear the deep roots in the All. In his previous animal pictures each form had possessed an equivalent in a second or third such form, but they worked as centers whose movements brought them closer one to the other. Here, instead, the overall rhythm dominates the entire picture. The basic red and the pointed shape of the fox's head function as fundamental pictorial elements that determine the general course of the entire form. Ever new facets of form-shaping color take over the basic theme, repeat it, let it fade, die away, then take it up again at some other place to vary anew. All other colors and forms serve only to support and enhance the basic theme, the cool as well as the complementary contrasts, the round forms and their vibrations. Not the fox but the foxlike was what the painter was after. It sets up a unison, emphasizes angularity (rather than the gentle roundness of the deer in other paintings), and ensures that the subject as such does not become the chief thing. Because symbolic language has found a valid form here, it too begins to establish its own intrinsic value. By then Marc had long understood that overeagerness for expressiveness and personal communication represent a latent danger for the picture itself, since it tempts one to deform by overemphasis or, if too much stress is put on symbolic content, lets the form dissolve in emotion-laden color.

Certainly the constructive elements of French Cubism were of help to Marc in the spiritual-formal ordering of his picture. Yet it was through the romantic feeling of union with the universe that the organizing scaffolding of the color and the sensitive structure of the composition were set into vibrant motion: a brief moment of what is a most difficult and rare equilibrium in the art of Germany.

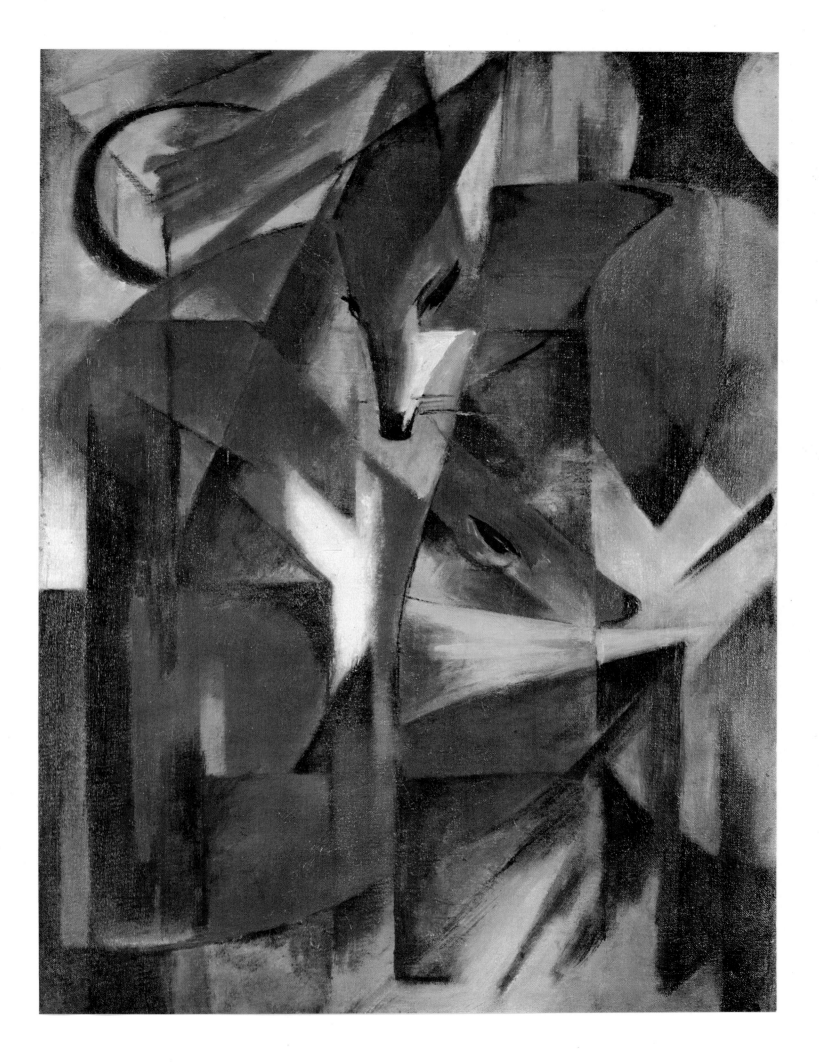

24. FRANZ MARC (1880–1916)

Tyrol

1914. Oil on canvas, 53 3/8 × 57″
Staatsgalerie Moderner Kunst, Munich

The first version of *Tyrol* was done in 1913 along with the famous *The Unfortunate Land of Tyrol* of the Guggenheim Museum, New York. Both go back to impressions of a trip through the Alps when Marc produced a great number of drawings and sketches which did not aim at topographical accuracy but were ideas that might serve for future works.

This painting was shown in 1913 in the First German Autumn Salon in Berlin, but it was removed by Marc himself who, as he wrote to Herwarth Walden, was not satisfied with it. What we see now is the repainting he did in 1914, and it marks a further step toward the visionary works of his last period, works that are something other than his abstract compositions.

It is obvious that Marc, at this point, though still working from visual impressions, by no means wished to give up assimilating the visible into a higher context, even when it was not the symbolic figure of an animal that was involved. At a glance one sees here how much the pictorial elements defining and characterizing real things have been absorbed into a fundamental, overall harmony. Only the foreground and the two white mountain chalets on a steep rise of rock still seem close to reality, although they too, like a third house in the upper right on a sheer mountain peak, are already assimilated into the crystal-faceted refraction of all the forms. The shape of the picture itself, almost a square, makes the mountains appear even steeper, and their peaks jut upward sharply without reaching the upper margin. The refractions of their forms go over directly into cosmic radiations, which plunge downward into the depths and transform the landscape into a transparent polyphony of color harmonies. The "major" tones dominate, a festive combination and juxtaposition of the basic colors that are both pure and broken-up. Most striking is the rich use of dark tones up to black. These work not only as formal elements, as in the falling tree in the foreground which sums up the predominant diagonality of all the pictorial elements, but also as resonance of a countertonality, thereby serving to intensify the luminosity of all the other colors.

The cosmic world experience that Marc's writings and pictures convey is here expressly symbolized by the heavenly bodies. The spatial effects of the color bring out precisely that dimension and open up remotest spheres. The dramatic agitation is heightened by harsh contrasts in which a blue receding back is placed directly next to a red pushing forward.

The first version may have had a symbol of the sun in the center. Alois Schardt, Marc's biographer, says it was "like a diamond that takes into itself the rays of the sun and radiates them out again like a rain of sparkling colors." In its place is a Madonna and Child on a crescent moon, and the picture has become something like a votive image. Klaus Lankheit, who published Marc's explanation that the Madonna is to be viewed as a symbol of the Tyrol's Catholic character, rightly warns against interpreting the picture too narrowly on the basis of its central motif. Certainly he is correct in observing that Marc chose to replace man and animal with a symbol of the divine as proclamation of the faith victorious, as emblem of spirit above matter. Such symbolic conceptions were typical of the Blaue Reiter group, and this was a time when Marc was more than ever preoccupied with getting beyond matter in an artistic parallel to the scientific discoveries of these years, notably the atomic theory that was shifting attention from the externals of things to the motive forces within them.

Marc himself wrote: "The value of the scientific discoveries is not to be measured by their fortuitous . . . social utility, but rather according to the degree to which they give a new orientation to our spiritual eye. . . . Matter is something that man still puts up with but disavows" (Aphorism No. 47).

In *Tyrol*, particularly, we sense the mutual influence of all forms, the exchange of energy between the various focal points that takes on the guise of color radiation. The world as dynamic movement, as eternal existence in flux—a conception that here achieves this utterly romantic fulfillment: to be taken up into the radiating sea of cosmic life.

Marc's aphorisms are not to be thought of as explanations of his pictures, although they can help to show how he came to grips with the concepts of color and form and with their expressive, symbolic, but also pictorial value: "I was surrounded by strange forms, and I drew what I saw: hard, unhappy forms, black, steel-blue, and green, that quarreled with each other. . . . I saw how everything was disrupted and at odds and mutually hindered to the point of pain. It was a frightful sight" (Aphorism No. 72). "My longing, swarming outward, saw another image, the deep image: the forms sprang in thousands of walls back into the depths. The colors struck against the walls, groped their way along them, and disappeared in the deepest depth. . . . Our souls dragged the colors down into the ultimate depth." "How beyond utterance are all these things, how unutterably beautiful" (Aphorisms Nos. 74, 75).

It is in the deepest sense logical that the painter, at the end of his work, should again come to the religious which, as a part of the history of Creation, had always been close to him.

Behind nature's forces the human spirit discerns the wonder of existence eternally repeated: the profoundest relationship between the I and the world, whose opposition may, perhaps, be bridged over. Marc set foot on that way, but death barred him from the goal.

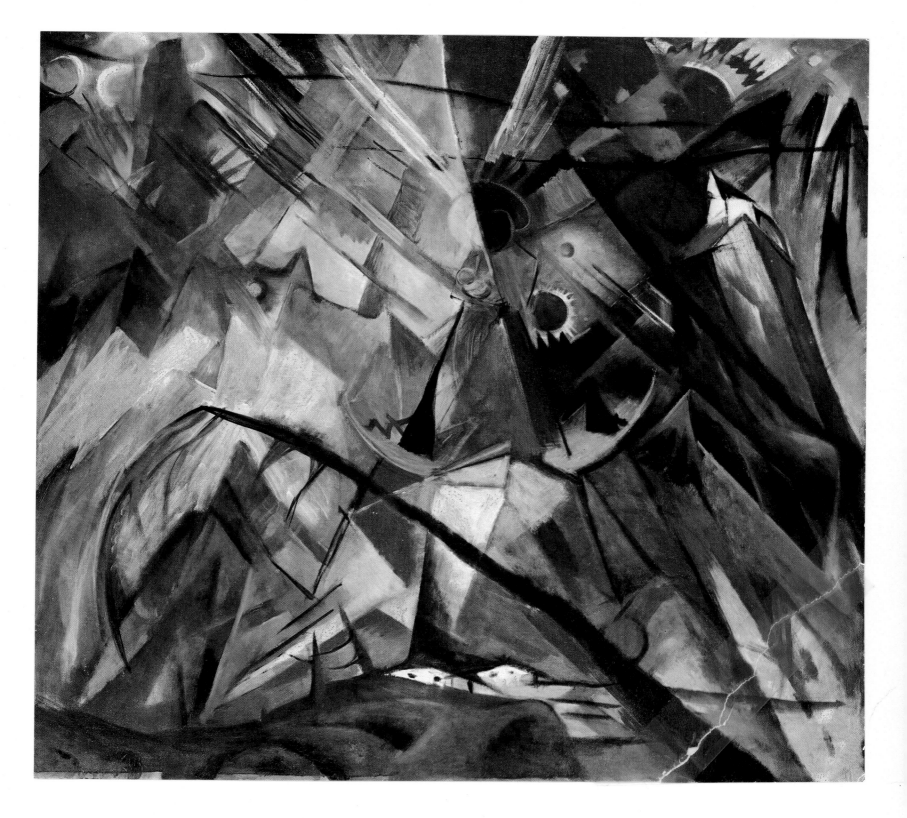

25. AUGUST MACKE (1887–1914)

Hat Shop

1914. Oil on canvas, 23 7/8 × 19 7/8''
Museum Folkwang, Essen

The eight months that August Macke spent in Hilterfingen on the Lake of Thun in Switzerland before war broke out were among the most fulfilling of his brief life.

Looking at his luminous and cheerful works of 1914, it is hard to think of them as Expressionist. Indeed, his art is to be understood only in terms of its distance from a style fraught with thought, emotion, and drama. No other painter of that time so fully brought out the cheerful, sensuous side of German art, the untormented tone it so seldom can find without help from elsewhere. Westphalian by birth, in talent and temperament Macke belonged heart and soul to the Rhineland where he grew up. Yet the lovely, light grace of his works should not blind us to the seriousness and effort they grew out of. What seems so relaxed, casual, almost playful was the product of years of laborious exercises striving for perfection. If nothing else, the astonishing number of drawings this short-lived artist left behind testify to an unflagging effort that is not hinted at in his finished paintings.

Generally Macke is treated as a member of the Blaue Reiter, and not without reason, as he was linked to Franz Marc by long friendship and a close exchange of ideas. Yet if one tries to measure just how much he really belonged among them, what inner relationships he might have to the romantic, symbolic cosmologies of Marc, or the spiritual world of ideas and the mystical conceptions of Kandinsky, the differences weigh more heavily than the similarities.

Certainly Macke's work has many links with the spiritual and intellectual currents of his time. Above all Delaunay's Orphic Cubism and Matisse's melodious color sense gave support to that aspect of his being that was striving for a sensuous, harmonious orderliness in the use of color—a very different bent from the insistence on personal expression championed by the Blaue Reiter artists. His warning to his friend Marc to beware of being too much the Blue Horseman and of concentrating too much on intellectual matters shows an attitude quite unlike theirs. "With me, work is a thorough enjoyment of and through nature." With this he opposed the dark striving of others after cosmic relationships and the sense of universality behind the great ideas of progress. The painting Storm, an attempt to feel his way into the problems racking the Blaue Reiter, was painted for their exhibition, and it strikes one as a foreign body in his oeuvre because of its abstract, symbolic manner as well as its subservience to their approach to form. Delaunay was closer to Macke, since he at least sought to unite the color movements into a synthesis "comparable to the polyrhythm of music" and likewise recognized that color, as much as form, is capable of forming rhythm and movement out of itself alone. With color understood also as equivalent of light, as "color-organism composed of complementary values, of masses completing each other in pairs, of contrasts from several sides at once," by irresistible logic the path had to end up in abstract painting as "pure orchestration of color and light" (Haftmann).

That challenge was perfectly clear to Macke. Beginning in 1907 he made almost regular trips to Paris, where in 1912 he and Marc visited Delaunay. Yet neither his admiration for the French, nor his interest in the theories of Orphic Cubism, could turn him into a mere imitator. His greatness was in discovering a way that signified a new intellectual relation with color without giving up the visible and real which, instead, could be transmuted into visual poetry. The Hat Shop of 1914, one of his last important works, documents what that way finally came to be for him. Compounded of freedom and binding necessity, it is both German and French.

Obviously the origin of the picture was something seen. Thus the underlying structure of the composition was based not on the quest for superordinate laws governing color, but on sensory observation. Form here is a fleeting instant of happiness. A young woman pauses before a hat shop window. As if stopped in her tracks she looks back, her eye caught by the gay invitation of the window where hats seem to swarm like a flock of brightly colored, exotic parrots.

The architectural framework makes a contrast. It is more rigorously controlled; reminiscences of Cubist organization produce a certain heaviness of what we can call constructed structure in which the effect of material substance of real things is not denied, as with the French, but deliberately aimed at. This is true of the strolling woman, whose coquettish parasol does not quite have the lightness that one associates with such a frivolous accessory ever since the Impressionists. Here, too, there remains something rather too substantial, a German element if you will. To this the shop window makes a weightless contrast. Against the geometrical partitioning of the interior, in which color field comes hard upon color field—one sees clearly what is like and unlike Delaunay's Fenêtres—the hats stand out in a colorful interplay of color and form contrasts, and again the attempt is made to counterpose color-as-light against color-as-matter.

By not worrying overmuch about the subject itself, we can see that here the visual impression has been ordered into a composition on the basis of color patterns, that everything objective has become part of an overall pictorial harmony without giving up its reality. The basic element is the color medium from which every form has arisen and which makes us see beauty allegorically, as order in and for itself.

August Macke was twenty-seven when he painted this picture. It reflects a measure of perfection that has eluded other artists even in their most mature years.

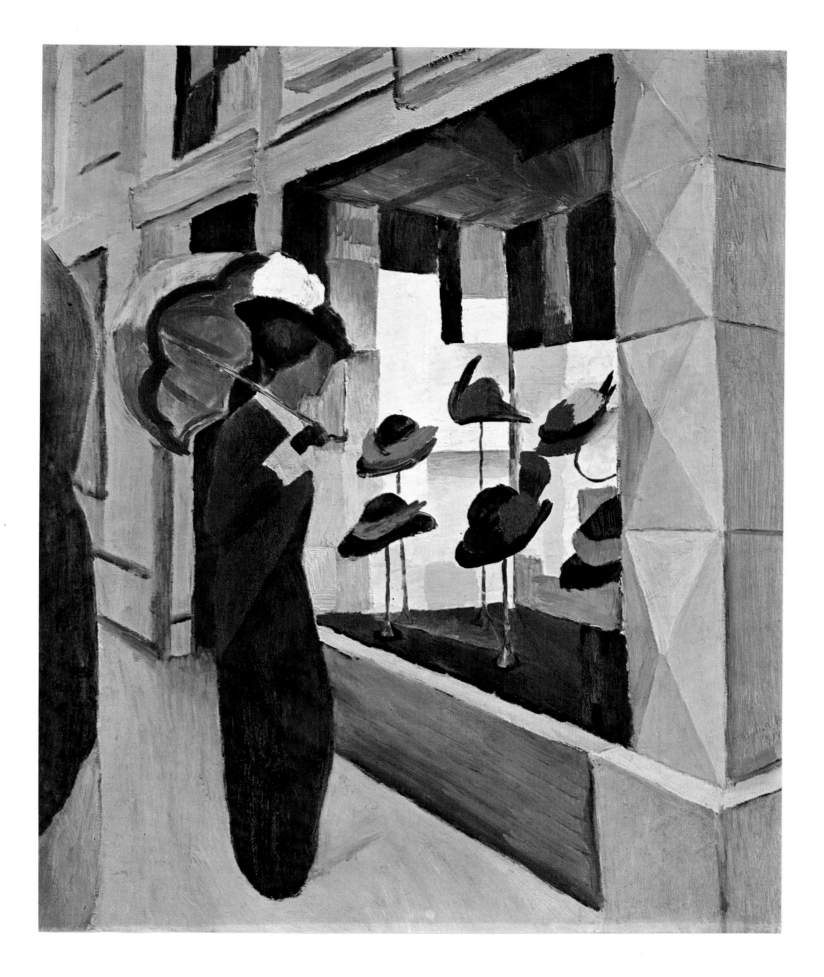

26. AUGUST MACKE (1887–1914)

Girls Among Trees

1914. Oil on canvas, 47 × 62 5/8"
Staatsgalerie Moderner Kunst, Munich

Likewise from the last year of August Macke's life, this painting differs from the *Hat Shop* (colorplate 25) in its new heightening of color. Although the Impressionist theme of couples or groups strolling in gardens and parks is not found in the works of the Blaue Reiter or the Northern and Central German Expressionists, it was frequent with Macke, especially in his last period. The explanation is obvious: for artists who thought and painted in terms of self-expression, nature always signified a conflict between the I and the world, the exposure of a latent relationship of tension between inner and outer domains, a quest for the motivating and organizing psychological forces. Those artists put nature to the question, or let it act as symbol reflecting their own conceptions, which for the most part represented a particular ideology of content or form. They did not take nature as something given but accepted it as material for their own reworking. Not so with Macke. It goes without saying that he never merely reproduced what he saw in nature, and he too sought for organizational factors, for principles governing the use of color or images that could channel the beautiful accidents of nature into the superordinate harmony of a picture. But his goal was to elevate to higher planes what he saw and experienced, then to bring it back, purified, to the point of departure—to the pleasure the eye takes in multiplicity and serenity, to the perfection of the visual impression that Macke knew how to heighten to poetry, to that "thorough enjoyment of and through nature" that he himself proclaimed.

Here again the medium of paint shaped and realized his conceptions and provided the means for the process of refinement and intensification. No doubt pictures like this reminded one of related currents in European painting of the time, but any similarities are more correctly understood as allusions consistent with Macke's openness to contemporary trends. The picture as "metaphor of a purely ordered beauty of the world" was a conception known also to German art; for example, Matisse's German pupils in Paris espoused it. And in any case, Macke worked from a related basis—the French Fauves' emphasis on color as organized pictorially by Matisse. And he was able not only to unite that basis with the properties of crystallized light inherent in pure colors as propounded by the Orphists, but also to imbue it with such a personal inspiration as to make what resulted a symbol of the experienced beauty of the world, a legend whose key was in the allegorical significance of the order imposed on color.

The Blaue Reiter, too, took the visible as point of departure but had more and more subordinated it to a higher spiritual context within which it could not help but lose its quality as visual impression. With Macke, however, the goal remained intact. And if we are still touched deeply today by the way that young painter felt the world to be a place of happiness, it is because in his works that feeling culminated in a timeless harmony.

Girls Among Trees is evidence of that point where the intellectual and the sensuous interpenetrated perfectly, where equilibrium was achieved between eye and picture, conception and painting. The open-air scene is built of color resonances that, here and there, let us see the effort to emancipate color and arrive at abstract form. Thus, at the right there are reminiscences of Delaunay's color circle, although every form is motivated both optically and as subject matter. The underlying structure of the composition is attuned harmoniously. Broken or angular shapes are deliberately avoided so as not to endanger the difficult equilibrium. Primary colors predominate and even where broken up by green, it is the warmer yellow areas that prevail. Blue acts as a festive, unsubstantial counterpoint and is toned down by white so as to keep its pitch within the soaring suspension characteristic of the entire pictorial surface and space. The blue may suggest space, but all spatial tensions are avoided. A succession of musical chords, used harmonically, give a cheerful rhythm to the picture as a whole. With light color values predominating, the way is opened to overtones that make the joy of a summer's day more real than any story-telling could ever contrive.

Then, too, the picture was painted with a relaxed and flowing hand. Although here and there the paint is laid on flatly, for the most part the brushwork emphasizes movement. And this is to the benefit of the picture, especially as compared with the *Hat Shop* where, despite its gaiety, the law of pictorial organization is never lost sight of. Here, conversely, there is an almost Impressionist solution that has nothing to do with the rationality of that style other than that here, too, an atmospheric feeling for the power of light has its part in the general effect of the picture.

Almost casually, the pleasure of a rare instant is held fast. This is surely a sign of the greatness of Macke's gifts, that in the seeming naturalness of the picture one forgets the artistic effort without which it could not have taken form.

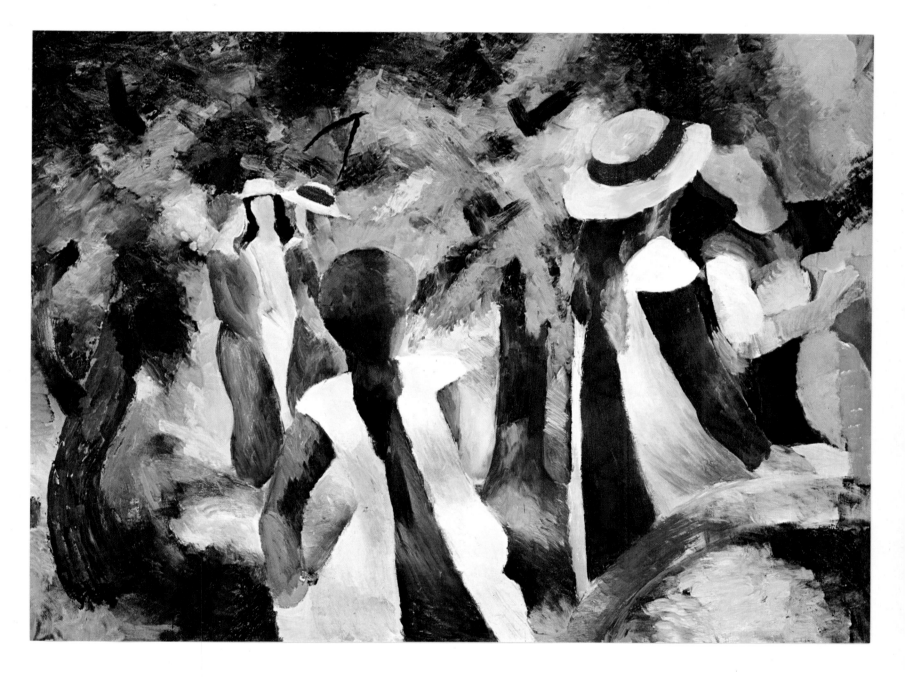

27. HEINRICH CAMPENDONK (1889–1957)

Bucolic Landscape

1913. Oil on canvas, 39 3/8 × 33 5/8''
Collection Morton D. May, St. Louis

The German schools that grew up in our century within the intellectual orbits of major art centers such as Berlin and Munich were of importance in the general artistic scene of the time. If the so-called provinces did not always carry the same weight and incisiveness as the focal centers of the development, still the artists who lived and worked there supplied accompanying tones that rounded out the overall picture.

Especially in the Rhineland, always open to the world, eagerly interested, and with its attention fixed on its French neighbor, the response was not so much to the impassioned Expressionism of the Brücke group as to the ideas being developed in the Munich Blaue Reiter. A painter such as Macke was especially representative of the Rhenish feeling for color. Always mentioned together with him is Heinrich Campendonk, whose art during the same years likewise found its spiritual home in Munich.

After studying with the Dutch artist Jan Thorn-Prikker in Krefeld, the young Campendonk was introduced by Helmuth Macke to his brother August, and by both of them to the Blaue Reiter group who gave a friendly welcome to his work. He entered that circle very early, showing in their first exhibition in 1911 at the Thannhauser Gallery in Munich. Not long after, the young Rhinelander, who had settled in Sindelsdorf in Bavaria to be with Franz Marc, was invited by Herwarth Walden to participate in the Berlin Autumn Salon.

Closeness to such strong personalities inevitably had its effect on the general tone of Campendonk's painting, although it was not August Macke, as one might expect, but Franz Marc who became his model. When Campendonk painted this *Bucolic Landscape* in 1913, the Blaue Reiter artists were at their peak. Marc and Kandinsky had already produced the works we regard today as decisive for the future, and to look at this painting alongside theirs is to see how much Campendonk did and did not owe to them.

The basic pictorial material is closely related to that of Marc. Here, too, nature is the point of departure for all artistic effort, reshaped by strains of feeling explicit in the theme itself. The picture is carried by the strength and expressive power of its color. Tree, house, animal, plants, mountain is a repertory shared with Marc; related also is the effort to make use of angular refractions of forms not to elucidate pictorial construction, but to dynamize planes so that the forms reach the verge of abstrac-

tion, suggesting French Cubism or, better, Delaunay's Orphism. A driving rhythm sweeps every detail into a unified whole.

Yet if one examines the details and pictorial conception with a critical eye, the seeming closeness to Marc is more than countered by fundamental differences. Color and form for Campendonk have quite a different pictorial function than for Marc. With the latter, the "inner necessity" so often cited by the Expressionists conditioned the effort to achieve spiritualization by means of transparency, by letting the visible filter through, by conceiving the picture as equivalent of a higher, cosmic world order—in short, by thinking through and treating the composition in a romantic, symbolic manner. Campendonk, however, used his pictorial vocabulary merely to develop a perfectly decorative fabric of images, and this called for a different creative process. Even in a reproduction one sees how he repeatedly toned down the full sonority of his primary and complementary colors by mixing them with white and thereby depriving them of their heightened effect. This blocks their spreading into an imaginary space and binds them more firmly to the surface. The animation of the formal rhythm, with its drive toward abstraction, is matched on the level of the subject matter by gesticulation. The shapes of people, animals, and landscape fill the picture surface in a soaring jumble, and the play of their interrelationships sets the character of the representation. The animal—with Marc an intellectual and spiritual formula—is here an integrated part of a linear pictorial system which, with its black outlining, often aims at the effects of a stained-glass window. Every shape has its outline. If it shares some color correspondence with its neighbor, it nonetheless remains chiefly a thing in itself, and only through the overall rhythm of the picture does it become incorporated into the whole: in short, a decorative principle.

This is matched by a use of color entirely on the surface. As is to be expected from a Rhenish painter, the color, for all its cheerfulness and animation, is quite inexpressive, although not without a feel for the charms of the fairy tale. Campendonk in those years was conceiving his pictures as decorative equations, not as intermediaries or interpreters between man and nature.

"Bucolic" as against "cosmic"—there lies the difference from Marc, but also the evidence of the independence of a painter such as Campendonk.

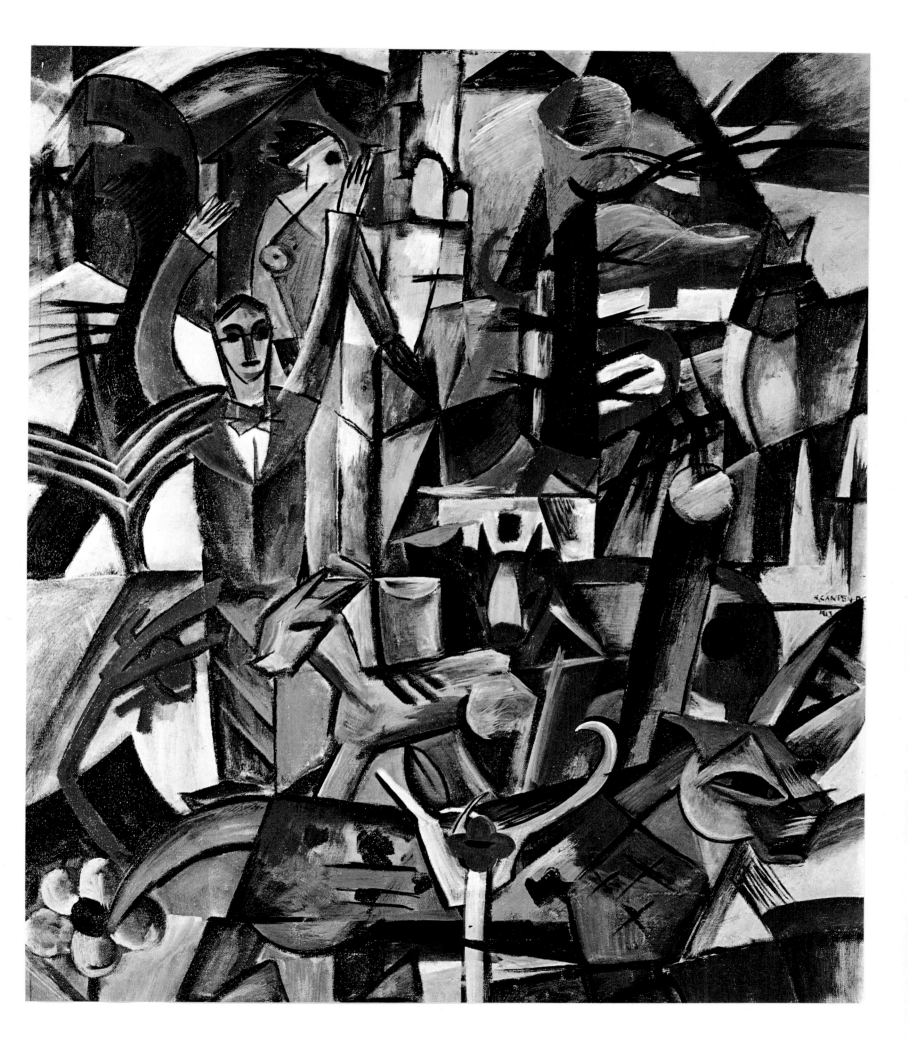

28. LYONEL FEININGER (1871–1956)

Gelmeroda I

1913. Oil on canvas, 39 3/8 × 31 1/2"
Private collection, United States

It was a stay in Paris, in 1911, that prompted the German-American Lyonel Feininger to concentrate on painting, until then only a secondary activity for him. The renowned caricaturist developed into an as yet unknown painter.

In this first period his art revolved around a few figure paintings of a dreamlike fantasy which, still under the sway of his style of drawing, took their character from their strong outlines; an exploration of perspective as both compositional and expressive means; ideas acquired from contact with the Brücke group in 1912; and his first attempts to deal with the possibilities of color.

In 1911 six of Feininger's paintings were hung in the Salon des Indépendants in Paris alongside those of the French Cubists. At that time he wrote: "I found the art world in a storm over Cubism of which I had as yet heard nothing, for which, entirely intuitively, I had been seeking for years." Concern with Cubism became the chief thing for him, offering an answer to the problem disturbing him for years, whether the artist did not have to "experiment and seek for new logical and constructive solutions in order to create synthetic, pure form."

What he had in mind was not the autonomous, formal organism of a picture, the organizational principle arising from the analytical investigation of objective reality but, instead, the visual perceptions that grew out of the new formal structure and could be used to enrich and strengthen his own vocabulary.

Added to this were influences from Italian Futurism. Feininger began to make the geometrized surface dynamic by setting into vibration the originally solid, formal framework through refraction and color reflection of the contours, and this without regard for the Cubist structural rationale but only on the basis of the formal interrelation in spirit, space, and time of all pictorial objects. As he tried to explain this process: "I endeavor to formulate a perspective of the objects which is entirely new, entirely my own. I should like to place myself inside the picture and from there observe the landscape and the things painted in it."

That meant a change of mind as consequence of an attitude that favored expression: object and pictorial construction were to be subordinate to the subjective outlook as vehicle of expression. To some extent this accords with the idea of the "mystical inward construction of the world picture" that the painters in the Blaue Reiter orbit were striving for: in short, expressive abstraction. "My cubism, to call it by that wrong name since it represents the opposite of the goal of French Cubism, rests on the principle of monumentality and concentration to the absolute limit of my capacity to see. . . . My pictures come steadily closer to the synthesis of the fugue," as he put it, and in this he drew closer to

Kandinsky's ideas of the musical character of form and color.

This approach dominates the architectural representations that would thenceforth be his chief theme. It was not outer appearances that he painted, although like all Expressionists he retained them as associative value, but "the relationship of architecture to space, of the human to the eternal" (Hans Hess). In so doing, however, his searching spirit reached far beyond the limits of Expressionism: what he was driving at was the law of form as the effective force in a picture. Color he understood as an intellectual relationship, as a rigorous organizational power without curtailing its capacity for expression as spiritual principle.

Gelmeroda I is perhaps the most important work of 1913, of the time when Feininger found himself. From his base in Weimar he visited on foot or bicycle the small Thuringian towns and was enraptured by the abundant impressions he received, many of them remaining in his memory to be used, often decades later, as motifs for paintings. Seen here is one of his most dramatic versions of a theme he often varied, the village church in Gelmeroda. It is both monumental and triumphal, dark in mood, crystalline in construction. It reveals the new basic principle of his work: lines and surfaces interpenetrate to become crystalline, prismatic structures behind whose more or less abstracted forms the initial experience of visible reality lives on.

A spiritual reality irradiates what the painter saw, and its primary form becomes architecture. Here, too, the prismatic breakdown of all forms creates a dynamic unrest that fills every corner of the picture, even the sky. The three-dimensional solidity of architectural forms is only suggested, and by interrupting or reversing possible lines of flight all perspective is deliberately devaluated in favor of the surface plane that constitutes the work's conceptual point of origin. Feininger dynamizes contours by carrying them beyond the shapes to which they belong, making them break into adjacent forms and interspaces and resound like a remote echo across greater distances. Other than the spire of the tower there are almost no perpendiculars in the composition, only diagonals, trapezoids, rhomboids, and acute triangles which, though not balanced against each other, nonetheless hold each other in an equilibrium replete with tension.

The colors chime in strong tonalities, with shades of blue, blackish-violet, and green predominating. Yet even out of the dark surfaces light breaks through. A shining yellow and a terse, gleaming red give scansion to the rigorous tonal melodies, in which the tower sounds forth like a mighty furioso: majesty and mystery in one.

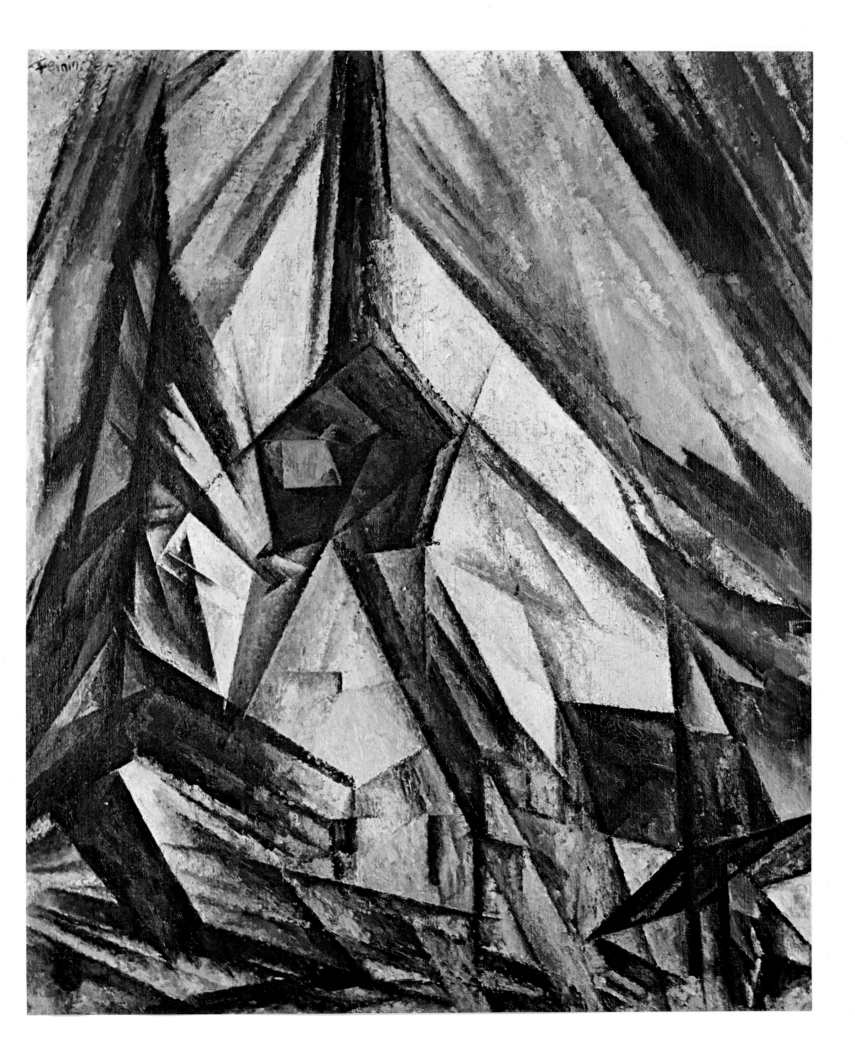

29. LYONEL FEININGER (1871–1956)

Portrait of a Tragic Being

1920. Oil on canvas, 33 1/2 × 31 1/2''
Serge Sabarsky Gallery, New York

Portrait of a Tragic Being is the title Feininger gave to this painting which, among his other works with their rigorous, architectonic construction, seems very much a foreign body, the more so since it sounds a key he usually did not touch. Here an artistic personality entirely devoted to harmony, discipline, and order gave himself over to Expressionist emotionality, subjected his pictorial thinking to a feeling of deep psychological disquiet, and let color and form be vehicles of expression rather than an organizational principle.

Clearly enough, the painter was not portraying any particular individual or personal fate, even if the picture, as we know, was based on the likeness of a friend, the wife of a musician. Nothing even tells us if it is a man or woman. What Feininger cites here is not the individual but the type, and that type is the Expressionist symbolic configuration of the human persona, the essence of a being.

The way to its formulation involved a steady intensification of means already at hand, the exploitation of their possibilities of evoking and suggesting. In this case Feininger set about it purposefully, in what seems to have been an effort to master some distressing memory or notion by realizing it in pictorial form.

The tragic quality lies in both the color and the form. The figure, unsharp in contour, leans somewhat to the left and props its head on its right hand—although nothing tells us what the arm itself rests on: a moment of sheer instability. The head gives the impression of a specific mass, light and shadow model it like a form in the round that tapers to a point and is splintered by stereo-metrical projections without losing its formal coherence. The eyes lie deeply beneath the heavily shadowed angles of nose and eyebrows, blankly, impersonally. The hand presses hard against the face, its edge lying sharply in front of the face, turning down-ward just as sharply: a moment of great harshness. The body is treated entirely on the surface, modulated only by the flow of the brush. Compared with the fastidious working out of the planimet-ric bases, the body is depressed and heavy in feeling, and this because the contours are blurred and the formal structure fails to make its point. One gets the impression that the painter set out to respect the usual organization of a picture, then gave up along the way. The color, too, because of the rejection of a basic construc-tional framework, is strangely imprecise in effect. It forces its way downward from the upper right toward the middle of the picture as a turbid, troubled timbre, then continues across the upper sur-face in a modified tonality, but in place of clarity a joyless character befitting the subject takes over. Even the yellow, although it retains something of its original luminosity and with the broken-up red makes a warm harmony within what is other-wise cool, is still so muted that it fails to make a strong pictorial accent. It no longer bears light within it, seems instead illuminat-ed from without. The way the paint is laid on matches the charac-ter of the color: restrained, less unquiet than burdened down, effortful, devoid of any dynamism or energy that would impose a particular direction on the brushwork.

If in other works of Feininger the boundaries between neigh-boring color fields serve to build up the abstract system of force and order through prismatic refractions, here the colors adjoin listlessly, all force spent. The contours imply neither radiation nor tension, and are despoiled of those traits so native to Feininger in particular.

Nowhere did Feininger come closer to Expressionism: witness the effort here to make color and form fit the urgent need for ex-pression, to shift their function to that of vehicles of emotional experience.

In our admiration for this unusual work, however, we should not overlook its date. Once more, at the end of World War I, an Expressionism in decline reached a last high point. But then it was no longer based on what had meanwhile become the classical style of its earliest exponents but, instead, on the strident radical-ism of literati and painters who came afterward and saw their salvation in the total overthrow of all existing order. An essential-ly liberating impulse had ended up in a demagogic irrationalism where it was utterly shattered. In spite of this, faith in a possible emancipation—the utopia of a new mankind—still held even the older and more experienced artists in its sway. A rallying point for the ideologists and idealists was the November Group that Feininger joined in 1918, doubtlessly galvanized by the general agitation of the time. That in 1919 he should turn out his famous woodcut *Cathedral of Socialism* (fig. 34) for the Bauhaus mani-festo—an Expressionistic graphic work whose primary signifi-cance was ideological and is to be understood today as a last flaring-up of Romanticism within Expressionism as is evident in the resort to the ''Gothic'' as leitmotif for transcendence—is proof of the depth of the spiritual unrest and the measure of human hope in a time that began aimlessly. Only in the Bauhaus was there again a goal and a conception, and to the extent that influence from expressive thought and action was pushed back.

This *Portrait of a Tragic Being* tells us where Feininger stood and where he was heading at that particular moment. It remained such an isolated instance that he never even used its color range again. In his subsequent Bauhaus phase he turned to other problems, to recreating the world as visual poetry through the medium of the picture. And this was the expression of a sensibility that may still have had an echo of Romanticism about it, but was committed to a fundamental orientation toward form.

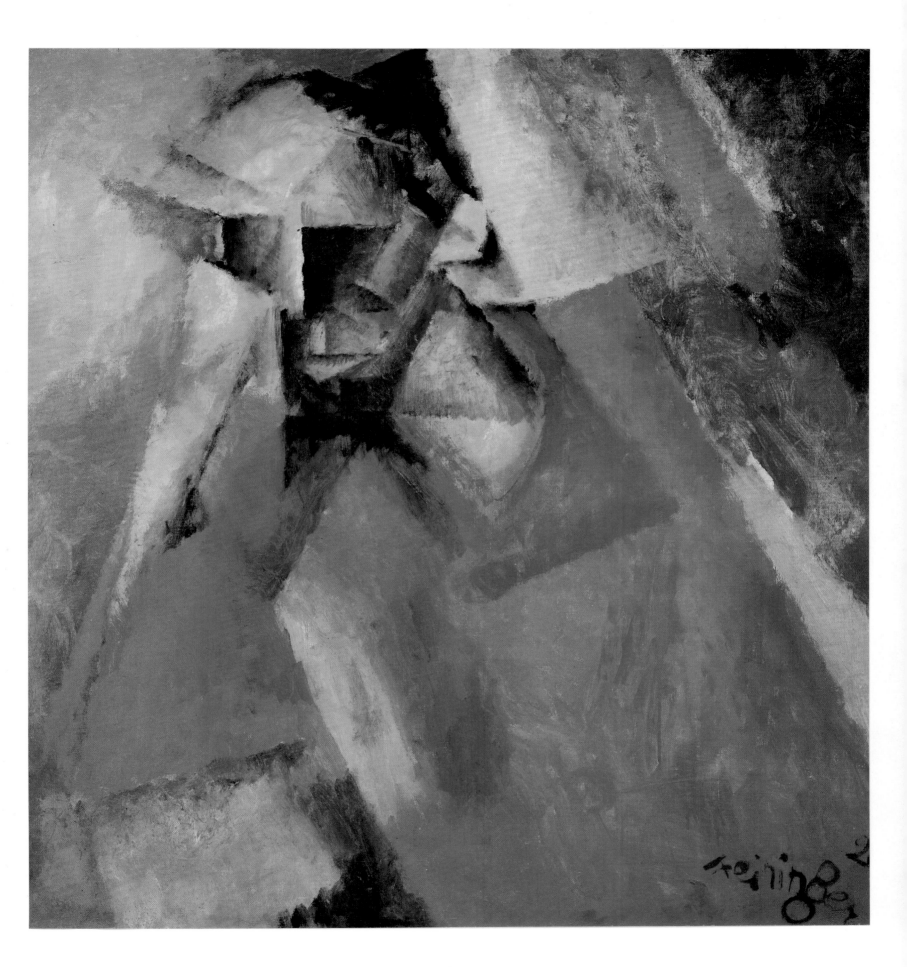

30. PAUL KLEE (1879–1940)

Villa R

1919. Oil on cardboard, 10 1/2 × 8 5/8″
Kunstmuseum, Basel

Initially devoting himself chiefly to drawings and watercolors, Klee only after World War I turned more and more to oil painting. In 1919 he already produced a good many pictures in his new way of working. Instead of color improvisations and rapid execution, now there was more thoughtful work on canvas or paper which, precisely because of the nature of the technique, obliged him to plan more carefully and build more slowly the pictorial zones.

This *Villa R* is among the most important products of that fruitful year. Klee was already becoming more at home with color. He had begun to master it in the happy months spent in Tunis in 1914, when he succeeded in making it something independent of nature but with equal rights. It was then that he confided to his diary: "Color possesses me. That is the meaning of this happy hour: I and color are one. I am a painter." Five years later he was on the way to those exquisite picture poems whose true significance would be understood only much later: not fairy tales, as people liked to think, but a new experiencing of the world.

This picture seems to be composed of isolated pictorial details that have grown together, each with its own meaning yet revealing its true identity only in the context of the others. But Klee's works are not to be read as picture puzzles. Any approach that tries to unmask real experiences behind their symbolic character shoots wide of the mark, misses what is so unique in his art. Here the inquiring eye first reconnoiters the separate zones, each like an alien landscape within the picture rectangle. The right foreground is taken over by a form with its own associations, a hill emphasized by outlining on which sprout mere indications of bushes or trees. From the left margin a broad band of smoothly laid-on, deep red swings across to the middle of the right margin like a road. Its sonority is taken up elsewhere and varied, in the housetops and in free geometrical shapes. In front of this strange highway a huge letter R dominates all with its complementary color contrast, a monument imposing itself on the scene.

The midground is made to stand out by a sort of architectural system that can be identified with the concept "house," without being anything like a house, but only house-related forms in various degrees of abstraction, in purely flat planes as well as Cubist shapes. These are set in front of and within a broadly laid-out "garden" background which, toward the top of the picture, appears to go into undulations reminiscent of mountains and hills; these are given final accents at either side by two shapes, a green half-moon and a yellow sun.

Yet such a summary description runs into difficulties. It says nothing at all about the picture itself: Klee is not to be understood in terms of what he seems to depict.

If, however, one looks at the picture surface as a magical ground on which freely devised structures come together in enigmatic relationships, comparable only to the realness of dreams, more convincing connections than the merely visual become clear. The picture has no depth, no perspective. What seems like space is only conjured up by the illusionistic spatial values of the colors deployed so ingeniously as to give the impression of an equilibrium, unstable as it may be, within the picture plane.

A peaceful picture, neither colors nor forms have any dynamic quality of their own. The only activity comes from the "pushy" red, which is promptly blocked by the barricade set up by the green of the R and, in a sense, is recalled to order. The insubstantial blue and the white of the squares, triangles, and oblongs fill the scene with cool light and put a stop to any nonsense from the illusionistic three-dimensional volumes of the cube and roof forms. If the "wooded landscape" of the foreground is still closer to what we see around us every day than are all the other parts of the picture, the "villa" takes the second step toward abstraction of forms. As for the shapes along the upper margin, they may be borrowed from landscape but register on our minds as merely ornamental surface movements: they are the elements most clearly subordinated to the picture plane and therefore to the picture itself, and so have forfeited their landscape character the most.

The delimiting triangle at the upper right and the curving shape at the opposite side act as frame to hold together the motley depiction. The sharp green of the moon acts as colder (since slightly bluer) countercolor to the R and at the same time delimits the composition on the left, while at the right the floating sphere, whatever we may wish to call it, makes a warm yellow counteraccent to the square red shape below it. Thus, secrets wherever one looks. Everything one would have thought self-evident and reliable takes on a magical personality. How else could the simple letter R pretend to lord over a composition like this?

Here we are peeking into a magical realm, one open only to initiates who can grasp that even the simplest element in a picture by Klee is not an arbitrary but an active component that affects the whole. The picture becomes a cosmos. In its two-dimensional world, things seen and experienced are transformed into the metamorphosed world of art. Klee himself sensed this as early as 1916: "I am seeking a remote starting point of creation where I sense a formula for man, beast, plant, earth, fire, water, air, and for all whirling forces."

The *Villa R* is a milestone on that path toward a new kind of picture. It marks the phase in which the real is transmuted into pictorial form and elevated, by means of abstraction, to a new naturalness on a higher plane. In it all objects achieve the dignity of a sign, as filtered experience, "like a writing that pushes its way into the visible."

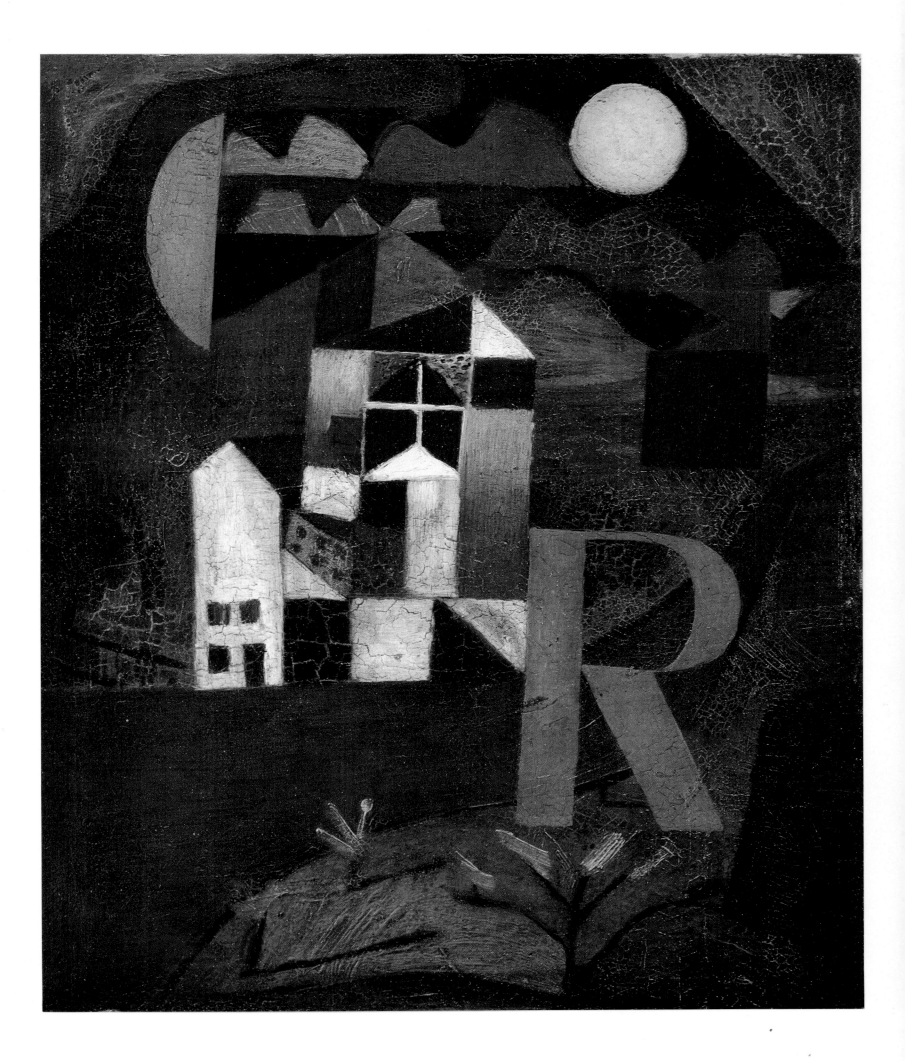

31. EGON SCHIELE (1890–1918)

Schiele's Room in Neulengbach

1911. Oil on panel, 15 3/4 × 12 1/2"
Historisches Museum, Vienna

In Vienna, paintings by Vincent van Gogh were twice on view at the start of the century—first at the Galerie Miethke in 1906, then at the famous Internationale Kunstschau in 1909. The influence on Austrian artists of this tension-racked spiritual commitment, of a second reality behind the visible, was as strong as its impact on the young Dresden Expressionists. What was revealed about the destruction of the traditional relationship of trust between man and world, and about the role of art in laying bare the concealed strata of the mind, fell in with kindred conceptions of the rising generation of artists. They fascinated the young Egon Schiele who, at nineteen, already had four works in the 1909 international exhibition. There he came to know Van Gogh's paintings and studied them so intensely that in the fall of 1911 he painted this picture directly after Van Gogh's famous *Bedroom at Arles*.

Schiele grew up as an artist in crisis-ridden Vienna, which was even more tormented with inner agitation than the German scene of the time. For most young Austrians the idol and model was Gustav Klimt, exponent of a rather special strain of Art Nouveau. His captivating sensuality, expressed in the overly refined and highly decorative compositions was transformed by the young Expressionists into lacerating, psychological tension. Kokoschka provides the keenest example of this step from a predominantly ornamental pictorial form to a disturbing and menacing manner that spelled out the secrets of the threshold realm of human experience.

Schiele, too, fought his way through Art Nouveau, without renouncing the possibilities it offered for his own development to the famous Austrian Secession style. In 1909, increasingly at odds with his teacher, he left the Academy. For all that he had responded to Van Gogh's stimulus, he took it only as a signpost because his own work was linked with it by inner agreement, not by dependency.

For art historians, it was around 1910 that Expressionism of an Austrian stamp made its breakthrough. It was then that the twenty-year-old Schiele was driving away at his art in a possessed state, seizing on everything he could use from the past and present, and translating it into a personal language. At that point his language united emotional agitation with a fanatical search for truth, resorting to symbolism to bring out the content of his experience—Expressionist paraphrases of meaningful models.

For all its outward relationship with Van Gogh, his picture of the room he lived and slept in at Neulengbach is an entirely personal manifestation of his own ability far more than merely a variation on a famous theme. One is immediately struck by the high viewing point. Although still taken into account, perspective is already forced to bow to personal commitment, to emotional development: the viewer is not in the room itself but soaring in some indefinable sphere. But what counts is not how much the things in the room are real, but the inner drama that seethes in a picture where, outwardly, nothing happens. It is not a matter of movement, since everything here is static, but of the tensions and contrasts between plane and space, color and line, light and dark, cold and warm, between the forms' connection with reality and the ornamental function assigned to them. The bed is an incorporeal shape and yet a mass, the elongated table at its side is fragile, unstable. Every object pictured is "normal." But by a slight shift of accent—overemphasis on a particular shape, restless but heavy brushwork, a choice of colors packed with tensions—something hidden emerges from that apparent normality. Behind the visible reality one glimpses a plane of reality expanded to include the things of the spirit as well, which comes only from the painter's communicative power: a characteristic process of transference of creativity.

Yet the organization of the picture is never thrown into question. With Schiele, expressive and pictorially decorative functions are in no way exclusive. This becomes especially clear when one concentrates not on the things depicted but on the relationships between their forms. Look at the effect of a black, red, or violet over a varied yellow. By stressing the color contrasts in the harshly opposed, geometrical forms, any possible harmony was ruled out in advance, although without entirely blocking the effect.

The painting, then, clearly sums up where Schiele stood at the time: an astounding sureness and awareness in such a young man, and the typically revolutionary attitude of a generation that at one and the same time did not deny its origins in the Secession and its link with Viennese tradition.

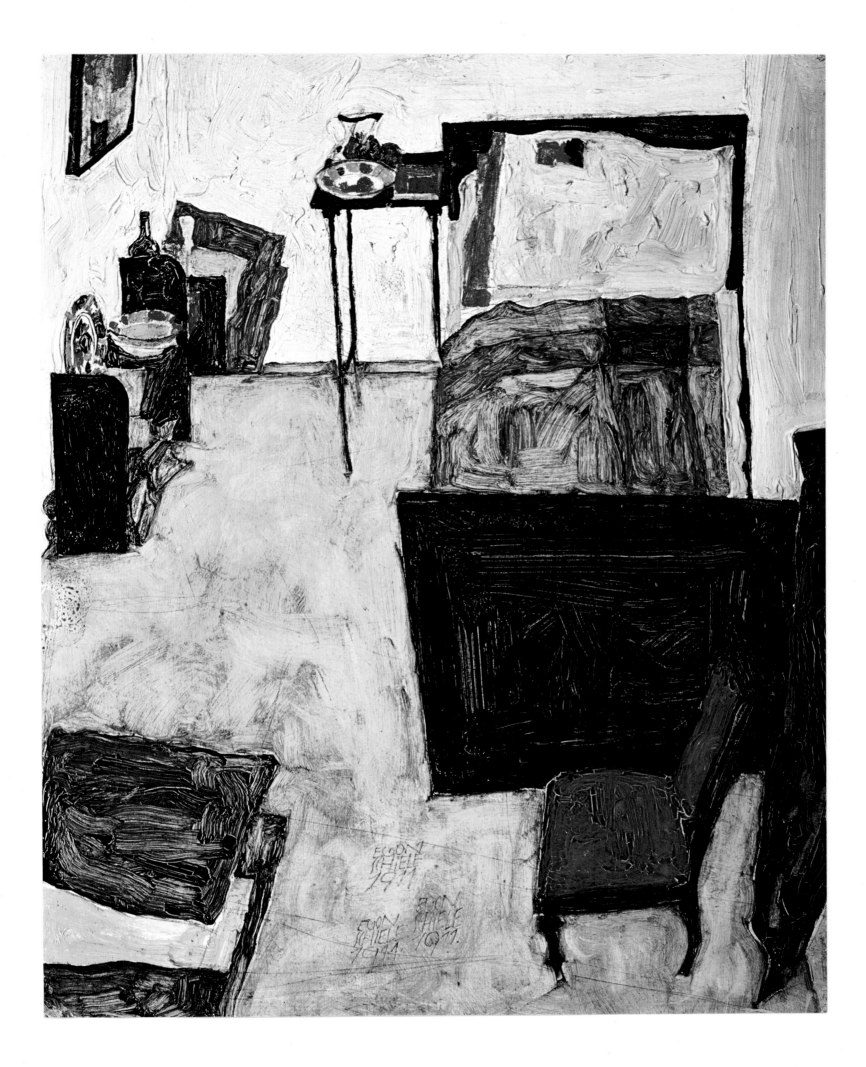

32. EGON SCHIELE (1890–1918)

Pregnant Woman and Death

1911. Oil on canvas, 39 5/8 × 39 5/8''
National Gallery, Prague

Among the characteristics of Expressionist art are its concerns with higher powers and forces, and its concentration on so-called primal experiences, themes that have to do not with individual experience but with essences. These themes left their stamp on the consciousness of a generation that was seeking to go beyond the personal and arrive at what is universally binding, and that often ran aground for precisely that reason. A new concept was created: phenomenology took the place of concrete personal experiences because of the wish to transform everything material into pure spirit, in which state it could be used as basis for intellectual insights.

Especially literature, but also scientific research, had pushed far ahead into the realm of the so-called typology of ideas. We know Sigmund Freud's theory that traditional human emotions are in the final analysis only a facade for the subconscious forces lurking behind them. That concept could not help but have an effect on the visual arts as well, particularly among the Viennese who, as Austrian Jugendstil had already shown, were very receptive to such subthreshold sensibility. The very special Expressionism of Kokoschka or Schiele can scarcely be explained without reference to the underlying psychology. The visual arts had for long made use of symbolic formulas that were at best circumlocutions when it came to depicting subjects still difficult to speak about openly and to find answers for them (a very essential concern of Expressionism). As one would expect, Schiele's generation continued to make use of traditional, natural forms. In Schiele's art, which especially pertinently mirrored the psychological situation of his time, objective reality continued to give rise to symbolic images, although now as aids to cast light on the inner life of mankind and to communicate its private experiences.

This explains the theme of death that was used at least once by virtually every Expressionist. In works with that subject we are repeatedly faced with the portrayal of the tragic existence of mankind, its revolts, its struggle for deliverance, and the resignation of the end. With Munch, there is particularly deep meaning in the room where someone is dead or dying; in the late works of Van Gogh one senses how it will all end in illness or self-destruction.

It was as early as 1910 that the young Schiele embodied the idea of the sovereign forces of destiny in his painting *Dead Mother*. The following year he did this *Pregnant Woman and Death*, a work of exceptional gravity and awe-inspiring finality. Erwin Mitsch has published a passage from a letter of 1912 in which Schiele may have given the key to it: "The picture must give out light on its own, bodies have their own light that they exhaust in living; they burn away, they are unlighted."

Coming into life and going out of life are given symbolic form here, facing each other harshly: a pregnant woman, death. Their forms are built up of color laid out in large areas and separated off from each other—again the principle of decorative organization by surface areas found in the view of Schiele's room (colorplate 31).

Death is dark, closed, hidden like a monk in a broad cowl scarcely differing from the darkness from which he comes. Out of his dark garments emerges the angular skull with closed eyes; the cloak's geometrizing lines underscore even more the hardness of its bony contours. Wide sleeves conceal the hands, emphasize the impression of withdrawal into himself already conveyed by the shut eyes. In the middle, where the monkish robe opens, a narrow, brighter strip hangs down, making a counterweight to the light of the skull.

To the rigid, upright stance of death is contrasted the body of the woman big with child, who sinks backward toward the right although still linked to the messenger of darkness by her head and belly. Her garment falls wide open to expose the heavy body that stands out like a monumental symbol, each plane outlined and graduated in color between white-underpainted, broken-up areas of yellow and variations of red that here and there take on particular pungency. The color has nothing to do with reality, makes sense only in terms of its expressive function, in the same way as the picture itself is not to be understood as portrayal of a particular situation, but as an image that speaks of tragic destiny. The surface divided up as in a stained-glass window and the contrasts between dark and light make for a mystical effect, and so, too, the utter immobility of the figures. No revolt, no grieving outcry. Death comes not as enemy or grim reaper, only as something that must and will take place. No need for dramatic gestures or action. The unspoken entente between two such opposed symbols as existence and extinction takes away from the depiction any trace of real happening, every personal trait, but also all individual participation. It stands for that contact with the eternal, with the natural law of the last truth where protest is of no avail.

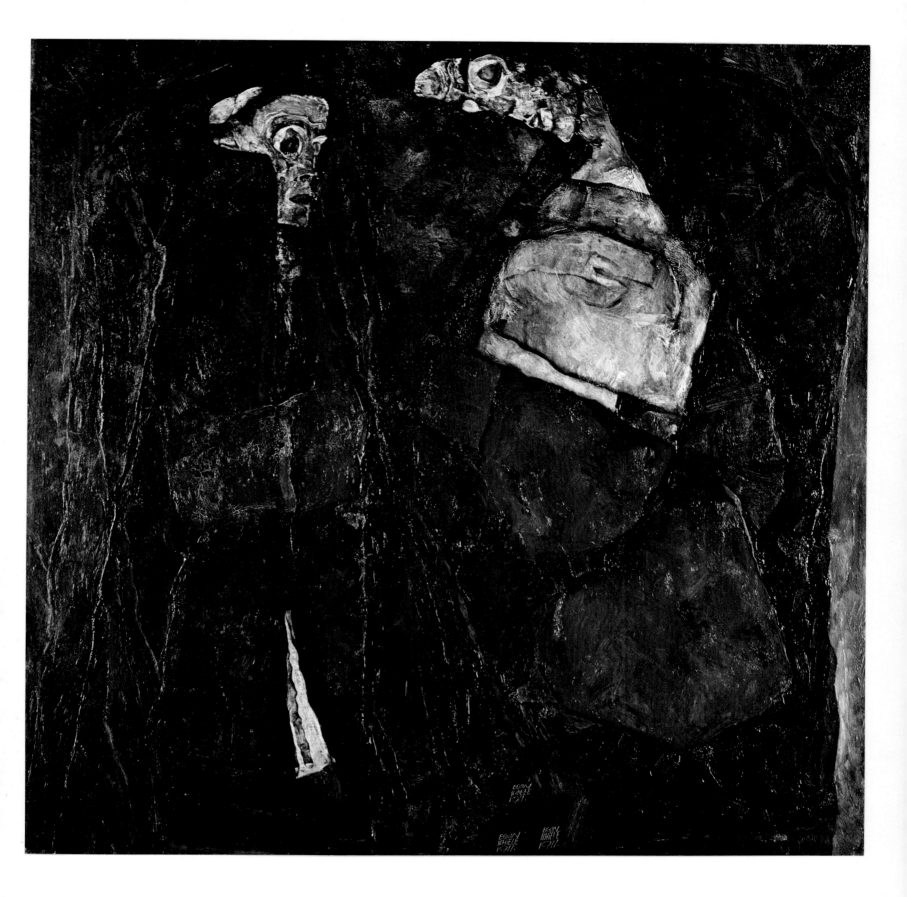

33. OSKAR KOKOSCHKA (1886–1980)

The Bride of the Wind (The Tempest)

1914. Oil on canvas, 71 1/4 × 87″
Kunstmuseum, Basel

No artist represents more clearly than Oskar Kokoschka the peculiar ambivalence of the Viennese spiritual climate after 1900. As a student in 1905 at the Kunstgewerbeschule, the applied arts school that enjoyed the reputation of being progressive as compared with the tradition-minded Academy of Fine Arts, the young artist was confronted with the impulses the Austrian art world was receiving from other European centers and, in its turn, enriching with that mixture of scientific diagnosis and human sensibility that we recognize today as one of its chief traits. Into the heady brew went ideas from the Munich Jugendstil, London Liberty, and Paris Art Nouveau, and all of these influenced Kokoschka's early work. His famous lithograph illustrations *Die träumenden Knaben* (*The Dreaming Boys*), with Symbolist, arabesque decorations on strongly colored grounds to a legendlike text, blended stimuli from Aubrey Beardsley and Gustav Klimt.

His next works already showed an unmistakable bent for the visionary, an attempt to master the images surging up from the subconscious by using a new pictorial language. This was the time when he brought out a group of dramas in which both word and image appear to elude the control of the intellect and in which hallucinatory emotions evoke abrupt outbursts while visible reality more and more makes way for imaginative self-expression. His pictures began to mirror the ego of a single artist as surrogate for the major phenomena of the time, among them Freudian psychoanalysis in Vienna itself. The result demonstrated the state of his soul within the traditional genres of still life and portraiture.

The youthful artist was irresistibly impelled toward Expressionism. Like his German colleagues of the same age, Kokoschka took as base the real and visible, which he could then transform into a metaphorical vehicle for overwhelming emotional experiences. His approach to color, however, was unlike theirs. Earlier than the other Expressionists he came to understand color as the cogent means for transposing psychological feeling directly into image. Drawing, whose nervous spiderwebbing had set the tone in his early works and to which he had been entrusting everything to do with a psychological aspect, could no longer take the lead.

The call to Berlin by Herwarth Walden in 1910 meant further encouragement to his great talents as graphic artist. The German metropolis was becoming the center of Expressionism. The intensity of its intellectual climate, for which at the start literature even more than painting was responsible, had a different impact on the young Austrian than on his German fellow artists. His personal exhibitionism was rooted in that instinctual compulsion that Freud had shown to be the latent motive force in human existence. It manifested itself much more through the hectic rhythms of his brushwork, through a deeply dimensioned figuration embodying the ego experience of the artist than through the harsh color sonorities that meant so much to Nolde and the Brücke painters. These, as compared with Kokoschka, were truly colorists still feeling their way to the expressive possibilities of color by intensifying its tonal values.

Although in those years, and even after the demise of Expressionist painting, the literary champions of the libido's primal drive exalted an unbridled surrender to ecstasy, the German painters handled such matters with restraint. In Expressionist art there are no pornographic images although the themes of loving couples, whores, and male or female nudes claim a wide place.

In this, too, Kokoschka was different. His pictures, like Schiele's, mirror the subterranean, intoxicating tension as "primal feeling" of the incipient, yet never consummated, union of the sexes; this along with a passionate protest against traditional notions of morality, but never that piquant or perverse eroticism found in the Art Nouveau of Aubrey Beardsley or Franz von Bayros. The overpowering wish to take a stand against bourgeois narrowness and repression of instinctual drives by shocking the world with the unabashed disclosure of his own intimate relationship became the basis for one of the most renowned works of the period, *The Bride of the Wind* of 1914.

The subject is his consuming passion for Alma Mahler, widow of the composer. It is the emotional core and content of this volcanic outburst of ecstatic feeling that Kokoschka nonetheless knew how to keep within the limits of art.

At first the painting seems an apocalyptic landscape, a moment in the story of Creation when form was brought into being out of formless cosmos. A Baroque pathos blows through the scene, whips everything real into mighty swirls. The festooning colors swing like great ornaments around the soaring couple who, in the very heart of universal uproar, appear uncannily calm and fulfilled. Churned-up feelings are bared, true, and what reveals them is the explosive way the picture was painted.

The dark tones of the ground make a foundation for a livid, white light that throws the surface of the picture into dramatic tension. The brushwork is unbridled, the forms tangle in wild skeins, unravel, are caught up again in the universal furor. More than the bodies, it is the man's tightly cramped hands that betray the psychological situation: in them the tension reaches its peak. The background remains open: germination within formlessness, man in the primal state of his feelings, between mounting tension and release. A prodigious double portrait that takes its grandeur from the drama of human experience even though the accepted laws of color are systematically smashed.

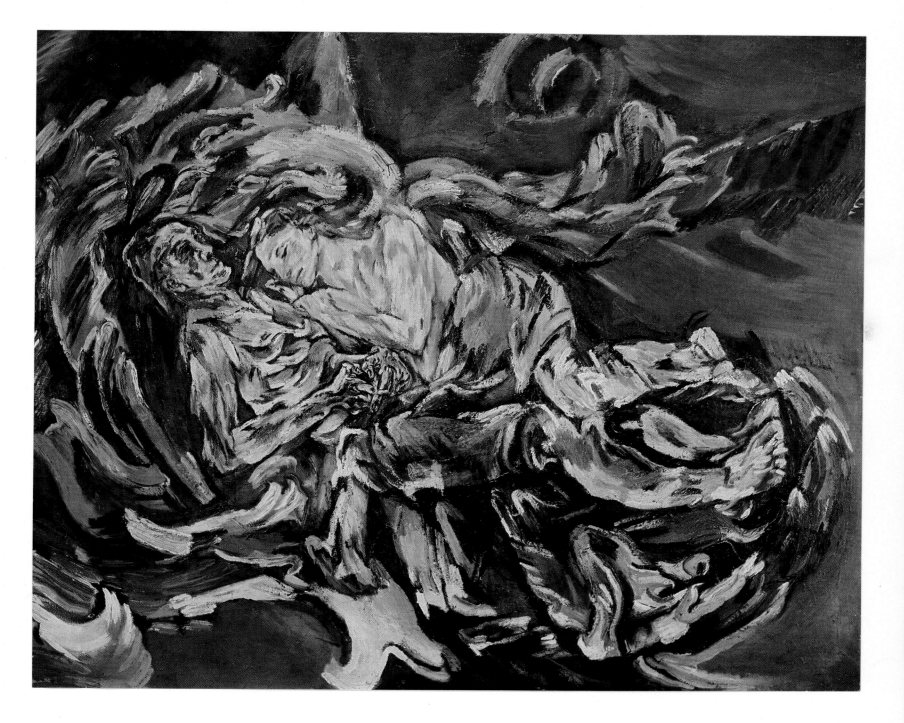

34. OSKAR KOKOSCHKA (1886–1980)

The Elbe River Near Dresden

1919. Oil on canvas, 31 5/8 × 43"
The Art Institute, Chicago

With his *Bride of the Wind* of 1914 Kokoschka was confirmed as a new force in Expressionism. For the years that followed it remained a key picture. When he returned to Berlin in 1916, convalescent from his war wounds, he had not overcome his exalted emotional state; to the contrary, the horrors of his military experience and the turmoil of the time that soon climaxed in revolution reinforced his exhibitionist drive. Nor did a move to Dresden in 1917 change anything, since he promptly joined its most bohemian circles.

The works of that interim period reflect his exceptional sensitivity for everything abnormal around him. The psychological and anguished side of his painting reached such a pitch at that time that it seems legitimate to question just what function art had for him in that state. It had become an inseparable part of his life, and existed without any need for some kind of law or desire for form and order even when threatened with bursting apart: more symbol than image.

What his paintings, mostly scenes with figures, were really depicting was what he called "psychological arrangements," symbolizations of his visions of "the battle of man against man," of "contrast between hate and love"; "and in every picture I seek out the dramatic accent."

Unquestionably, such an approach signified carrying the Expressionist emotional drama to its utmost intensity. In a way it was entirely attune to the Berlin scene of those years, where painters as well as writers were proclaiming the death of art, but also salvation through anarchism. Yet even in that precarious situation, and despite his undisciplined attitude toward content and form, Kokoschka was still the greater artist than those about him. Paint remained the vehicle for his urge to expressive communication, paint heavy in substance, nervous in application, hectic in its churning twists and scrolls.

Not until he made a new contact with the outer world, with landscape, was there a change. Among the many landscapes he produced in Dresden, which launched his later fame as painter of cities, various views of the Elbe River are of particular note. Although they were painted from well-known sites, especially from the terrace of the Brühl Gardens, Kokoschka dealt freely with what he saw, reflecting his personal view of the cityscape with a new concentration on form and a forceful and glowing use of color.

Even in these, the old Expressionist emotionality lingered on.

But now it was supporting a new pictorial organism that could do without frantic excitement and in which force and matter were no longer equated with disruption and explosion. Full-bodied colors predominate, often brilliant in effect, and Werner Haftmann is certainly on the right track in seeing in them Nolde's influence.

Typical of that phase, and a fine work in its own right, is this view of Dresden. If its use of paint suggests a first step toward "dramatic Impressionism," this means chiefly that a painter bursting with temperament was returning to a delight in nature, coming to happier terms with it by way of painting, while his own personal feelings continued to determine the impressions received by his eyes.

The foreground is taken up with the deeply luminous blue of the river. Small areas toned down by white alternate with richly built-up, green streaks and patches. A strip of sky replies to this, taking over and varying the colors of the river without breaking out of its tonal scale. The city view across the midground contains the main color accents, which counter the full but cool blue used elsewhere. Here Kokoschka staked all on strong contrasts, not only light and dark, cold and warm, but also, predominantly, those of complementary couples: red against green, blue against orange. A festive sonority rings through this firmly organized composition. The earlier festoons of paint have been given up, the picture is built of structural planes and flecks of color now used both as sonority and as material. Looked at purely in terms of paint, the composition seems almost abstract. But do not overlook the details which are of key importance for the picture as visual experience, and which reveal a delight in narration almost alien to Kokoschka: horsemen wading through the shallows, the architecture of churches and houses, clumps of trees, and arches of the bridge. Even his signature becomes part of the color ensemble, a strong red accent against the dominant blue which it reinforces.

Happy in feeling, the picture shows that Kokoschka was going through the same development as the other Expressionists around 1920. The encounter with nature was putting a damper on their blazing passions and leading them again—with Kokoschka it was for the first time—to come to terms with visible reality whose spontaneity, for him, continued to depend on the Expressionist way of seeing: "The landscape is assimilated to the dramatic state of the observer" (Haftmann).

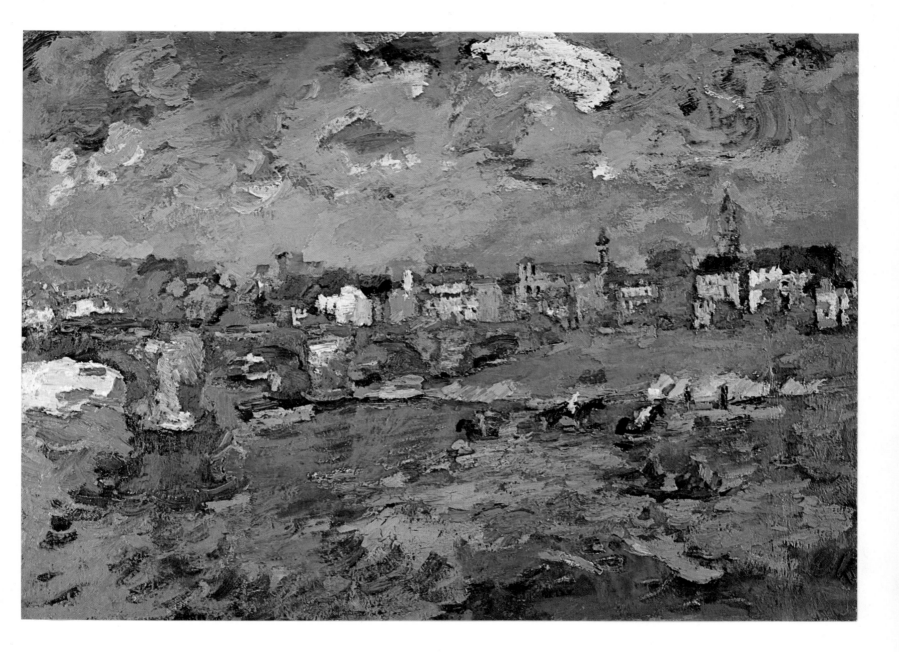

35. WILHELM MORGNER (1891–1917)

Path Through the Fields

1912. Oil on pasteboard, 29 3/8 × 39 1/8''
Property of the city of Bochum

The year 1912 had special significance in the brief career of the Westphalian Wilhelm Morgner: a visit to the Cologne Sonderbund Exhibition opened the eyes of the twenty-one-year-old painter to the true innovators of the time, from Van Gogh to the famous Fauves, Cubists, and Expressionists including the Blaue Reiter artists who were dominating the current scene. He had not been unaware of avant-garde developments. As a pupil of Georg Tappert in the art school at Worpswede in 1908, he had been introduced not just to the craft of painting but also to the art of expressive creation. But perhaps he was still too young to profit from such ideas and, besides, he did not study long. Lack of funds soon sent him back to Soest, where he tackled the problems of form on his own, although color still lay beyond his grasp.

It was only about 1911 that his work began to take on a recognizable direction: objects were monumentalized into large forms by simplification, outlining was used not to delimit shapes but as a source of strength as well as of decorative surface rhythms, and color was treated as streaming flow and kinetic impulse. In this the young man was instinctively facing up to problems occupying artists in the chief centers, although they were more successful thanks to the more international climate. Morgner's slow turning away from realism was effected by stylizing the things depicted, with the aim of bringing surface, pictorial space, and form into a unified field of tension without recourse to traditional illusionism or perspective. The intensification of the pictorial means resulting from that process of concentration was based on Neo-Impressionist ideas of color, although used coarsely and without the French rationality. Laid on with uniform, bright tones, color lost all its capacity to illuminate and to create illusion, and became simply a means of painting in itself, devoid of expressive communication or symbolic value.

That was the state of Morgner's art when this *Path Through the Fields* was painted in 1912, but now enriched and perhaps motivated by the experience of the Cologne exhibition of that year. The picture is still not a convincing psychological unity; the artist was only gradually beginning to sense his goal. Yet it shows an astonishing power and emotional resoluteness, especially from a young man growing up outside the orbit of the leading ideas and only just embarking on his career.

The theme is simple: a vast landscape before a deep, dark sky with flaming sun. The depiction is entirely based on color, and the intention was plainly not to reproduce something seen but, at the most, to make use of that visual experience as impulse toward a fury of color to which the artist surrendered entirely, yet without losing control—an attempt that, with some reservations, can be considered a parallel to the first efforts of the young Brücke painters six years earlier to come to grips with color.

The many-stranded stream of colors in the central foreground and midground splits open like an energy-packed bundle of rays and gives rise to a dramatic tension in both form and color contrasts. The movement is stemmed by a bridgelike arch of strong red behind which the gleaming blue evokes an unreal pictorial space without recognizable limits, and to this the flaming circle of the many-colored sun makes a dynamic counteraccent. It is obvious that the painter was striving for the strongest expression in color and did not find it easy to set any sort of artistic limits on the explosion he was unleashing. All possible harmonic effects were passed over in the orgiastic recourse to a full scale of colors. From there, only a small step would turn the entire pictorial field over to color alone, with everything objective negated. Logically, this Morgner tried to do in the same year.

A picture now meant more to the young artist than ever. It had become the expression of an intense personality that had been given status by contact with the great of his time and accepted by participating in their exhibitions. There was a feeling of liberation from compulsion and opposition, an ecstatic desire to smash open traditional conceptions in order to touch the farthest limits of the possible. Perhaps this work can be called "Westphalian Expressionism" because of its color symbolism. If it shows contact with the pioneering tendencies of the time, it does not follow their lead since it is first and foremost self-expression. It strives to break through the barriers to the "universe of the inner man," the ultimate goal for Wilhelm Morgner as for all the artists of his time who thought and painted in terms of personal expression.

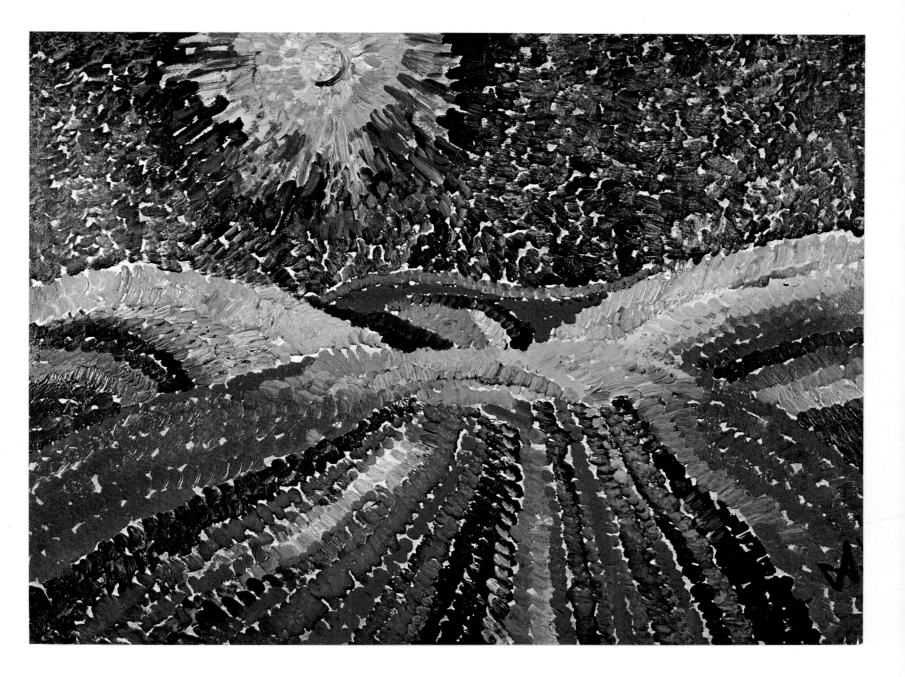

36. OTTO DIX (1891–1969)

War (Arms)

1914. Oil on pasteboard, 38 3/4 × 27 3/8″
Kunstmuseum, Düsseldorf

Dix and Grosz, two essential representatives of the first post-Expressionist generation, had in common their age, training, war, disillusionment, revolt. Both had to stand fast during the general collapse before having had a chance to make a place for themselves in life and art because of their youth. Very early, though, the differences in their temperaments became obvious. If Grosz sought to convey experience by hard diagnosis, to unmask the world, and through exaggerated caricature to hold it up to view like a propaganda poster, Dix was inclined to approach step by step what eluded comprehension and to wrench from it the formal, symbolic sign that alone could express what he felt about it.

Dix, unlike Grosz, had to endure the nightmare of trench warfare from 1915 on and suffered a number of wounds. His intense involvement in all these horrors at first made it impossible for him to get them under control. Lacking was the distance that would have enabled him to face up to them by force of intellect. Thus his many drawings and gouaches of the war years are only fragmentary sketches of isolated moments of experience which could not embrace the totality of the horror.

Dix was not trained as a painter, and at the start the medium was not of particular moment for him. He entered the Dresden School of Applied Arts in 1909, studied ornamental drawing and three-dimensional design, and thanks to his skill in drawing soon won a reputation as poster artist. Fine art, taught only at the Academy, and the applied arts were such entirely separate studies that even their final goals were irreconcilable. Dix's early attempts at painting, from 1911 on, were therefore the efforts of a self-taught artist. Certainly his horizon was widened by having to work things out for himself. He learned what he could from Van Gogh and the Expressionists, and rapidly acquired an astonishing sureness in using the means of painting.

Two important works closely related in style, this one of 1914 and the *Self-Portrait as Mars* of the next year, tell us much about where the young artist began, and they already contain all the bases for the further development of his painting and drawing.

Not only the cannon in the center makes this picture a symbol of the disasters of war. It was an attempt to project the entire notion and meaning of war with what formal means and artistic stimuli were within his grasp at the time. Considering its date, it could not derive from his own experience but only from literary sources and general ideas.

War is represented in direct terms, as embodiment of universal destruction and at the same time as explosive action summed up visually in disintegrated forms and bursting tension between the pictorial details. However disconcerting all this compositional arsenal may seem at first, one easily picks out particular objects: grenades and machine guns, unmeshed gear wheels juxtaposed like parts of a senseless mechanism, exploding projectiles, houses in flames, collapsing walls, fragmentary faces like spare parts of robots—a grotesque world of anonymity from which anything human has been banned, a tumult ingurgitating all and everything.

It was far from easy to unite formally such bits and pieces without imposing a too strict order that would make all this anarchical, terrifying, faceless confusion look like a new principle of form. Dix mastered the problem by liberally borrowing from the European art scene. He took over the method, but decidedly not the rationality, of Analytic Cubism and used it, as did the Expressionists, to intensify the meaning by breaking down objects into a geometrizing system that was largely dominated by prismatic refraction. In this he had found the linguistic possibilities of purely pictorial means which at the same time were psychological.

He further eluded the balanced rationality of Cubism by adopting the dynamism of the Italian Futurists whose intention was to depict the violent excitement of motion and speed, the intoxication of action. Dix borrowed this aspect that had been arrived at by analysis of movement: the absolute movement of lines of force indicating how an object becomes decomposed by the movement and form that are inherent in them. These abstract, dynamic forms work like the radiation of a field of force within the pictorial space; and along with this, relative movement is made visible by two simultaneous currents of movement occurring at different times.

The static center of all this is the mortar with its barrel raised menacingly. The rest of the picture shows the consequences: cannon bursts, houses blown to pieces, wheels spinning to swivel the big gun into position, even the uproar of the detonations. The individual planes of reality, outer and inner, seen and felt, near and far, are thrown together into a new kind of pictorial unity, a more complex one than classical art could ever have imagined.

The color, too, is entirely in the service of this action: hard, lurid tones full of contrast that force the picture's dynamic to its utter limits.

Cubism and Futurism exploited in an expressive manner to communicate the artist's own state of feeling—here is Dix's synthesis which, in 1914, still seemed to him as if it could master real events.

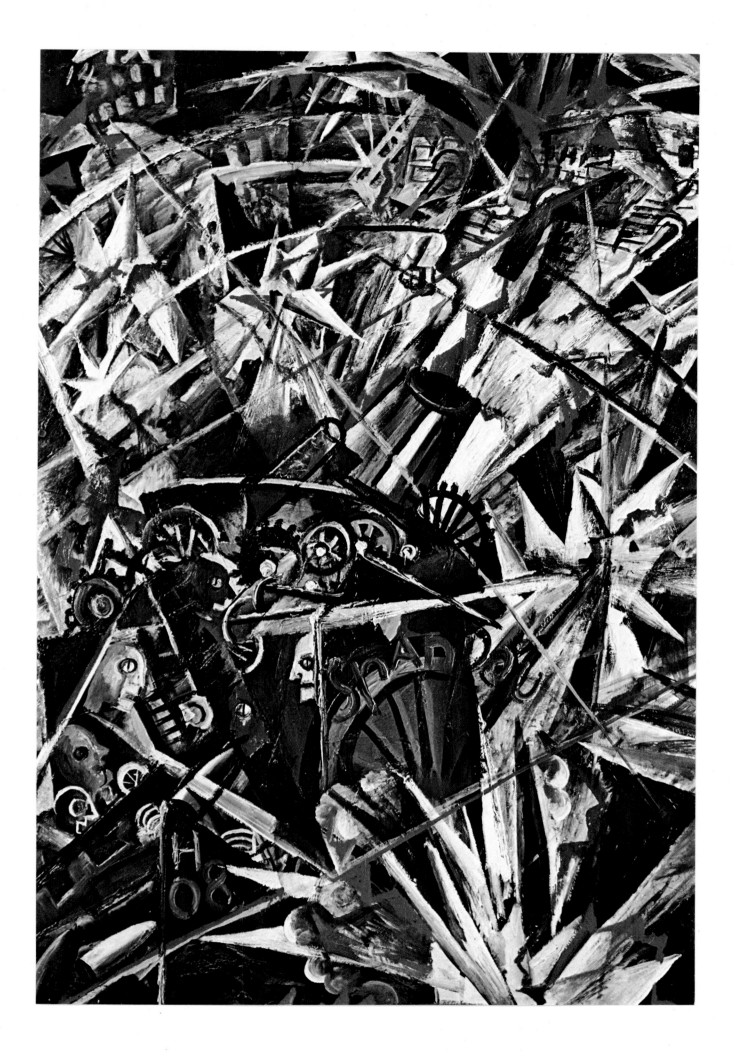

37. LUDWIG MEIDNER (1884–1966)

Burning City

1913. Oil on canvas, 27 × 31 3/4″
Collection Morton D. May, St. Louis

The critic who said of Meidner's first exhibition in Berlin in 1918 that "one felt almost a shudder before the extraordinary shamelessness with which the soul was laid bare" brought into sharp focus incipient Late Expressionism, that second wave of compulsion to expressive communication represented by the followers, not the founders, of the movement. The works with which those younger painters first came before the public around the start of the war showed that to their minds the classical Expressionism of the Brücke group, by then at home in Berlin too, was simply a new aesthetic and no longer a revolutionary principle. The fact is, by then only a die-hard public determined to be shocked at all costs still damned as barbarous the brilliant formulations the first generation had arrived at. Today, we can recognize in those works a sovereign mastery that already spoke of the imminent demise of what had been a revolutionary style.

Not so with the next generation. From their ranks new strengths came to Expressionism that stretched the style to the limits of the possible and would later lead to the demand for the annihilation of all art.

Meidner was typical of an age group distinguished from the classical Expressionists less by birth dates than by a difference in conception. That his pictures always strike us as those of a self-taught artist is what one would expect from the time: one learned things only to make no use of them.

Yet Meidner did attend the Royal Art School in Breslau, worked as fashion designer in Berlin, and spent two years in Paris studying Impressionism. Not until about 1912 did anyone take note of him. As cofounder of the short-lived Pathetiker group, he was brought to public attention by the Sturm Gallery.

The young artist craved intense spiritual experience, the scream of ecstasy, destruction as sole hope of the oppressed. Those were years when there was a veritable babel of tongues: to make oneself heard one had to shout louder than the others. So the chief aim had to be to raise means and possibilities to the highest power, and for that the picture as form rooted in organization would not do, and color seemed too tainted with outmoded aesthetic pretensions if used as the Brücke and Blaue Reiter "old masters" were doing.

The *Burning City* of 1913 was not only a product of this situation, it was also prophetic of things to come. Apocalypse and vision had a firm place in the works of the Pathetiker painters, works that convey no visual experience but the lurid expression of their own stark need. If that was to be communicated, new pictorial signs would have to be sought. Meidner also found the formal method of Cubism useful, used not logically and constructively like the French but for elemental expressiveness like the Germans.

Here the splitting of the picture into a higher and consequently emphasized foreground and an equally emphasized background creates its own kind of exasperated tension. Deep unrest pulses through the painting. The big-city tenements are jammed in against each other at acute angles, one looming over the other, their wobbling shapes by no means immaterial as with Grosz or Steinhardt, but of a painful hardness. The quiet night sky and its stars and the warm, yellow glow of the street lamps are deceptive: explosions shatter the fabric of the metropolis, fires break out, and black stars make a truly apocalyptic countertone to them. Although Meidner was not yet working with the Futurist system of simultaneity so much favored by his age group to intensify visual noise and dynamic, as we have just seen with Dix, there are hints in that direction.

The broad foreground acts as a powerful parapet above the dramatic panorama of the city. Here the anonymous event of the background is condensed into a symbolic form of human beings that seem like ants between the rows of tenements. Twisted faces, cramped hands, a mouth opened in a scream—the intensification of feeling becomes a caricature in its excess, man as mockery of himself. No question of individuality. Not the fate of this man or that sets the tenor of the scene, but the Expressionistic search after types in a posterlike reality. The masks racked with emotion, the feeling of precariousness that this seemingly firmly built bastion nonetheless conveys, these reflect the catastrophe behind them, focus the horrors of destruction as in a burning glass.

It is precisely here that the inadequacies of this early work, where the wish outstrips the achievement, stand out particularly gravely. The faults are due not to this artist's personal qualities, but to the Expressionist process of artistic conception itself: anything goes so long as it screws the pitch even higher. Once again the outcry of protest failed to find adequate pictorial form, again the drama was entrusted more to gesture and symbol than to the expressive power of paint and color. Yet this work could not be more typical of the approach of that in-between generation: action not art, poster not picture. Premonitions of the impending debacle have swept over the artists. Dim despair ends up in frenzied outbursts whose intensity goes far beyond the possibilities of paint. Expressionism has reached its furthest limit.

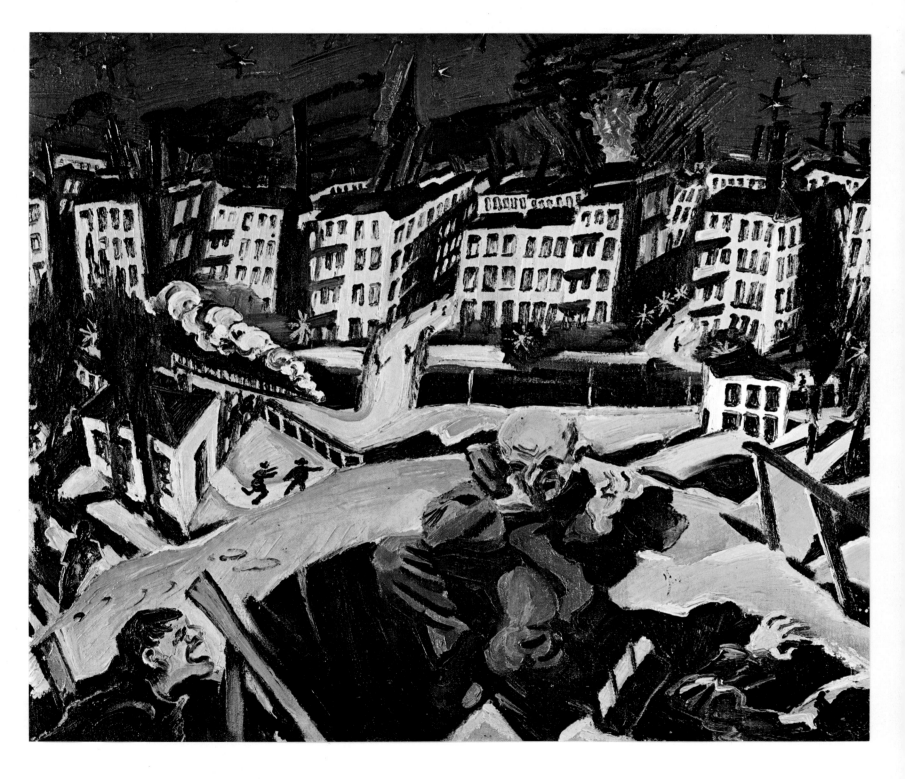

38. JAKOB STEINHARDT (1887–1968)

The City

1913. Oil on canvas, 24 × 15 3/4″
Staatliche Museen Preussischer Kulturbesitz, Nationalgalerie,
Berlin

Of the short-lived Pathetiker group, which burst on the Berlin scene so aggressively in 1912 under the auspices of the Sturm Gallery, only Ludwig Meidner, doubtless the strongest artist among them, still gets some attention. The two other members, Richard Janthur (1883–1956), who came from Zerbst, and Jakob Steinhardt, born in Zerkow (Posen) and died in Israel, are almost forgotten in Germany: the fate of a generation that came on the scene at the start of a general collapse and whose early successes had so much to do with the temper of the time as to make them already out of date by the early twenties.

Steinhardt's parents belonged to the tiny Jewish community in a small town inhabited otherwise only by Poles and Germans. He received every encouragement. Thanks to the tireless efforts of his mother, who had great faith in his talent, Posen benefactors enabled him to study at the Berlin Academy after painters such as Max Liebermann, Wilhelm Trübner, and Lovis Corinth had praised his first works.

A stay in Paris followed, a brief month in the studio of Matisse, then study under Théophile Steinlen at the Académie Colarossi. Return to Berlin and a trip to Italy which ended in depression: in Florence, the young painter destroyed everything he had done. Not that he was unique in having such a crisis. It was the lot of many other young men searching for new points of departure. Received ideas seemed to offer no firm grounds for further development, and there were signs of a widespread conversion to realism among the Fauves around Matisse, the German Expressionists, the Italian Futurists. To commit oneself was difficult for anyone who had not yet found his own way, who could perceive the future only dimly.

That Steinhardt met Meidner at that point was a stroke of luck. They had much in common, and friendship and working together made a difficult situation easier to bear. Together they could formulate a common goal: no longer to filter characteristic form out of things seen but, instead, to lay bare the depths of the soul, to establish valid relations between man and reality, to use art for communication—still Expressionist principles, in content at least.

The name Pathetiker was easily thought up. Pathos—in the sense of deep feeling, emotion—was not judged something negative but the expression of life itself, a slogan for resistance, for the revolt of man against the prison world of conventions.

This painting of 1913 sums up the situation. As with Grosz and Dix, here too there are distant reminiscences of French Cubism and the Italian Futurists, and as in their works the formal accents are likewise given an expressive cast. Yet Steinhardt's approach is already plain: the picture is a psychological fabric of feeling, the formal scaffolding is exploited as a communicative vocabulary. Feininger, in his early graphic work, had similarly set about despoiling the architectonic framework of the city by refraction and dislocation, by elongating it almost in a Gothic manner so as to arrive at a transcendental vision of metropolitan life.

Here unreal houses open their windows and let us look in, not stripping off veils, as Dix and Grosz did later, but simply making a statement, bearing testimony to the presence of life. An expressive light permeates the separate scenes and makes them appear immaterial; so, too, the street where masses of people push along, through which a tram has a difficult time making its way. Here, too, there are no real people, only shadows, elongated like the figures of El Greco, beyond individuality, faceless, fateless, mere types. The overall tone is cool. The night scene is dominated by a scale between blue and green contrasted only by a few shades of yellow and ochre that stand for light. The structural framework of the composition arouses dynamic tension similar to the so-called fields of force in Futurist paintings. Yet this is not the complex world the Italians were trying to represent. Here everything takes place in silence, spooklike, alienated, remote.

The head in the lower left corner, which can be singled out from the gloom around it only with some effort, provides a focus for the painting's inner world. With half-shut eyes and pensive pose, the man is entirely inactive, concentrated on whatever unexpressed thought goes on inside him, and thereby sets the mood which, despite the seeming frenzy of the street, penetrates the entire picture: lostness, loneliness, apartness. This second generation brought out repeatedly this constellation of feeling in its many pictures on city themes—the awareness of being alone among thousands, lost in the anonymity of existence, barred from sharing company with others: the tragic stage set of art and of life.

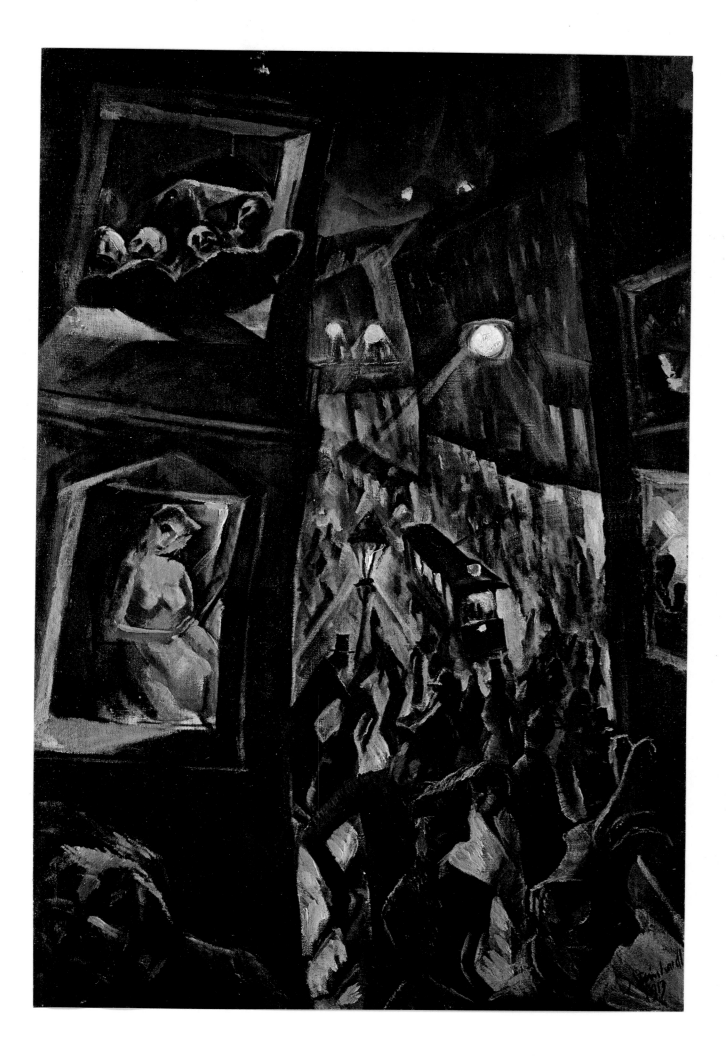

39. GEORGE GROSZ (1893–1959)

Metropolis

1917. Oil on cardboard, 26 3/4 × 18 3/4″
The Museum of Modern Art, New York

Toward the end of World War I the age gap of a decade or so between the generation of the classical Expressionists and their direct successors was responsible for a shift in accent. Color became harsher; it was no longer a question of what is "art" but only of the position taken by the individual artist toward the phenomena of his time, ending in propaganda, provocation, revolt, and hatred born of disillusionment. But a painter such as Grosz, to name one of the sharpest critics among the generation born in the 1890s, was by no means self-taught as were so many of the Brücke group. He had learned his trade at the traditional Dresden Academy and had never come into contact with the Expressionists still living in Dresden, or troubled to face up to their art: "All this scarcely penetrated the thick walls of the Academy, nor did it penetrate the thick skulls and goggles of the state-employed teachers" (Grosz).

The war was the first testing ground for the young man in his early twenties. As yet he had no personal style with which to catch these experiences. True, there was the Expressionist vocabulary that in the hands of his elders had proved an uncommonly trenchant arsenal of communication. But to his generation that seemed suspect and usable only conditionally because it was too firmly stamped with the founders' marks and had played a rather different role in artistic expression.

So Grosz's quandary was first voiced in a mountain of drawings plus a few paintings, which show how much he was still searching for the right forms. As he put it: "What I saw filled me with loathing and contempt for mankind. . . . I began to feel that there was a better goal than to be working for myself and the art dealers. I wanted to become an illustrator because high art did not interest me, it only depicted the beauty of the world."

At the end of the war Grosz had no particular political attitude. He saw himself motivated only by utter contempt, whose symbol he chose to make the bourgeoisie. As the quintessence of human ugliness and degeneration, the bourgeois could be depicted only unaesthetically, in an image from which every sort of traditional notion of beauty had been rooted out.

Seeking new pictorial possibilities in order to find a style that could render the cruelty and lack of human charity in his subjects, Grosz lighted on the infantile scribblings on the walls of houses and toilets as model—these gave to his drawings their unmistakable character. The Berlin metropolis with its frenzied excitement, its aggressive newspapers, literary cliques, and revolutionary artists' cells proved a fertile breeding ground for his ideas when, discharged from the army, he went there a second time in 1917.

In the innumerable paintings of these years on big-city themes, two contrary tendencies took shape, both typical of Grosz: the unmasking of human nastiness, and the fascination of the great city with its spectacular, daily merry-go-round. Both are present in *Metropolis*, one of the important paintings of 1917. At first the composition seems more confusing than it really is. Its formal sources are obvious: expressive deformation, Cubist shattering of forms, Futurist action—outgrowths of the European art scene before the war used not in accordance with the necessity of compositional order, but only as an individual vocabulary of expression. The question of spatial organization remains unanswered. Perspective exists only as foreshortening. In an unreal color space the stage props of the objective world—houses, streets, furniture, things—are disposed with, against, over each other like mutually interpenetrating shadows. Within this unstable interweave of geometrizing forms the artist planted the symbolic figures that most fueled his pessimism: a full-bellied bourgeois, young dandy, profiteer, whore, lapdog, and through it all the murder motifs that cropped up repeatedly in his works of those years.

No question, the picture was painted to shake us up, to slap us in the face with none of the nicety of cultivated art, to speak about social collapse, outrage, dirty double dealings. And yet—despite the artist—it remains an aesthetic event, a representation of a double sense due to the character of Grosz himself. Petty bourgeois in background, forever racked by envious lusting after the better life of "the others," he despised the class he claimed to be fighting for: a split personality in contact with a split world.

Grosz obviously relished the role he assumed in those years, as only an artist could permit himself to do who felt ill at ease as outsider and yet reveled in having the door shut on him, who attacked society so he would not need to serve it, who knew this was the way to win applause—in short, the familiar Expressionist attitude.

As a style, Expressionism could no longer mean much to a painter such as Grosz. True to type, he found his home in Dada when it turned up in Berlin in 1918. It was to be expected that the Dada manifesto, which Grosz also signed, should begin by running down Expressionism. Having begun under the cover of introspection, Expressionism, it was said, was now awaiting "yearningly" its due honors in art history and was posing its candidacy to be given a certificate of honorable conduct by the bourgeoisie.

The break with Expressionism is plain in *Metropolis*. Yet it also shows how, even against the will of the parties concerned, the Expressionist optic was setting the tone for the New Realism at the start of the 1920s.

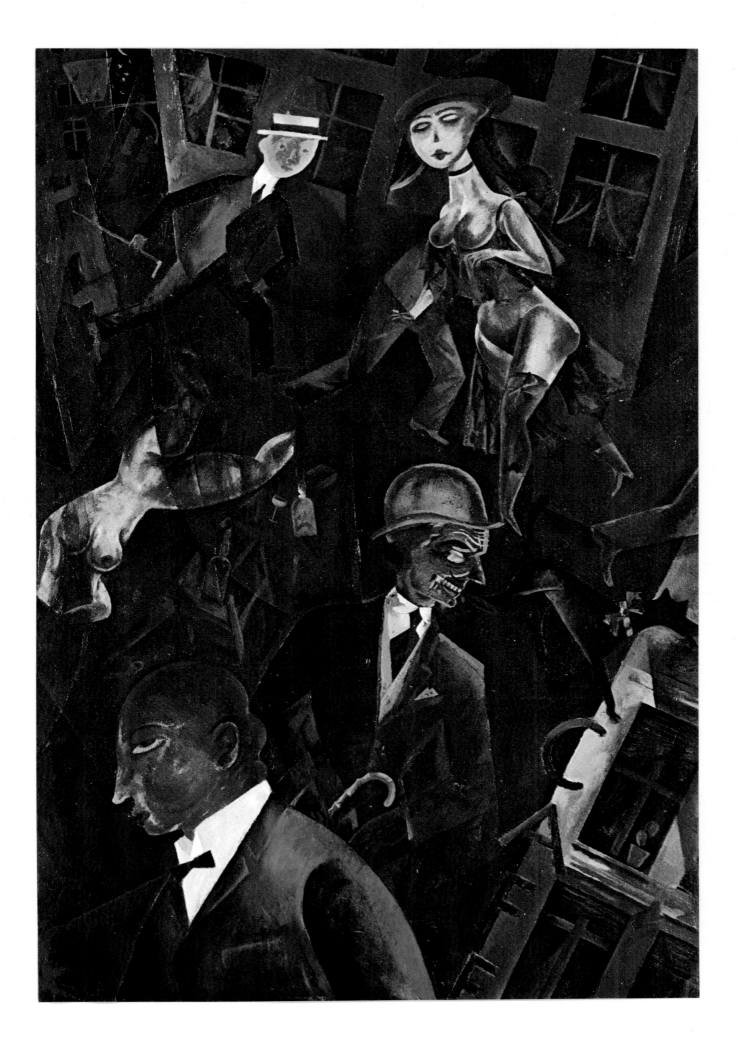

40. MAX BECKMANN (1884–1950)

Christ and the Woman Taken in Adultery

1917. Oil on canvas, 58 3/4 × 49 7/8″
St. Louis Art Museum (Bequest of Curt Valentin)

As a graduate of the Weimar Academy, young Max Beckmann in Berlin, 1905, was almost inevitably drawn into the orbit of the famous triple constellation of Max Liebermann, Max Slevogt, and Lovis Corinth, the brilliant luminaries of pleinair painting in the German capital. Yet his own attempts to master reality frequently strayed far from the methodology of the so-called German Impressionists. Again a question of generations: not direct contact with nature but a real facing up to reality seemed to many younger artists their one true task, and it was one to which Beckmann devoted himself vigorously. At first he could not get along without a dose of allegory when he strove to express his equivocal feelings for the multiplicity of existence, for the tension behind the outward beauty of the visible. When Munch encouraged him to continue in the manner of his *Great Death Scene* (rejected by the jury), this showed that the older master and the young artist had something spiritual in common.

The horrors of the world war finally impelled Beckmann toward Expressionism. During his military service he had the good luck to serve with Erich Heckel and other artists in a unit commanded by Walter Kaesbach, art historian and devoted friend of modern art. Their long discussions about current problems opened new perspectives but did not help the young man to master the problems of form that his new notions entailed. Even the stylistic approach of expressive deformation and heightened color put to the test by the Brücke painters did not seem to him adequate to depict the horrendous reality he saw around him. That, he felt, had to be attacked frontally so as to wrench from it the signs that could convey an unsparing reality in pictorial form. Painting was no longer to come from formal, but from human experience.

About 1917 artists began to glimpse new ways open to them. At that time Beckmann was counted along with Dix and Grosz among those Late Expressionists who, through personal experiences and an overwhelming drive for achievement, had come close to a more outspoken verism unequivocally based on an expressive approach. For all their common ground in many respects, their ways were very different. Verism was not Beckmann's goal, but realness as raw material for a new reality.

The attentive observer finds that approach crystallized in a series of works of that time, among them this one on a religious theme that throws brilliant light on the artist's place. There is an air of theater about it. Figures and objects come together as allegories, a show put on for the watchers outside, dreamed up and directed by the artist who wields his brush like a public ballad singer pointing to the words on the broadsheet; along with this a naive realism and exaggerated gestures and physiognomies. Every aspect, every object becomes part of a story, speaks of the meaning of a life experience that may seem a Bible incident, but is a matter of everyday life.

Christ, dominating the picture, is the only figure to fill the entire height of the canvas and takes on even greater bulk because of the kneeling adulteress. Swirling around them is the circle of participants, each with his own function in the picture. A board fence running obliquely into the background and a lattice of lances shut off the left side against outsiders threatening to break through. Swivelling powerfully inward, blocking the way, the figure of the guard symbolizes staunch resistance to the blindly raging menace of hatred, blocked too in a gentler way by the quiet turn of Christ's head. Christ alone is beyond time, withdrawn into himself. His pronounced gestures—warding off, defending, explaining all at the same time—have the expressivity of early medieval miniatures. His contours take in the very much reduced figure of the adulteress, whose closed eyes bear witness to her faith in her protector. But behind her, a striking contrast in pose, gesture, and color, a clown steps on stage to point mockingly at the earnest scene before him. He embodies the moral of the picture: his pharisaical disdain and hypocritical puritanism make him stand out sharply from the other figures—the only real adversary of Christ. For all the many figures, only four faces are seen, and in them the entire story is summed up in a swift shorthand.

Striking is the physical volume of all the figures, made even more emphatic by shadowing. Despite all the formal relationships of every figure with its neighbors, each exists as an isolated emblem sharply outlined, yet strangely weightless. The lances and fence denote spatial depth: the problem of pictorial space as a cut-out piece of the world was to be a major concern for Beckmann in the next years. The few colors are laid on harshly: Beckmann's determination to have his say counts more than any painterly perfection. The picture's drama comes from the spacing, from the conflict between chaos and order without one or the other getting the upper hand.

Perhaps we can now get a better answer to the question of whether or not this is realism: every shape of visible reality takes on an existential function, appears as challenge to spiritual order. Painting was freeing itself from the aesthetic norm to become a moral act.

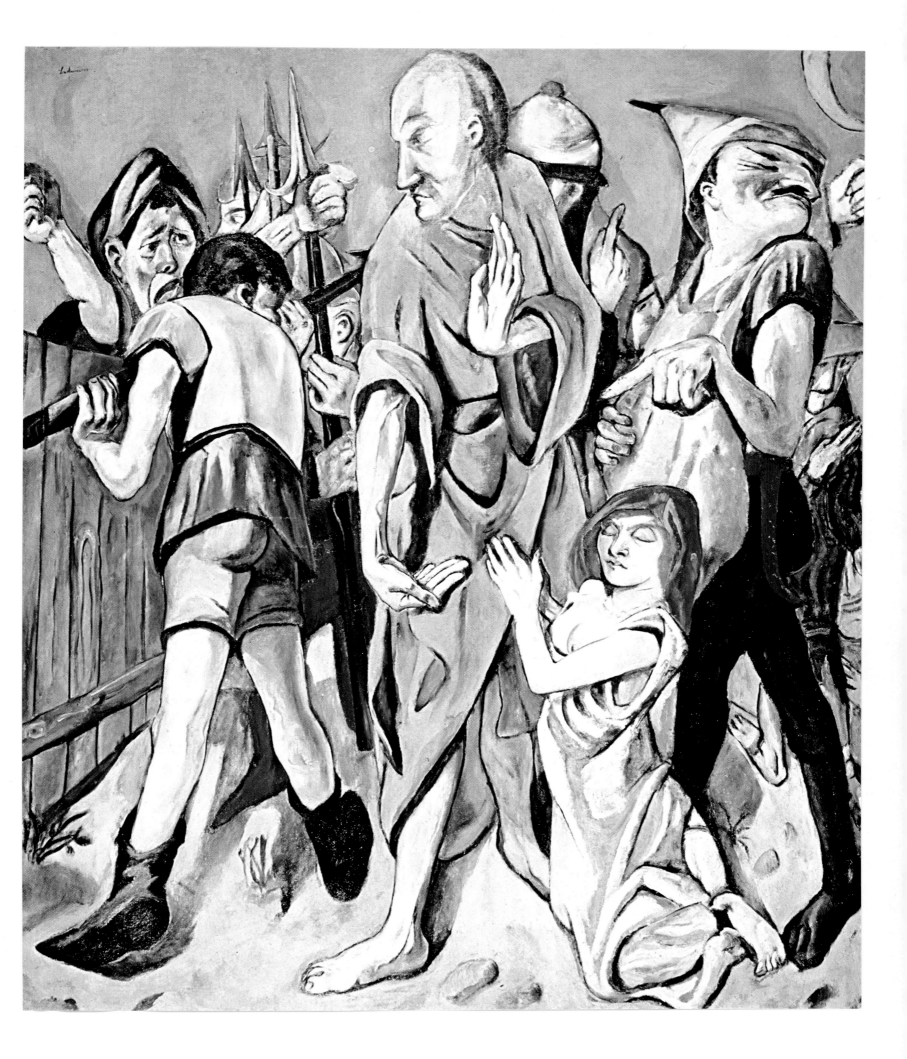

BIBLIOGRAPHY

GENERAL

Barr, Alfred H., Jr. *German Painting and Sculpture*. New York: The Museum of Modern Art, 1931.

Buchheim, Lothar Günther. *The Graphic Art of German Expressionism*. New York: Universe Books, 1960.

Chipp, Hershel B., ed. *Theories of Modern Art. A Source Book by Artists and Critics*. Berkeley: University of California Press, 1968.

Dube, Wolf-Dieter. *Expressionism*. New York: Oxford University Press, 1972.

German Expressionism in the Fine Arts: A Bibliography. Los Angeles: Hennessey & Ingalls, 1977.

Goldwater, Robert J. *Primitivism in Modern Painting*. New York: Vintage Books, 1967.

————— and Treves, Marco, eds. *Artists on Art*. New York: Pantheon, 1945.

Grohmann, Will. *The Expressionists*. New York: Harry N. Abrams, 1957.

Haftmann, Werner. *Painting in the Twentieth Century*. Translated by Ralph Manheim. New York: Frederick A. Praeger, 1965.

Herbert, Robert L., ed. *Modern Artists on Art. Ten Unabridged Essays*. Englewood Cliffs, N.J.: Prentice-Hall, 1964.

Hodin, Joseph Paul. *The Dilemma of Being Modern. Essays on Art and Literature*. London: Routledge and Kegan Paul, 1950.

Hoffmann, Werner. *Expressionist Watercolors 1905–1920*. New York: Harry N. Abrams, 1967.

Kuhn, Charles L. *German Expressionism and Abstract Art*. Cambridge, Mass.: Harvard University Press, 1957.

Lang, Lothar. *Expressionist Book Illustrations in Germany 1907–1927*. Translated by Janet Seligman. Boston: New York Graphic Society, 1976.

Miesel, Victor H., ed. *Voices of German Expressionism*. Englewood Cliffs, N.J.: Prentice-Hall, 1970.

Myers, Bernard Samuel. *The German Expressionists: A Generation in Revolt*. New York: Frederick A. Praeger, 1966.

Pehnt, Wolfgang. *Expressionist Architecture*. Translated by Gerd Hatje. New York: Frederick A. Praeger, 1973.

Read, Herbert A. *A Concise History of Modern Painting*. 3d printing. New York: Frederick A. Praeger, 1964.

Reed, Orrel P., Jr. *German Expressionist Art: The Robert Gore Rifkind Collection: Prints, Drawings, Illustrated Books, Periodicals, Posters*. Includes essays by Ida Katherine Rigby and Isa Lohman-Siems. Los Angeles: Frederick A. Wight Art Gallery, University of California, in collaboration with the New Orleans Museum of Art, the City Art Museum, St. Louis, the Busch-Reisinger Museum, Harvard University, Cambridge, 1977–79.

Roditi, Edouard D'Israeli, ed. *Dialogues on Art*. London: Secker and Warburg, 1960.

Roethel, Hans Konrad. *Modern German Painting*. Translated by Desmond and Louise Clayton. New York: Reynal, 1957.

————— *The Blue Rider*. With a catalogue of the works of Kandinsky, Klee, Macke, Marc and other Blue Rider artists in the Municipal Gallery, Munich. New York: Frederick A. Praeger, 1971.

Roh, Franz and J. *German Art in the 20th Century*. Translated by Catherine Hutter. Greenwich, Conn.: New York Graphic Society, 1968.

Rosenblum, Robert. *Modern Painting and the Northern Romantic Tradition*. New York, Harper and Row, 1975.

Selz, Peter. *German Expressionist Painting*. 3d printing. Berkeley: University of California Press, 1974.

Stubbe, Wolf. *Graphic Arts in the Twentieth Century*. New York: Frederick A. Praeger, 1962.

Vergo, Peter. *Art in Vienna 1898–1918: Klimt, Kokoschka, Schiele and their Contemporaries*. London: Phaidon, 1975.

Willet, John. *Expressionism*. New York: McGraw-Hill, 1970.

Worringer, Wilhelm. *Abstraction and Empathy*. Translated by Michael Bullock. Cleveland: World Publishers, 1967.

Zigrosser, Carl. *The Expressionists: A Survey of Their Graphic Art*. New York: Braziller, 1957.

ARTISTS

ERNST BARLACH

Carls, Carl Dietrich. *Ernst Barlach*. New York: Frederick A. Praeger, 1969.

Schult, Friedrich. *Ernst Barlach: Werkverzeichnis*. Hamburg: Ernst Hauswedell, 1958–71. Vol. 1, *Plastic Oeuvre*, 1960; vol. 2, *Graphic Oeuvre*, 1958; vol. 3, *Drawings*, 1971.

Werner, Alfred. *Ernst Barlach*. New York: McGraw-Hill, 1966.

MAX BECKMANN

Fischer, Friedhelm W. *Max Beckmann*. London: Phaidon, 1973.

Göpel, Erhard and Barbara. *Max Beckmann. Katalog der Gemälde*. Rev. ed. With bibliography by Hans Martin von Erffa. 2 vols. Berne: Kornfeld, 1975.

GÜSE, ERNST GERHARD. *Das Frühwerk Max Beckmanns. Zur Thematik seiner Bilder aus den Jahren 1904–1914*. Berne: Kornfeld, 1977.

KESSLER, CHARLES S. *Max Beckmann's Triptychs*. Cambridge, Mass.: Belknap, Harvard University Press, 1970.

LACKNER, STEPHAN. *Max Beckmann*. New York: Harry N. Abrams, 1975.

———— *Max Beckmann: Memories of a Friendship*. Coral Gables, Fla.: University of Miami Press, 1969.

SELZ, PETER. *Max Beckmann*. With contributions by Harold Joachim and Perry T. Rathbone. New York: The Museum of Modern Art in collaboration with the Museum of Fine Arts, Boston, and the Art Institute of Chicago, 1964.

WIESE, STEPHAN VON. *Max Beckmanns zeichnerisches Werk 1903–1925*. Düsseldorf: Droste, 1978.

HEINRICH CAMPENDONK

ENGELS, MATHIAS TONI. *Campendonk: Holzschnitte*. With list of woodcuts. Stuttgart: Kohlhammer, 1959.

WEMBER, PAUL. *Heinrich Campendonk, Krefeld 1889–1957 Amsterdam*. Krefeld: Scherpe Verlag, 1960.

OTTO DIX

CONZELMANN, OTTO, ed. *Otto Dix*. Hannover: Fackelträger Schmidt-Küster, 1959.

———— *Otto Dix. Handzeichnungen*. Hannover: Fackelträger Schmidt-Küster, 1968.

KARSCH, FLORIAN. *Otto Dix, Das graphische Werk*. Hannover: Fackelträger Verlag, 1970.

LÖFFLER, FRITZ. *Otto Dix. Leben und Werk*. Vienna: Anton Schroll, 1967.

LYONEL FEININGER

HESS, HANS. *Lyonel Feininger*. New York: Harry N. Abrams, 1961.

Lyonel Feininger: The Formative Years (exhibition catalogue). Introduction by Ernst Scheyer. Detroit: Detroit Institute of Arts, 1964.

PRASSE, LEONA E. *Lyonel Feininger, A Definitive Catalogue of his Graphic Work, Etchings, Lithographs, Woodcuts* (Cleveland Museum of Art). Kent, Ohio: Kent State University Press, 1972.

SCHEYER, ERNST. *Lyonel Feininger: Caricature and Fantasy*. Detroit: Wayne State University Press, 1964.

CONRAD FELIXMÜLLER

HERZOG, G. H., ed. *Conrad Felixmüller, Legenden 1912–1976*. Tübingen: Ernst Wasmuth, 1977.

PETERS, H., ed. *Conrad Felixmüller*. Kunstblätter der Galerie Nierendorf, No. 8. Berlin: Nierendorf, 1965.

SÖHN, GERHART, ed. *Conrad Felixmüller, Das graphische Werk 1912–1974*. Düsseldorf: Graphik Salon Gerhart Schön, 1975.

WALTER GRAMATTÉ

ECKARDT, F. *Das graphische Werk von Walter Gramatté*. Vienna: Amalthea, 1932.

Walter Gramatté (exhibition catalogue). Berlin: Brücke-Museum, 1968.

GEORGE GROSZ

BITTNER, HERBERT, ed. *George Grosz*. With an essay by the artist.

Introduction by Ruth Berenson and Norbert Muhlen. New York: Arts Inc., 1960.

GROSZ, GEORGE. *A Little Yes and a Big No: The Autobiography of George Grosz*. New York: The Dial Press, 1946.

HESS, HANS. *George Grosz*. London: Macmillan, 1974.

LEWIS, BETH I. *George Grosz: Art and Politics in the Weimar Republic*. Madison: University of Wisconsin Press, 1971.

SCHNEEDE, UWE M. *George Grosz, Der Künstler in seiner Gesellschaft*. Cologne: DuMont Schauberg, 1975.

ERICH HECKEL

DUBE, ANNEMARIE, ed. *Erich Heckel. Das graphische Werk*. New York: E. Rathenau, 1964–65. Vol. 1, *Woodcuts*; vol. 2, *Etchings and Lithographs*; vol. 3, *Addendum*, 1974.

KÖHN, HEINZ. *Erich Heckel, Aquarelle und Zeichnungen*. Munich: Bruckmann, 1959.

RAVE, PAUL ORTWIN. *Erich Heckel*. Berlin: Volk und Buchverlag, 1948.

VOGT, PAUL. *Erich Heckel* (catalogue of paintings, murals, and sculpture, with bibliography). Recklinghausen: Aurel Bongers, 1965.

ALEXEY VON JAWLENSKY

RATHKE, EWALD. *Alexej Jawlensky*. Hanau: Dr. Hans Peters Verlag, 1968.

SCHULTZE, JÜRGEN. *Alexej Jawlensky*. Cologne: DuMont Schauberg, 1970.

WEILER, CLEMENS. *Alexej Jawlensky: Heads, Faces, Meditations*. New York: Frederick A. Praeger, 1971.

WASSILY KANDINSKY

BILL, MAX, ed. *Wassily Kandinsky*. With essays by Jean Arp, Charles Estienne, Carola Giedion-Welcker, Will Grohmann, Ludwig Grote, Nina Kandinsky, Alberto Magnelli. Paris: Maeght, 1951.

EICHNER, JOHANNES. *Kandinsky und Gabriele Münter. Von Ursprüngen moderner Kunst*. Munich: F. Bruckmann, 1957.

GROHMANN, WILL. *Wassily Kandinsky. Life and Work*. New York: Harry N. Abrams, 1958.

KANDINSKY, WASSILY. *The Art of Spiritual Harmony*. Translated with an introduction by Michael T. H. Sadleir. Boston: Houghton Mifflin, 1914.

———— *Concerning the Spiritual in Art*. A version of the 1914 Sadleir translation with retranslation by Francis Golffing, Michael Harrison and Ferdinand Ostertag. New York: George Wittenborn, 1947.

———— and MARC, FRANZ, eds. *The Blaue Reiter Almanac*. New documentary edition by Klaus Lankheit. (Originally published in German in 1912.) New York: Viking Press, 1974.

LASSAIGNE, JACQUES. *Kandinsky: Biographical and Critical Study*. Geneva: Skira, 1964.

LINDSAY, KENNETH C. E. and VERGO, PETER, eds. *Kandinsky: The Complete Writings*. The Documents of 20th-Century Art. New York: Viking Press, in progress.

OVERY, PAUL. *Kandinsky: The Language of the Eye*. New York: Praeger Publishers, 1969.

RÖTHEL, HANS KONRAD. *The Graphic Work of Kandinsky* (with

catalogue). Washington: International Exhibitions Foundation, 1973.

WEISS, PEG. *Kandinsky in Munich: The Formative Jugendstil Years.* Princeton, N.J.: Princeton University Press, 1979.

ERNST LUDWIG KIRCHNER

DUBE, ANNEMARIE. *Kirchner. His Graphic Art.* Greenwich, Conn.: New York Graphic Society, 1966.

DUBE, ANNEMARIE and WOLF-DIETER. *Ernst Ludwig Kirchner, Das graphische Werk.* 2 vols. (catalogue and plates). Munich: Prestel, 1967.

GORDON, DONALD E. *Ernst Ludwig Kirchner.* Cambridge, Mass.: Harvard University Press, 1968.

———— *Ernst Ludwig Kirchner.* New York: Arts Inc., 1961.

SCHIEFLER, GUSTAV. *Die Graphik E. L. Kirchners.* Vol. 1 (to 1916), 1924–26; vol. 2 (to 1927), 1927–1931. Berlin, Charlottenburg: Euphorion, 1924–1931.

PAUL KLEE

ARMITAGE, MERLE, et al. *Five Essays on Klee.* New York: Duell, Sloan & Pearce, 1950.

COOPER, DOUGLAS. *Paul Klee.* Harmondsworth: Penguin Books, 1949.

GEELHAAR, CHRISTIAN, ed. *Paul Klee: Schriften, Rezensionen und Aufsätze.* Cologne: DuMont, 1976.

GIEDION-WELCKER, CAROLA. *Paul Klee.* New York: Viking Press, 1952.

GROHMANN, WILL. *Paul Klee.* New York: Harry N. Abrams, 1966.

HAFTMANN, WERNER. *The Mind and Work of Paul Klee.* New York: Frederick A. Praeger, 1954.

KLEE, PAUL. *The Diaries, 1898–1918.* Felix Klee, ed. Berkeley: University of California Press, 1968.

Paul Klee: The Inward Vision. Watercolors, Drawings, Writings. With an essay by Paul Klee and texts by Carola Giedion-Welcker, Will Grohmann, Werner Haftmann, Werner Schmalenbach, and Georg Schmidt. New York: Harry N. Abrams, 1958.

Paul Klee: Three Exhibitions—1930, 1941, 1949. Preface by Paul Klee. Edited by Monroe Wheeler. New York: Museum of Modern Art, 1970.

KORNFELD, E. W. *Paul Klee, Verzeichnis des graphischen Werkes.* Berne: Kornfeld, 1963.

RÖTHEL, HANS KONRAD. *Paul Klee in München.* Berne: Stämpfli, 1971.

SPILLER, JURG, ed. *Paul Klee Notebooks.* Volume 1, *The Thinking Eye.* Translated by Ralph Mannheim. Reprint. New York: Wittenborn, 1978.

———— *Paul Klee Notebooks.* Volume 2, *The Nature of Nature.* Translated by Heinz Norden. New York: Wittenborn, 1973.

OSKAR KOKOSCHKA

BULTMANN, BERNHARD. *Oskar Kokoschka.* New York: Harry N. Abrams, 1961.

HODIN, JOSEF PAUL. *Oskar Kokoschka: The Artist and His Time.* Greenwich, Conn.: New York Graphic Society, 1966.

HOFFMANN, EDITH. *Kokoschka, Life and Work.* With two essays by Oskar Kokoschka and a foreword by Herbert Read. London: Faber & Faber, 1947.

KOKOSCHKA, OSKAR. *A Sea Ringed with Visions* (literary works). London: Thames and Hudson, 1962.

———— *My Life.* New York: Macmillan, 1974.

Oskar Kokoschka: Watercolors, Drawings, Writings. With an introduction by John Russell. New York: Harry N. Abrams, 1963.

RATHENAU, ERNEST, ed. *Kokoschka Drawings.* With an introduction by Paul Westheim. London: Thames and Hudson, 1962.

———— *Oskar Kokoschka: Drawings, 1906–1965.* In collaboration with the artist. Translated by Heinz Norden. Coral Gables, Fla.: University of Miami Press, 1970.

WINGLER, HANS MARIA. *Oskar Kokoschka. The Work of the Painter.* Salzburg: Welz, 1958.

———— and WELZ, FRIEDRICH. *Oskar Kokoschka, Das druckgraphische Werk* (catalogue of works). Salzburg: Welz, 1975.

———— *Oskar Kokoschka, Das graphische Werk* (catalogue of works). Salzburg: Welz, 1971.

KÄTHE KOLLWITZ

BITTNER, HERBERT. *Kaethe Kollwitz: Drawings.* New York: Thomas Yoseloff, 1959.

KLEIN, MINA and ARTHUR. *Käthe Kollwitz: Life in Art.* New York: Schocken Books, 1973.

KLIPSTEIN, AUGUST. *Käthe Kollwitz: Verzeichnis des graphischen Werkes.* Berne: Klipstein, 1955.

KOLLWITZ, HANS, ed. *Diary and Letters.* Translated by Richard and Clara Winston. Chicago: Henry Regnery, 1955.

KOLLWITZ, KÄTHE. *Twenty-One Late Drawings.* Boston: Boston Book & Art, 1970.

NAGEL, OTTO. *Käthe Kollwitz.* Translated by Stella Humphries. Greenwich, Conn.: New York Graphic Society, 1971.

ZIGROSSER, CARL, ed. *Prints and Drawings of Käthe Kollwitz.* New York: Dover Publications, 1969.

AUGUST MACKE

August Macke: Tunisian Watercolors and Drawings. With writings by August Macke, Günter Busch, Walter Holzhausen, and Paul Klee. New York: Harry N. Abrams, 1959.

ERDMANN-MACKE, ELISABETH. *Erinnerungen an August Macke.* Stuttgart: Kolhammer, 1962.

VRIESEN, GUSTAV. *August Macke* (with catalogue and bibliography). Stuttgart: Kolhammer, 1957.

FRANZ MARC

LANKHEIT, KLAUS. *Franz Marc, Katalog der Werke.* Cologne: DuMont Schauberg, 1970.

———— *Franz Marc, Sein Leben und seine Kunst.* Cologne: DuMont, 1976.

———— *Franz Marc: Watercolors, Drawings, Writings.* New York: Harry N. Abrams, 1960.

———— ed. *Franz Marc: Schriften.* Cologne: DuMont, 1978.

MARC, FRANZ. *Briefe aus dem Feld.* Berlin: Rembrandt Verlag, 1940.

LUDWIG MEIDNER

GROCHOWIAK, THOMAS. *Ludwig Meidner.* With extensive bibliography. Recklinghausen: Aurel Bongers, 1966.

PAULA MODERSOHN-BECKER

Paula Modersohn-Becker (centenary exhibition catalogue). Bremen: Kunsthalle, 1976.

Paula Modersohn-Becker: Gemälde, Zeichnungen, Graphik (exhibition catalogue). Bremen: Graphisches Kabinett U. Voigt, 1968.

Paula Modersohn-Becker (exhibition catalogue). Bremen: Graphisches Kabinett Wolfgang Werner, 1972.

WILHELM MORGNER

SEILER, HARALD. *Wilhelm Morgner.* Recklinghausen: Aurel Bongers, 1956.

Wilhelm Morgner (exhibition catalogue). Münster: Westfälischer Kunstverein—Landesmuseum für Kunst und Kulturgeschichte, 1967.

OTTO MUELLER

BUCHHEIM, LOTHAR GÜNTHER. *Otto Mueller, Leben und Werk.* With a catalogue of graphic works by Florian Karsch. Feldafing: Buchheim, 1963.

Otto Mueller zum hundertsten Geburtstag: Das graphische Gesamtwerk. Introduction by Florian Karsch. Berlin: Nierendorf, 1974.

GABRIELE MÜNTER

EICHNER, JOHANNES. *Kandinsky und Gabriele Münter: Von Ursprüngen moderner Kunst.* Munich: Bruckmann, 1957.

ROTHEL, HANS KONRAD. *Gabriele Münter.* With bibliography. Munich: Bruckmann, 1957.

EMIL NOLDE

GOSEBRUCH, MARTIN. *Nolde Watercolors and Drawings.* Translated by E. M. Künstner and J. A. Underwood. New York: Frederick A. Praeger, 1973.

HAFTMANN, WERNER. *Emil Nolde.* New York: Harry N. Abrams, 1959.

———— *Emil Nolde: Unpainted Pictures.* New York: Frederick A. Praeger, 1965.

NOLDE, EMIL. *Jahre der Kämpfe, 1902–1914.* Cologne: DuMont Schauberg, 1967.

SCHIEFLER, GUSTAV. *Das graphische Werk.* Rev. ed. by Christel Mosel. 2 vols. Cologne: DuMont Schauberg, 1966–1967.

SELZ, PETER. *Emil Nolde.* New York: The Museum of Modern Art in collaboration with the San Francisco Museum of Art and the Pasadena Art Museum, 1963.

URBAN, MARTIN. *Emil Nolde: Landscapes, Watercolors, and Drawings.* New York: Frederick A. Praeger, 1973.

MAX PECHSTEIN

FECHTER, PAUL. *Das graphische Werk Max Pechsteins.* With catalogue. Berlin: Fritz Gurlitt, 1921.

LEMMER, KONRAD, ed. *Max Pechstein und der Beginn des Expressionismus.* Berlin: Lemmer, 1949.

OSBORN, MAX. *Max Pechstein.* Berlin: Propyläen, 1922.

CHRISTIAN ROHLFS

Christian Rohlfs: Watercolors, Drawings, and Prints. Introduction by Paul Vogt. Washington: International Exhibitions Foundation, 1968.

VOGT, PAUL. *Christian Rohlfs.* Cologne: DuMont Schauberg, 1967.

———— *Christian Rohlfs, Das graphische Werk.* With catalogue. Recklinghausen: Aurel Bongers, 1960.

———— *Christian Rohlfs: Oeuvre-Katalog der Ölgemälde.* Recklinghausen: Aurel Bongers, 1978.

———— *The Best of Christian Rohlfs.* New York: Atlantis, 1964.

EGON SCHIELE

COMINI, ALESSANDRA. *Egon Schiele.* New York: George Braziller, 1976.

———— *Egon Schiele's Portraits.* Berkeley: University of California Press, 1974.

———— *Schiele in Prison.* Greenwich, Conn.: New York Graphic Society, 1973.

KALLIR, OTTO. *Egon Schiele: Oeuvre-Catalogue of the Paintings.* With essays by Otto Benesch and Thomas M. Messer. New York: Crown, 1966.

LEOPOLD, RUDOLF. *Egon Schiele: Paintings, Watercolors, Drawings.* Translated by Alexandra Lieven. New York: Phaidon, 1973.

MITSCH, ERWIN. *The Art of Egon Schiele.* New York: Phaidon, 1975.

KARL SCHMIDT-ROTTLUFF

BRIX, KARL. *Karl Schmidt-Rottluff.* Vienna: Schroll, 1971.

GROHMANN, WILL. *Karl Schmidt-Rottluff.* With chronological catalogue and bibliography. Stuttgart: Kohlhammer, 1956.

WIETEK, GERHARD. *Schmidt-Rottluff Graphik.* Munich: Karl Thiemig, 1971.

JAKOB STEINHARDT

KOLB, LEON. *The Woodcuts of Jakob Steinhardt.* San Francisco: Genart Company, 1969.

The Graphic Art of Jakob Steinhardt. Introduction by Haim Gamzu. New York, London: Yoseloff-Barnes, 1963.

GEORG TAPPERT

Georg Tappert, 1880–1957, exhibition catalogue. Berlin: Akademie der Künste, 1961.

HEINRICH VOGELER

PETZET, HEINRICH WIEGAND. *Heinrich Vogeler: Von Worpswede nach Moskau.* Cologne: DuMont Schauberg, 1972.

———— *Heinrich Vogeler, Zeichnungen.* Cologne: DuMont Schauberg, 1976.

INDEX

Page numbers are in roman type. Black-and-white figures and colorplates are specifically so designated. Titles of works are in *italics*.

PHOTOGRAPH CREDITS